BY DONNA GUSTAFSON

WITH ESSAYS BY
EUGENE R. GADDIS, ELLEN HANDY,
KARAL ANN MARLING,
AND LEE SIEGEL

THE MIT PRESS
CAMBRIDGE, MASSACHUSETTS
LONDON, ENGLAND
AND
AMERICAN FEDERATION OF ARTS
NEW YORK

IMAGES FROM

THE WORLD BETWEEN

**THE CIRCUS IN 20TH
CENTURY AMERICAN ART**

This catalogue has been published in conjunction with *Images from the World Between: The Circus in Twentieth-Century American Art*, an exhibition organized by the American Federation of Arts.

Publication Coordinator Michaelyn Mitchell
Editor Stephen Robert Frankel
Designer studio blue, Chicago
Indexer Laura N. Ogar

Library of Congress Cataloging-in-Publication Data

Gustafson, Donna.
Images from the world between : the circus in 20th century American art / by Donna Gustafson ; with essays by Eugene Gaddis ... [et al.].
p. cm.
Catalogue of the exhibition held Oct. 19, 2001–Jan. 8, 2002 at Wadsworth Atheneum Museum of Art, Feb. 1–Apr. 14, 2002 at John and Mable Ringling Museum of Art, Sarasota, Fla., and June 7–Aug. 19, 2002 at Austin Museum of Art. Includes bibliographical references and index.

ISBN 1-885444-22-2 (paperback)
ISBN 0-262-07228-9 (hardcover)

Circus in art – Exhibitions. 2. Art, American – 20th century – Exhibitions. I. American Federation of Arts. II. Wadsworth Atheneum Museum of Art. III. John and Mable Ringling Museum of Art. IV. Austin Museum of Art. V. Title

N8217.C3 G88 2001
704.9'497913 – dc21

2001022704

Front cover Everett Shinn, *The Tightrope Walker* (detail), 1924 (fig.15)

Printed in Hong Kong.

Published in 2001 by The MIT Press and the American Federation of Arts.

The MIT Press
Massachusetts Institute of Technology
Cambridge, Massachusetts 02142
http://mitpress.mit.edu

American Federation of Arts
41 East 65th Street
New York, New York 10021
www.afaweb.org

Exhibition Itinerary
Wadsworth Atheneum Museum of Art
Hartford, Connecticut
October 19, 2001–January 6, 2002

John and Mable Ringling Museum of Art
Sarasota, Florida
February 1–April 14, 2002

Austin Museum of Art
Austin, Texas
June 7–August 19, 2002

FEATURING

Addison Gallery of American Art, Philips Academy, Andover, Massachusetts

D'Amelio Terras Gallery, New York

AXA Financial, Inc., through its subsidiary The Equitable Life Assurance Society of the U.S.

The William Benton Museum of Art, University of Connecticut, Storrs

Berkeley Art Museum, University of California

Berry-Hill Galleries, New York

Brigham Young University Museum of Art

The Butler Institute of American Art, Youngstown, Ohio

Carnegie Museum of Art, Pittsburgh

Columbus Museum of Art, Ohio

The Currier Gallery of Art, Manchester, New Hampshire

Curtis Galleries, Minneapolis

The Dayton Art Institute, Ohio

De Cordova Museum and Sculpture Park, Lincoln, Massachusetts

Des Moines Art Center

The Detroit Institute of Arts

The Eames Office and Pyramid Media

The J. Paul Getty Museum, Los Angeles

Samuel P. Harn Museum of Art, University of Florida

Heckscher Museum of Art, Huntington, New York

Hirshhorn Museum and Sculpture Garden, Smithsonian Institution, Washington, D.C.

Hood Museum of Art, Dartmouth College, Hanover, New Hampshire

International Center of Photography, New York

Vivian Kiechel Fine Art, Lincoln, Nebraska

Kraushaar Galleries, New York

Ricco/Maresca Gallery, New York

Robert Miller Gallery, New York

The Metropolitan Museum of Art, New York

Milton Avery Trust

The Museum of Modern Art, New York

Museum of Fine Arts, Boston

National Gallery of Art, Washington, D.C.

National Gallery of Canada, Ottawa

Oakland Museum of California

Pennsylvania Academy of the Fine Arts, Philadelphia

Philadelphia Museum of Art

The Phillips Collection, Washington, D.C.

Harry Ransom Humanities Research Center, University of Texas at Austin

The John and Mable Ringling Museum of Art, the State Art Museum of Florida

The Roland Collection

Swarthmore College, Pennsylvania

Terra Foundation for the Arts, Chicago

University of Michigan Museum of Art

Wadsworth Atheneum Museum of Art, Hartford

Whitney Museum of American Art

Yale University Art Gallery, New Haven

Polly Apfelbaum

Rhona Bitner

Barbara Balkin Cottle and Robert Cottle

Audrey Chamberlain Foote, Washington, D.C.

William H. Lane Collection

Mary Ellen Mark

Anonymous

LENDERS

TO THE EXHIBITION

ACKNOWLEDGMENTS

An art form in and of itself, the circus mirrors the human condition in a way that has intrigued many twentieth-century American artists. The work of those artists who have embraced the rich subject matter of the circus — many of them using it as a departure point for formal experimentation — is the focus of this exhibition and its accompanying publication, and the great variety of paintings, sculpture, prints, and photographs included here reflects its multifaceted allure. Artists have responded variously to its exoticism, its visual dynamics, its social taboos, its glamour, the physical prowess or physical uniqueness of the performers, as well as its many contradictory qualities: freedom/danger, beauty/gro-tesqueness, charm/decadence, joy/pathos.

Our thanks begin with the curator of the exhibition, Donna Gustafson, Director of Exhibitions at the Hunterdon Museum of Art and formerly AFA's Chief Curator, for conceiving and developing the project with intelligence and imagination. In addition to curating the exhibition, Ms. Gustafson expertly guided every aspect of the exhibition's organization, and we are particularly grateful to her for her perceptive essay. We also wish to acknowledge the other contributors to the catalogue: Eugene R. Gaddis, the William G. Delana Archivist and Curator of the Austin House, the Wadsworth Atheneum Museum of Art; Ellen Handy, Director of Studies at Christie's Education; noted author and cultural historian Karal Ann Marling; and Lee Siegel, a contributing editor for *The New Republic*, *Harper's* and *ARTnews*.

On the AFA staff, recognition also goes to Thomas Padon, Director of Exhibitions, for his role in the planning and shaping of the exhibition. Michaelyn Mitchell, Head of Publications, adeptly coordinated the editing, design, and printing of this impressive book. Other staff members who share credit for the success of this project include Karen Convertino, Registrar, who handled the challenges of preparing and touring the exhibition; Beth Huseman, Editorial Assistant, who scrupulously attended to innumerable details on the publication; Dolores Pukki, Assistant to the Chief Curator, who contributed her considerable research and organizational skills to the project; Lisbeth Mark, Director of Communications, and Stephanie Ruggiero, Communications Associate, who oversaw the promotion and publicity for the project; and Erin Tohill, Registrar Assistant, who assisted the registrars.

For his careful editing of the text, thanks go to Stephen Robert Frankel, and for their inspired design of the book we wish to gratefully acknowledge Garrett Niksch, Matt Simpson, and Gail Wiener of studio blue in Chicago. We also wish to thank Deborah Schwartz, Education Consultant, for her careful preparation of the educational materials.

We are delighted to have joined forces with MIT Press and wish to acknowledge and thank Roger L. Conover, Executive Editor, for his commitment to the project.

To the many lenders who so generously allowed us to borrow their paintings go our warmest appreciation.

Finally, we wish to acknowledge the venues on the tour — the Wadsworth Atheneum Museum of Art, Hartford; the John and Mable Ringling Museum of Art, Sarasota, Florida; and the Austin Museum of Art. We are so pleased to be collaborating with them in presenting this exhibition to an extended and diverse audience around the country.

Julia Brown
Director, American Federation of Arts

The title *Images from the World Between* derives from an essay by the German literary critic Heinz Politzer on Franz Kafka's short story "In the Gallery."[1] Politzer speaks of Kafka's exploration of the circus as "a world between," a place outside of the common ken, a metaphorical space where reality is bent in strange but seemingly plausible ways. Kafka uses the circus as a metaphor, but Politzer's apt phrase reminds us that the circus is a separate place with its own hierarchical structure, rules of conduct, rhythms, and cycles. As this exhibition and book are intended to reveal, the circus in art is both the documentation of a succession of factual occurrences in time and space and an imagined place that can serve to illustrate ideas. The circus in American art is often a potent metaphor for the forces in American life and also a reflection of American life, at once darker and more light-filled than reality.

The realization of this exhibition and book has enlisted the assistance of many people. I am indebted first to my colleagues, both past and present, at the AFA who have been extraordinarily generous. I would like to particularly thank Julia Brown, Director, and Serena Rattazzi, former Director, for their support of the project; Thomas Padon, Director of Exhibitions, for his ideas and advice; Michaelyn Mitchell, Head of Publications, who produced this handsome book; Dolores Pukki, my assistant, who proved herself equal to every challenge I threw her way with grace and good humor; Christina Ferando, Assistant to the Director of Exhibitions, for her fine research skills; and Beth Huseman, Editorial Assistant, for her work on the publication. I am grateful to Karen Convertino, Registrar, and Kathleen Flynn, Head Registrar, who handled all of the registrarial details with their customary professionalism. I am also indebted to Eugene R. Gaddis, Ellen Handy, Karal Ann Marling, and Lee Siegel for their insightful readings of the circus in America. Their texts provide a wider lens through which to view the circus in American art.

Throughout the course of the exhibition planning, I have had the pleasure of collaborating with colleagues at the Wadsworth Atheneum Museum of Art, the John and Mable Ringling Museum of Art, and the Austin Museum of Art. At the Wadsworth Atheneum, I want to especially thank Amy Ellis, Associate Curator of American Art, and Betsy Kornhauser, Chief Curator, who was responsible for bringing about the collaboration with the Wadsworth and for making it possible for Eugene Gaddis to contribute to the catalogue. At the Ringling Museum, Mitchell Merling, Curator of European Art, Aaron De Groft, Chief Curator, and Debra Walk, Archivist, were helpful in every way. At the Austin Museum of Art, I want to thank Elizabeth Ferrer, Director, and Dana Friis-Hansen, Chief Curator, for their cooperation.

For their assistance in many ways, I am grateful to the following: Donald Albrecht, Maxwell Anderson, Polly Apfelbaum, March Avery, Marie-Thérèse Brincard, Lynn Deines, Rhona Bitner, Thomas Bruhn, Nick Capasso, Joe Coleman and Whitney Ward, Barbara Balkin Cottle and Robert Cottle, Fred Dahlinger, Bruce Davidson, Shanie Ellison, Susan Faxon, Ruth Fine, Audrey Chamberlain Foote, Erin Foley, Glen Gentele, Gregory Gilbert, Kimberly Gremillion, Denis Hall, Erica Hirschler, Lisa Hodermarsky, Constance Cain Hungerford, Katherine Kaplan, Vivien Kiechel, Judy Kim, Lisette Model Foundation, Louise Lippincott, Mary Ellen Mark, Joan Marter, Jane Myers, Shelley Mills, Jason Nutt, John O'Reilly, Klaus Ottmann, John Pelosi, Carol Pesner, Paul Provost, Alexander Rower, Anthony Roland, Andrew Spahr, Pari Stave, Jeanette Toohey, Meredith Lue, Nanette Maciejunes, Marilyn Neuhart, Suzanne Ramljak, Phyllis Rosenzweig, Novelene Ross, Elizabeth Hutton Turner, Jeffrey Weiss, Nichole Wholean, Alan Wintermute, Sylvia Yount, and the lenders who wish to remain anonymous.

Finally, thanks to my family, Andrew and Kate Mitchell who have contributed to this project in ways too numerous to quantify, especially to Kate, whose fear of clowns does not keep her from the circus.

Donna Gustafson

[1] Heinz Politzer, *Franz Kafka, Parable and Paradox* (Ithaca, NY: Cornell University Press, 1962), reprinted in 1965 as *Franz Kafka der Kunstler*.

IMAGES FROM

THE WORLD BETWEEN

THE CIRCUS IN 20TH CENTURY AMERICAN ART

DONNA GUSTAFSON

WHAT IS THE CIRCUS IF NOT A WORLD BETWEEN, "A TINY CLOSED OFF ARENA OF FORGETFULNESS"[2] BETWEEN EVERYDAY LIFE AND THEATER WHERE ANIMALS AND HUMAN BEINGS PERFORM TO THE BEST OF THEIR ABILITIES. THE CIRCUS IS DISTINCT FROM THE THEATER IN THAT THE DANGERS THE PERFORMERS FACE ARE REAL, NOT IMAGINED; A MOMENTARY LAPSE OF JUDG-MENT, A FAILURE OF SKILL, OR A CHANCE OCCURRENCE CAN CAUSE SERIOUS INJURY OR EVEN DEATH. AS THE ACROBAT SWINGS FROM A GREAT HEIGHT, THE PARTNER OF THE KNIFE-THROWER TAKES HIS OR HER PLACE, THE ANIMAL TRAINER ENTERS A CAGE TO FACE A GROUP OF BIG CATS, THE AUDIENCE IS BY TURNS AWED, MOVED, FRIGHTENED, AND RELIEVED. THE CIRCUS MARKS PROGRESS BY CIRCULAR MOVE-MENT, NEVER IN A STRAIGHT LINE; AS EACH SELF-CONTAINED, INDIVIDUAL ACT COMES TO A CLIMAX AND A SUCCESSFUL CLOSE. LIFE IS AFFIRMED, CONTROL IS MAINTAINED, AND ART TRIUMPHS.

In America, where the carnivalesque is in constant battle with Puritan traditions,[3] the circus has rarely been seen as an art. More often than not, it has suffered from a negative reputation fueled by its outsider status, its supposed appeal to children, and the riotous activities of a three-ring circus that make focus on any particular moment an impossibility. To declare your allegiance to the circus is to court suspicion, or at least skepticism. More often than not, people will confess to a fear of clowns or to outrage directed toward the exhibition of sideshow attractions and performing animals. However, for many of those who have experienced the new circus — such as the Big Apple Circus, Circus Flora, Cirque du Soleil, the Pickle Family Circus, or the international circuses that perform at arts festivals around the country — the circus is understood as a serious alternative to contemporary theater. The current revival of the circus, which has been under way since 1974, is a return to the single ring of the classic European circus, stripping away one hundred years of American innovation and returning the circus to its modern origins in the eighteenth century.[4] How the circus came to be considered an appropriate subject for American art and why are the subjects of this essay.

The history of the American circus begins in the eighteenth century, gathers steam in the nineteenth, and reaches a golden age in the early years of the twentieth century.[5] Three names are outstanding in this history: John Bill Ricketts (ca. 1760–1800), credited with bringing the modern circus to the United States in the late eighteenth century; P. T. (Phineas Taylor) Barnum (1810–1891), who dominates discussion of popular entertainment in the nineteenth century[6]; and John Ringling (1866–1936), perhaps the most flamboyant of the Ringling Brothers, themselves the most important figures in any discussion of the circus in twentieth-century America.[7]

The creation of the modern circus is credited to an enterprising and talented British horseman named Philip Astley, who gave up a successful career in the British army in 1766 to stage public performances of equestrian feats in London. An inspired showman who developed trick riding into an art, Astley discovered that the combination of centripetal and centrifugal forces would keep a standing rider from falling off his horse as it galloped in a circle. The ring he designed and performed within is the prototype for that of the contemporary circus. His popular and financial successes led him to construct an enclosed arena that he subsequently named Astley's Amphitheater of the Arts. Not content with simply presenting his equestrian acts, Astley incorporated all the variety acts that are commonly seen in a circus. He introduced live music, a strong man, jugglers, a tightrope walker, trained dogs, acrobats, and a famous clown act, "Billie Button, or the Tailor's Ride to Brentford."[8] He was also the first to establish the tradition of comic dialogue between the ringmaster (himself) and the clown. Astley's contributions — the design of the ring that is the defining spatial construction of the modern circus, the ringmaster's costume of red jacket and black boots (signifying the ringmaster's original identity as skilled horseman), and the prominence given to the equestrian performances — are all features of the modern American circus.

A Scotsman, John Bill Ricketts, brought Astley's innovations to the United States and presented the first American circus performance in Philadelphia on April 3, 1793 (fig. 1).[9] Ricketts, like Astley, was a trick rider who included rope walkers, tumblers, pantomime, and dramatic recitations in his performances. "Ricketts is recognized as the first circus owner in the United States largely because he added variety acts to his equestrian exhibition, built amphitheaters expressly for his shows, advertised them specifically as circuses and kept the company together as a recognizable troupe."[10] The Ricketts Circus toured from Philadelphia to New York, Boston, Hartford, and Charleston. President Washington, who appreciated trick riding, visited the circus on more than one occasion.[11] Ricketts's successful career as a circus owner ended when his New York and Philadelphia arenas were burned to the ground. His example, however, proved that a traveling circus could thrive in the United States as long as the populations in those cities to which it traveled were large enough to fill the temporary buildings and theaters in which the circus appeared.

Somers, New York, was a center for the early American circus, and many of the circus pioneers hailed from the surrounding area.[12] In 1825 two New York showmen introduced a circus tent large enough to contain a forty-two-foot circus ring and a few hundred standing spectators,[13] and the American circus became a traveling show that set up, performed for a day or two, closed down, and moved on. By the 1830s, wagon shows that combined circus performances with either an exhibition of wild and exotic animals or an animal performance were traveling throughout the eastern United States. These circuses — their contemporaries who now travel by truck are known as "mud shows" — visited isolated communities that might have no other contact with the outside world.[14] W. C. Coup, an early circus showman who would later join forces with Barnum, described the rough-and-ready character of many early circus performances.

The sturdy sons of toil came to the show eager to resent any imagined insult; and failing to fight with the showmen, would often fight among themselves…. It was no infrequent occurrence to be set upon by a party of roughs, who were determined to show their prowess and skill as marksmen with fists and clubs if required. As a result showmen were armed…. Almost daily would these fights occur, and so desperately were they entered into that they resembled pitched battles more than anything else.[15]

One of the most vivid descriptions of the mid-nineteenth-century American circus is Mark Twain's account of his fictional character Huckleberry Finn attending what historians believe is a performance of the Dan Rice Circus in Hannibal, Missouri.[16]

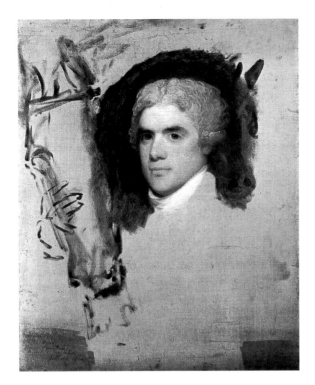

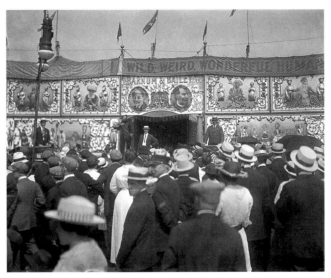

Twain eloquently describes the active role of the audience in the circus performance, a role that was to disappear in the circus of the twentieth century (see pages 162–63 of Siegel's essay in this catalogue for Twain's description, quoted from *The Adventures of Huckleberry Finn*).

The so-called golden age of the American circus, 1871–1917, was marked by a series of mergers and acquisitions that swallowed up smaller circuses and created enormous tented shows. Barnum, an impresario with a long and varied career predating his association with the "Greatest Show on Earth,"[17] was an important force in this period (fig. 75, page 75). In 1871 he teamed up with Coup and Dan Costello, a former clown, to form Barnum's Great Traveling Museum, Menagerie, Caravan, Hippodrome, and Circus. In 1872, Coup, the practical genius of the operation, put the entire show on more than sixty railroad cars and used the railroads to both carry the circus throughout the country and to bring people to the circus. Harnessing the railroad, "the first nationally effective agent of technological empowerment,"[18] dramatically increased the ability of the circus to travel in search of an audience and was instrumental in the evolution of the American circus. The success of the railroad circus engendered a series of changes that would distinguish the American circus from its European counterparts. In order to placate the ever-increasing audiences, who inevitably did not all have unobstructed views of the performances, Coup introduced a second ring, so there would be two focal points at all times, in effect creating two simultaneous shows. In 1880 Barnum and Coup joined forces with James A. Bailey and James L. Hutchinson to form P. T. Barnum's Greatest Show on Earth, Howes's Great London Circus, and Sanger's Royal British Menagerie known

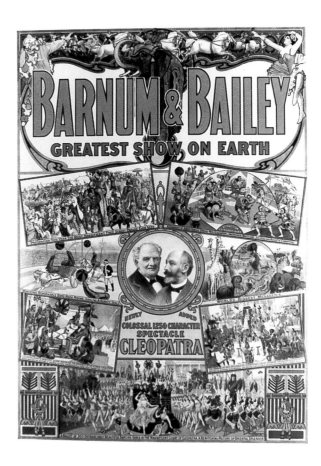

for short as the Barnum & London Circus, and reorganized in 1887 between the two showmen as the Barnum & Bailey Circus: The Greatest Show on Earth (fig. 2). The addition of a third ring in 1881 created the need for more performers and also set up a ranking system that gave top billing or center-ring status to the stars, and secondary status to the second- and third-ring acts. By 1890 nearly all American circuses has adopted the three-ring format. Clowns who had previously entertained crowds with jokes, oratory, and witticisms could no longer talk to their audiences and instead became pantomimic performers. The circus lost the intimacy between performer and audience that had characterized it in the mid-nineteenth century, but gained spectacle (fig. 3):

In the eighties and nineties specialists in pageantry appeared, like Imre and Bolossy Kiralfy, who produced "Nero and the Destruction of Rome" and "The Fall of Babylon," and John Rettig of Cincinnati, whose productions included "Montezuma and the Conquest of Mexico" and "Moses, or the Bondage in Egypt." As their titles indicate, these presentations were de Mille–type extravaganzas with casts of hundreds (some circus pageants involved twelve hundred people), supported by almost as many animals, along with exotic music, dancing, and scenes of violence.[19]

After Barnum's death, Bailey brought the Barnum & Bailey Circus to Europe for a successful tour of England and the Continent that lasted from 1897 to 1903. During the show's run in England, the term "human prodigies" was introduced to describe the human exhibitions in Barnum & Bailey's circus. In Paris, during the winter of 1901–02, the Barnum & Bailey Circus performed in three rings and on two platforms in extravagant style at the Hippodrome. In Germany, the efficiency of the enormous traveling show received high praise and was observed by military officers eager to "imitate their precision."[20] After six years abroad, the Greatest Show on Earth returned to New York in triumph, only to find that the Ringling Brothers Circus, headquartered in Baraboo, Wisconsin, had become large enough to compete for the eastern territory that had once belonged to Barnum & Bailey's.

If Barnum was the embodiment of the carnivalesque, then the Ringlings — who labored mightily to create a respectable family circus — were descendents of the Puritan ideal.[21] Hailing from Wisconsin, the Ringling Brothers (fig. 4) earned a reputation for a "Sunday School circus" by refusing to allow disreputable games and graft on their premises.[22] Year by year, they built up their show with more acts and better performers; in 1890 they moved from wagons to railroads and began to extend their reach into eastern territories. In 1907 they bought the Barnum & Bailey Circus from the widow of James Bailey and ran the two circuses independently: the Ringling Brothers Circus from Baraboo, Wisconsin, and the Barnum and Bailey Circus from Bridgeport, Connecticut. In 1918 they merged the two shows into the Ringling Brothers and Barnum & Bailey Combined Shows, known from then on as "the Big One." In 1924 the Ringling Brothers and Barnum & Bailey Circus moved its winter quarters from Bridgeport to Sarasota, Florida. In 1960 the circus moved to Venice, Florida.

The fascination with the circus as a subject for modern art begins in late-nineteenth-century Paris, where the "cult of the circus"[23] was in full flower and three permanent circuses, each with their own audiences, participated in the cultural life of the city.

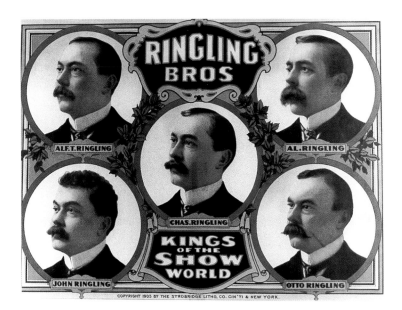

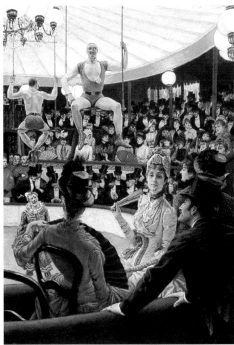

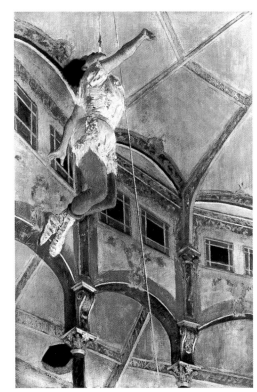

4
Ringling Brothers
Circus Poster (Kings
of the Show
World),1905.
Ringling Bros. and
Barnum & Bailey

5
Edgar Degas,
*Miss La La at the
Cirque Fernando*,
1879.
Oil on canvas,
46 x 30 ½ in.
National Gallery,
London

6
James Tissot,
The *Amateur Circus
(Les Femmes du
sport)*, 1883–85.
Oil on canvas,
58 x 40 ¼ in.
Museum of Fine
Arts, Boston;
Julia Cheney
Edwards Collection

The Cirque d'Été on the Champs-Elyseés performed from April to September and catered to the upper crust; the Cirque d'Hiver, open from October to April, played to a more socially diverse crowd near the Place de la République; and in Montmartre, the Cirque Fernando (later known as the Cirque Médrano) performed year-round to a local clientele made up of working-class Parisians and the artists who had made Montmartre their home. The newfound appreciation of the circus among avant-garde writers,[24] theater critics, and visual artists was tied up with the larger movement toward the incorporation of popular culture (seen to be a signifier of modern, contemporary life) into the realm of high art.[25] Edgar Degas, Henri de Toulouse Lautrec, Auguste Renoir, James Tissot, and Georges Seurat all attended the circuses of Paris and found subjects for their paintings in the acrobats, equestrian performers, and clowns. Degas's focus on an acrobat in midair in *Miss La La at the Cirque Fernando* (fig. 5) allowed the artist to take his explorations of unusual perspectives and viewpoints to a new extreme without losing coherence or sacrificing a realist's principles. In contrast, Tissot's image of the circus provides fascinating evidence of the complex social taboos that were associated with the circus among the Parisian upper classes. In his painting *The Amateur Circus (Les Femmes du sport)* (fig. 6), Tissot represents the Cirque Molier.[26] Founded by Ernest Molier in 1880, this was a private circus of amateur aristocrats who performed once a year in a benefit for charity before an audience made up of upper-class patrons. Tissot has portrayed comte Hubert de la Rochefoucauld sitting on the trapeze with his monocle in place; his partner, with his back to us on a second trapeze, is a painter named Théophile Pierre Wagner. The predominance of women among the audience and the near-nakedness of the male acrobats provoke a reading of the circus as a space where seemingly improper physical displays are sanctioned. The sexual allure of circus performers — more often women — is one of the underlying themes of many European and American works of the nineteenth and twentieth centuries.

Seurat's *The Circus (Le Cirque)* (fig. 7) has rightly been acclaimed as a painting that sets the artist's classicism into motion, looking forward to the concerns of the twentieth century.[27] Exhibited unfinished at the Salon des Indépendents in 1891, *The Circus* was criticized for its anti-naturalist stance, a result of the artist's attempt to create something new, a "modern and democratic decorative painting."[28] Seurat's painting represents the circus as a microcosm of modern society and includes the full spectrum of social classes, identified by costume and by placement in the seats. The well-dressed men who congregate around the entrance to the ring, like the well-dressed men depicted in Degas's images of the ballet, frequented such places to form liaisons with the women performers. Within the ring, meanwhile, the ringmaster cracks his whip, the equestrienne performs, an acrobat leaps, and the clown — who is ambiguously placed in the painting — pulls at what might be a curtain as if to close off our further viewing. Seurat's image

places the clown in the long-established role of the artist as the knowing outsider who observes and remarks on what he sees.[29] Picasso, who frequented the Cirque Médrano after moving to the Montmartre area of Paris in 1904, particularly enjoyed the company of the clowns,[30] and also portrayed the clown, the harlequin, and the acrobat as symbolically charged personifications of the alienated artist (fig. 8). Many American and European artists of the twentieth century, including Max Beckmann, Paul Klee, Fernand Léger, and Henri Matisse, would draw from the iconographies and traditions established by these late-nineteenth-century artists. Samuel Halpert (1884–1930), an American modernist, drew directly from the example of Seurat in two circus paintings from 1924 (figs. 11 and 12).

Throughout the nineteenth century, American artists routinely traveled to Europe to complete their artistic training. Because the majority of them returned to the United States with European-derived styles and ideas for suitable subjects, American art followed the fashions of European and, more specifically — especially in the late nineteenth century — French art. By the turn of the century, America had become an economic and industrial power, and the importation of European culture to America was being countered by the exportation of American popular culture to Europe. Barnum and Bailey's tour had shown Europeans an American circus. The elements that had contributed to its success were those that distinguished it as American — the immensity, the mechanical and technological prowess, as well as the brash advertising campaign that billed itself as the "greatest show on earth." While the circus and other aspects of American popular culture were embraced by both Americans and Europeans; American art (with a few exceptions) remained an unknown and undefined quantity.

One of the most significant moments in the struggle to assert American art's independence from Europe was the 1908 exhibition of works by a group of American artists centered around the charismatic painter and teacher Robert Henri (1865–1929). Henri and The Eight (as they were called in honor of that exhibition) advocated a search by American artists for new subjects based on their investigation of American life.[31] As American artists, collectors, and critics began to look at home for inspiration, for art to purchase, and for thoughtful commentary, respectively, certain characteristics of American life — especially those aspects of America that seemed to be inherent or recognizably American — began to claim their interest. Although Henri did not paint images of the circus, he identified it as an American subject and used it as an instructive metaphor. He wrote to his students in 1915:

A friend of mine took his two boys to the circus. It was their first circus. He was worried and discouraged because his boys did not get the thing. He kept saying to them "Look! Look!" but they were always looking the wrong way. It was pretty rough to find that his boys were not real boys. That night he left the table to read his

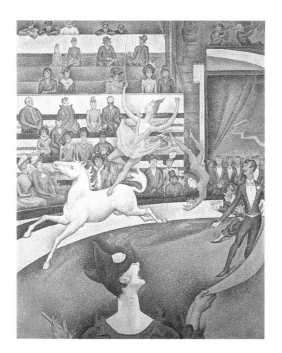

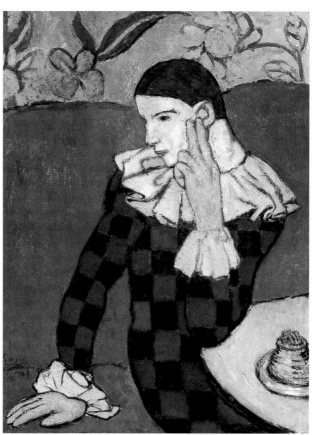

paper. The boys remained with their mother, and from the next room he heard them tell what they had seen at the circus, and their account settled the matter. His boys were real boys! They had seen all and several times more than he had.[32]

Henri's lesson is clear. American artists, like the boys in the anecdote, must follow their instincts and not be led by their elders to see only what has been pre-selected for them. By looking in new places, by exploring unremarked areas, they will prove themselves to be real artists. To an extent that Henri could not have predicted, American artists have seen all in the circus: proof of America's cultural coming of age; an opportunity to explore a symbolic space of mystery and bliss; a mirror of society; and evidence of social disarray.

Appreciating the circus as an embodiment of American culture, three of Henri's colleagues among The Eight – George Luks (1867–1933), John Sloan (1876–1953), and Everett Shinn (1871–1951) – and several of his contemporaries, including the realist painter George Bellows (1882–1925), painted images of the circus. For these artists, the circus was a spectacle of modern life in the same way that prize fights, vaudeville, early movie houses, and the theater were modern, urban experiences. Sloan's painting *Clown Making Up* (fig. 13) is a sympathetic portrayal of a clown in a private moment. An early image in our survey, it evokes American artists' continuing fascination with the clown as fool, wise man, and artist. Sloan's clown is a performer preparing for his public appearance, shown in the act of putting on make-up – an insightful metaphor for the act of painting. Indeed, when is a self-portrait a

self-made face – and what is the purpose of such a disguise? The clown painted by Luks in 1929 (fig. 14) is, in contrast, a portrait of the clown fully prepared to meet his audience. The white face, pretty costume, and fanciful background not only identify the sitter as a circus clown, but also provide the artist with the opportunity to experiment with Fauvist color without sacrificing realism.

Shinn's interest in the circus began early in his life and was manifested in a variety of mediums.[33] The most theatrical of The Eight, he painted circus performers, designed the sets for Goldwyn Pictures' 1929 movie *Polly of the Circus*, and illustrated and wrote the introduction called "A Boy's Dream in Action" for *Toby Tyler or 10 Weeks with a Circus* by James Otis (published in 1937),[34] in which he recounts the dream of the young Everett Shinn as a circus star performing on the tightrope. The sympathetic, poetic vision conveyed in his painting *The Tightrope Walker* (fig. 15) suggests that he continued to identify with the acrobat. Here the performer tremulously steps across the wire, resplendent in a white costume that glitters like the chandelier hanging nearby. Shinn's *Clown* (fig. 17) harks back to romantic notions of the clown that were prevalent in nineteenth-century French painting. Jean-Léon Gérôme's *The Duel After the Masqerade* (fig. 16) provides an instructive comparison. Like Gérôme, Shinn has spun a narrative around the secret identity of the clown as "a character with a private life full of tragedy, passion and sentimentality"[35] who lies dying in the arms of friends. Shinn's fascination with the circus lasted throughout his life; in 1949, he traveled to Sarasota, where he enjoyed and sketched the circus acts that were performed nightly at the Ringling Hotel.

Gifford Beal (1879–1956) was also intrigued by the circus as a subject and produced many paintings of the circus from the 1920s through the 1950s. Decidedly positive in outlook, Beal's circus pictures are part of his larger interest in festive scenes including parks, racetracks, cafes, and the stage. A student of William Merritt Chase, Beal was impressed with the spectacle of exotic individuals, the elephants, and the stagecraft evident in performances of the circus. His painting *Circus Rehearsal* (fig. 18) is a preparatory sketch that could very well have been done on the spot. The casual arrangement of the circus performers and animals and the group of top-hatted men who are interspersed in the performing area provide a behind-the-scenes look at the circus not unlike the scenes that Degas and his contemporaries produced of the ballet. Beal's *Circus Ring and Elephants* (fig. 19) focuses on the extravagant productions characteristic of the American circus until the start of its decline, precipitated by the stock-market crash of 1929 and the ensuing Great Depression. Here, Beal depicts the "spec – the grand entry and indoor parade around the circus ring – which introduced the full company of glittering, costumed circus performers and animals to the audience. Exoticism has always been one of the most compelling attractions of the American circus for it brings the rich grandeur of faraway lands and strikingly different cultures within the range of sight, hearing, and smell.

Taking the circus for a subject of realistic inquiry is just one way to view the circus. Other artists in the early decades of the twentieth century saw the American circus as a point of departure for formal experimentation. Thomas Hart Benton (1889–1975),

continued on p. 28

7
Georges Seurat,
*The Circus
(Le Cirque)*, 1891.
Oil on canvas,
21 3/4 x 18 1/8 in.
Musée d'Orsay,
Paris

8
Pablo Picasso,
Harlequin, 1881.
Oil on canvas,
32 5/8 x 24 1/8 in.
The Metropolitan
Museum of Art;
gift of Mr. and Mrs.
John L. Loeb, 1960
(60.87)

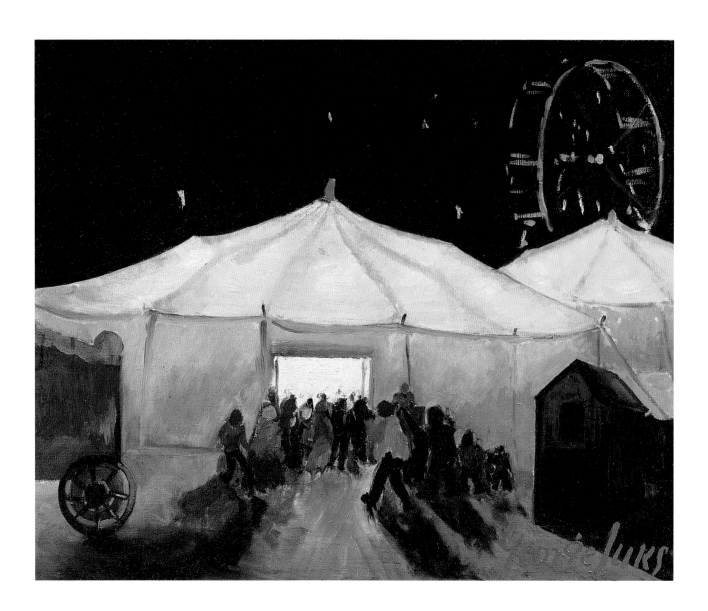

9
George Luks,
The Circus Tent,
ca. 1928–30.
Oil on canvas,
18 x 22 in.

10
George Bellows,
The Circus, 1912.
Oil on canvas,
33 7/8 x 44 in.

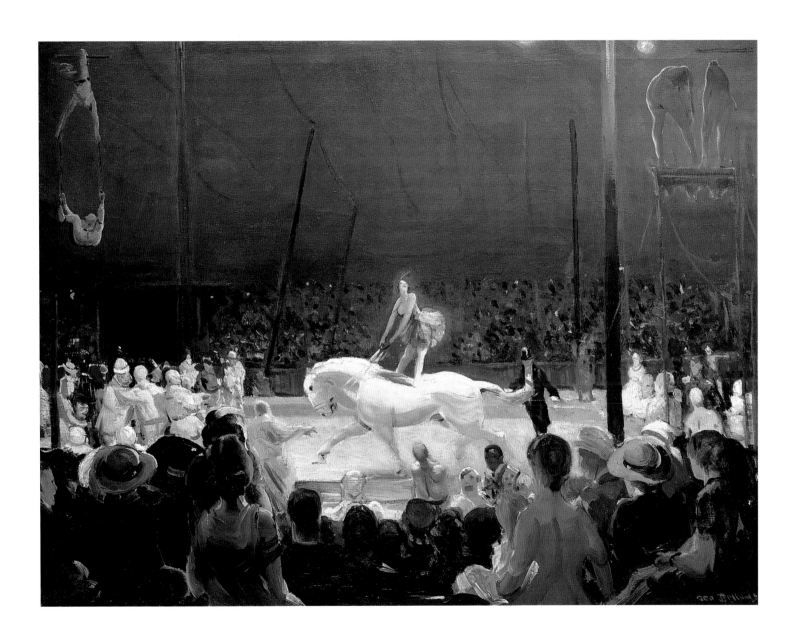

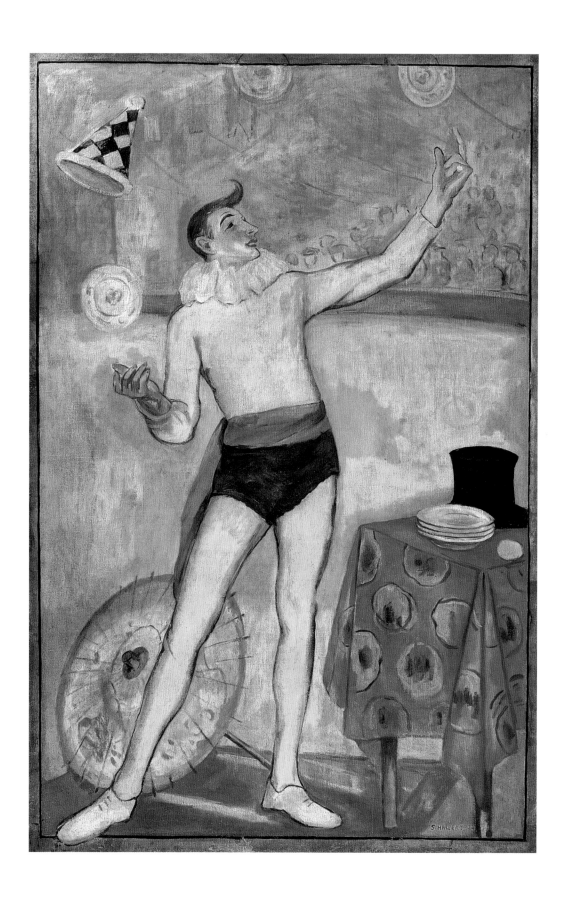

11
Samuel Halpert,
The Juggler, 1924.
Oil on canvas,
59 x 39 in.

12
Samuel Halpert,
Trapeze Artist, 1924.
Oil on canvas,
59 x 39 in.

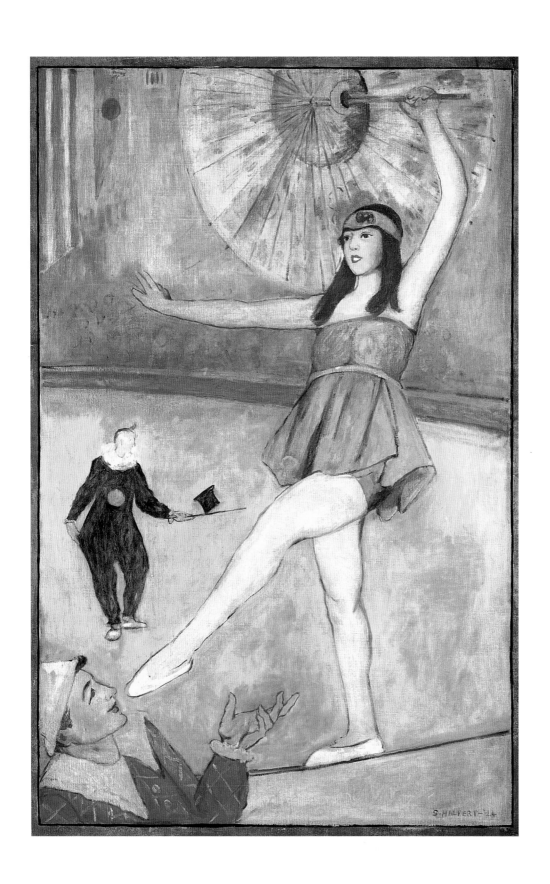

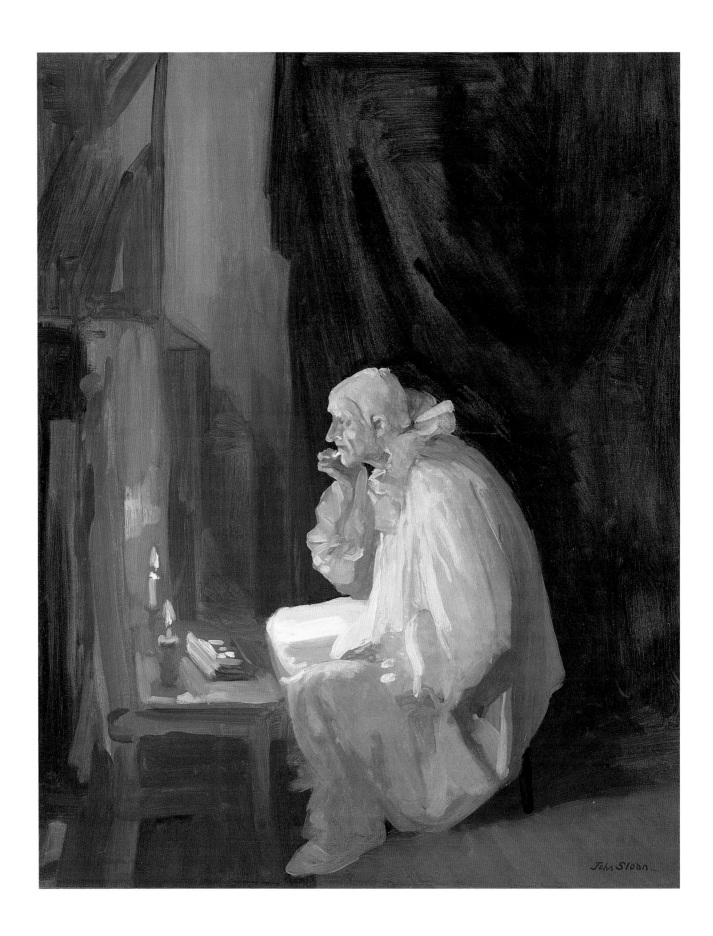

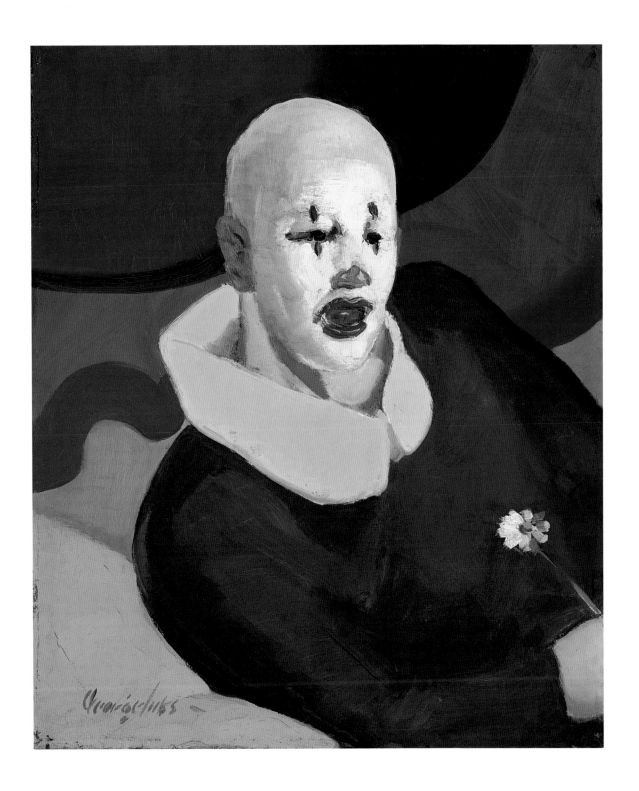

13
John Sloan,
Clown Making Up,
1910.
Oil on canvas,
32 1/8 x 26 in.

14
George Luks,
Clown, 1929.
Oil on canvas,
24 1/8 x 20 in.

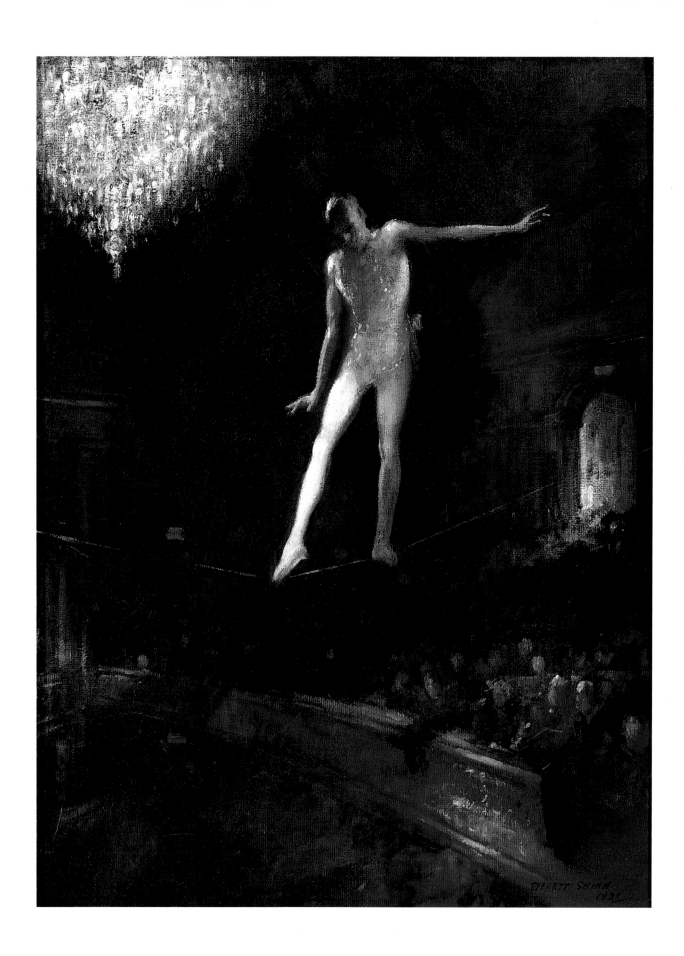

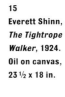

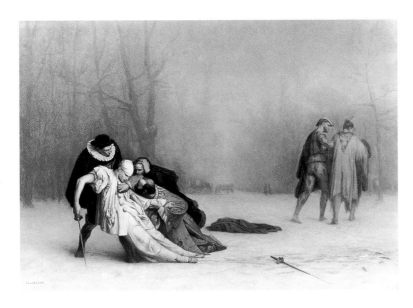

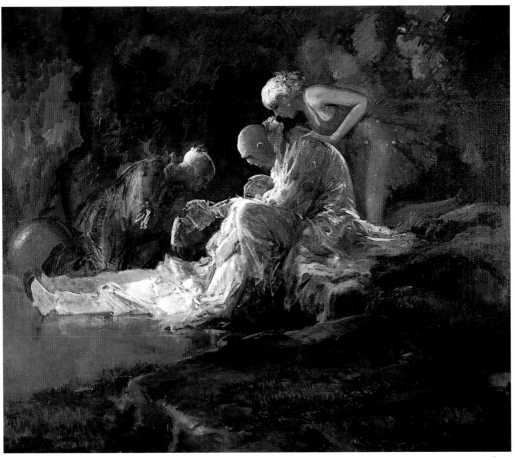

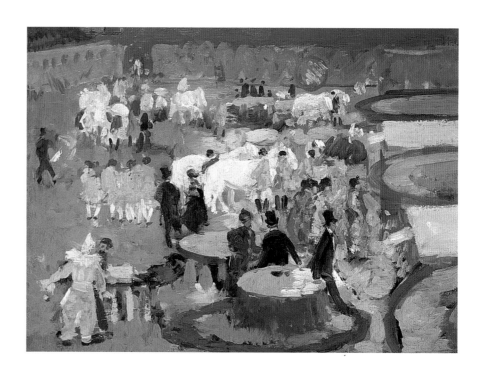

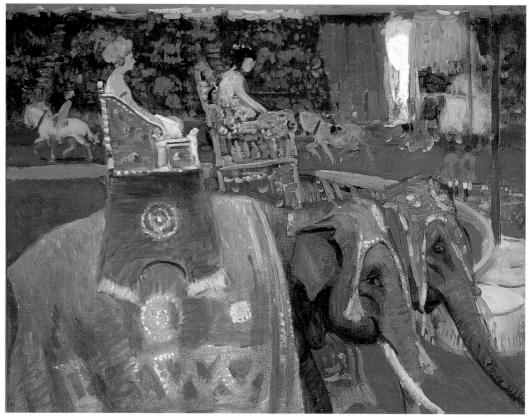

18
Gifford Beal,
Circus Rehearsal,
n.d.
Oil on Masonite,
18 x 24 in.

19
Gifford Beal,
*Circus Ring and
Elephants*, n.d.
Oil on canvas,
24 x 30 in.

20
Thomas Hart Benton,
Circus Performers,
ca. 1911.
Watercolor on
laid paper,
16 3/8 x 9 7/16 in.

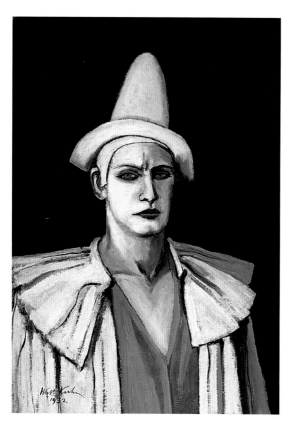

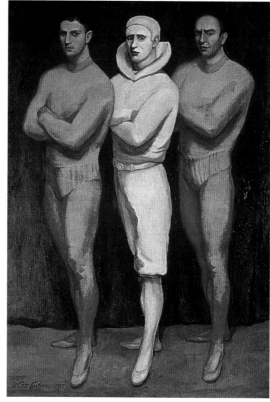

21
Walt Kuhn,
*Portrait of the Artist
As a Clown
(Kansas)*, 1932.
Oil on canvas,
32 x 22 in.
Collection Mr. and
Mrs. Barney Ebsworth

22
Walt Kuhn,
Trio, 1937.
Oil on canvas,
72 x 48 in.
Colorado Springs
Art Center, Colorado
Springs

who would later turn passionately against abstraction, experimented as a young man with the Synchromism of the American avant-gardists Morgan Russell and Stanton MacDonald-Wright. His early watercolor *Circus Performers* (fig. 20) is a transitional work that combines Fauvist color with the dynamic, rounded figures that would become the signature of his regionalist style. Charles Demuth (1883–1935) and Marsden Hartley (1877–1943), two pioneers of modernism who were members of the Stieglitz circle, identified the circus as a uniquely American, modern experience; with the critics Robert Coady and Gilbert Seldes, they promoted the circus, cabaret, and vaudeville as the best arts America had to offer.[36] Demuth began his studies in Philadelphia at the Pennsylvania Academy of the Fine Arts at a time when the aesthetic philosophies of Robert Henri were much vaunted, and experimented with subjects that were clearly linked to the subjects of The Eight: boxing, theater, and the circus.[37] His depictions of the circus and vaudeville, places where reality was bent into fiction, allowed Demuth to create an alternative to realism, a personal modernist idiom that was both abstract and representational. It embraced popular culture but was also refined and elegant in execution. Most of Demuth's circus pictures date from 1916 to 1918; *White Horse* (fig. 23) is an early, thoroughly modern representation of Henri's American life.

Although Hartley never chose the circus as a subject for his work, he was full of admiration for the visual dynamics of the circus and wrote about the circus and vaudeville. He described acrobats as "superior artists" and dreamed of being able to "merge himself in the fine pattern that their bodies drew in space."[38] He traced his lifelong love of spectacle to "early boyhood and the big days of the year, the coming of the circus to Lewiston – the real Barnum's

circus, and the annual State Fair."[39] The abstract qualities that Hartley appreciated were also of interest to another artist associated with the Stieglitz group, John Marin (1870–1953), who found inspiration in the circus in his later years. Turning from the landscapes of Maine and the cityscapes of Manhattan to the interior world of the circus tent, Marin explored the circus as a microcosm for the urban spectacle and as a mysterious, ritualized arena where a different formal logic was in place.[40] Marin's *Juggler* (fig. 25) combines frontal formality with symbolic figures and signs; his *Circus Forms* (fig. 26) freezes the frenetic action of the circus into a vivid realization of energy in stasis. Helen Torr (1886–1967), an artist who studied at the Pennsylvania Academy with Demuth and was affiliated with the Stieglitz group through her relationship with Arthur Dove, also turned to the circus as a subject, depicting a circus tent nestled in a craggy landscape in her 1930s watercolor *Circus* (fig. 27).[41] The circus tent was of interest to many American artists, including the Pittsburgh-based Luke Swank (1890–1944), who photographed the process of erecting the big top and its abstract beauty in the 1930s (figs. 82–84, pp. 89–91).

There are few American artists who are more closely associated with the circus than Walt Kuhn (1880–1949) and Alexander Calder (1898–1976).[42] Each turned to the circus as a source of imagery in the late 1920s. Kuhn (fig. 21) was a theatrical insider whose experiences with vaudeville, theatrical, and circus productions gave him access to the non-public spaces of the circus.[43] One of the organizers of the Armory Show of 1913, he was also an American artist with impeccable modernist credentials who was well informed about avant-garde European art. Developing his own expressionist style out of a combination of American theatrical life and European artistic precedents, Kuhn created a series of portraits that are at times moving, disturbing, or simply strange. His circus paintings focus more often than not on the humanity of circus performers and set up a dynamic opposition between the individual personalities of his subjects and their group identity as performers. Kuhn's subjects are individuals, but they are presented as costumed characters and are thus set apart from everyday life, whether consciously posing in a manner reminiscent of their identities as performers, as in *Acrobat in Green* (fig. 28), *Lancer* (fig. 29), and *The Blue Clown* (fig. 30), or in a more informal attitude, as in *White Clown* (fig. 31). Kuhn believed that *White Clown* was one of his most successful works; in it he captured the essential physicality of a powerfully built, psychologically tense young man in a moment of near relaxation. *Trio* (fig. 22) is an unusual choice in Kuhn's repertory. Rather than focusing on a single figure and psychology, the artist has set the camaraderie and essential teamwork of circus performances front and center. Other artists in the exhibition celebrate teams of performers, but only Kuhn presents the team formally posed as if for a studio photograph.

Calder's first images of the circus date from about 1925, when he was commissioned to cover the Ringling Brothers and Barnum

& Bailey Circus's Madison Square Garden performances for the *National Police Gazette*.[44] He had enrolled at the Art Students League in 1923 and counted among his instructors Luks, Sloan, Guy Pène du Bois, and Boardman Robinson, who helped Calder to obtain a position as an illustrator for the *National Police Gazette* in 1924.[45] Under their influence, he painted scenes of urban New York, including street scenes, prize fights, animals at the zoo, and the circus (see *Circus Scene*; fig. 32).[46] Whatever Calder's previous experience of the circus, in the mid-1920s it became a subject of great significance in his oeuvre. As one author astutely remarked,

what began as a journalist's assignment continued into a full-scale iconography, shared with European modernists Pablo Picasso, Joan Miró, Jean Cocteau, and others. Later, Calder created renditions of circus animals and acrobats in oil, registering his enchantment with the spatial dynamics of the circus, the energy and excitement, and the ever-changing choreography of creatures in motion. The subjects rendered in Calder's early circus studies, whether single animals performing or an overall impression of the exuberant activity beneath the big top, appear in an assortment of mobiles, stabiles, and drawings in the fifty years following his sketches at the Barnum and Bailey Circus.[47]

Calder, who had earned a degree in engineering from Stevens Technical Institute in New Jersey, arrived in Paris in 1926 and began making his first circus figures out of wire, cork, and bits of cloth at the same time that he was designing toys for the 1927 Salon des Humoristes.[48] With *Le Cirque Calder* (fig. 36), performed on both sides of the Atlantic between 1927 and 1940, he explored theater, choreography, and chance behavior, all in a world of his own creation. The performances he gave, at first to earn money to pay his rent, were a great success; and as word of the marvelous performances spread, Calder became acquainted with the most significant artists of the European avant garde, among them, Marcel Duchamp, Fernand Léger, and Joan Miró. Calder was interested in various aspects of the circus, including the physical space of the circus: "I was very fond of the spatial relations. I love the space of the circus. I made some drawings of nothing but the tent. The whole thing of the — vast space — I've always loved it."[49] He also loved the "fantastic balance in motion that the performers exhibited" (fig. 33).[50] In 1931–32, Calder devised a new kind of sculpture, which became known as mobiles after Duchamp's description. These featured abstract forms balanced on wire supports, often evoking heavenly bodies suspended or revolving in cosmic space, much as the circus incorporated moving objects within a constellation of abstract forces. Even in later years, as he continued to create these more abstract works, he also made sculptures such as *Tightrope* (fig. 39), which clearly indicate that elements of the circus remained of interest to him.

continued on p. 42

23
Charles Demuth,
White Horse, 1912.
Graphite and water-
color on paper,
9 3/8 x 5 3/16 in.

24
Charles Demuth,
The Circus, 1917.
Watercolor and
graphite on paper,
8 x 10 5/8 in.

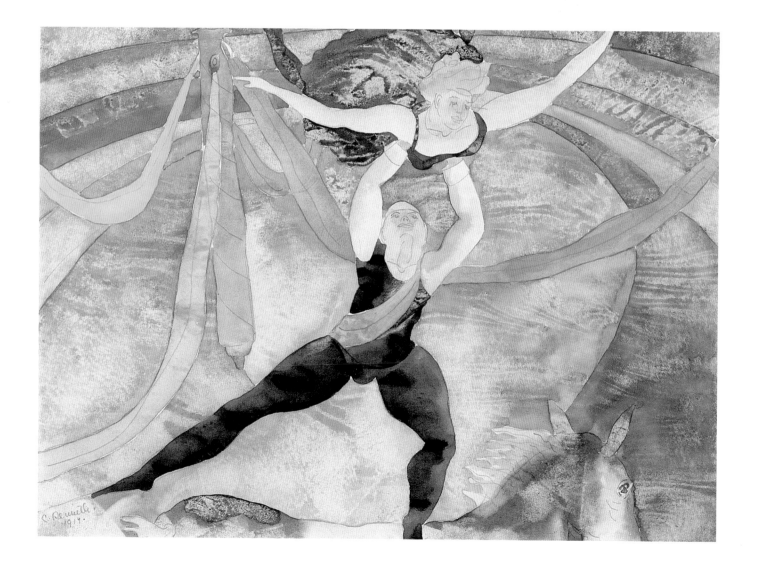

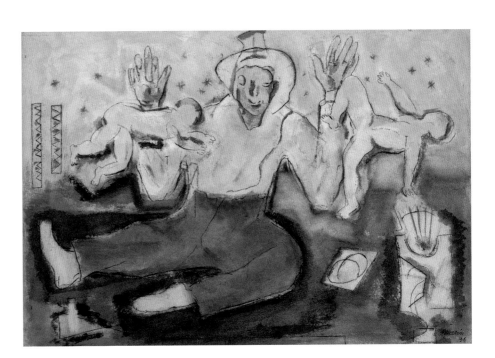

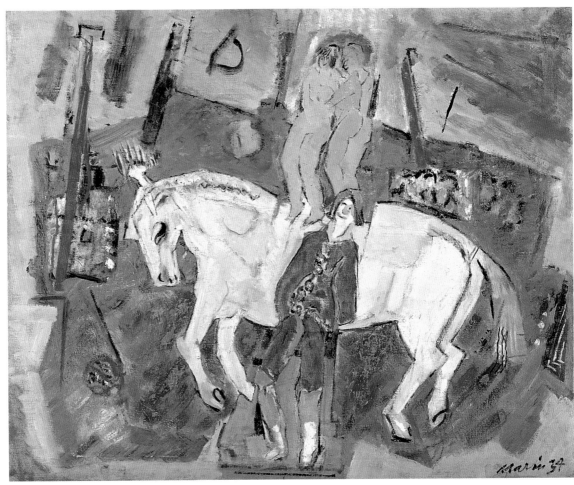

25
John Marin,
The Juggler, 1936.
Watercolor and ink
on paper,
21 3/4 x 30 1/2 in.

26
John Marin,
Circus Forms, 1934.
Oil on canvas,
29 x 36 1/4 in.

27
Helen Torr,
Circus, 1930s.
Watercolor
on paper,
8 1/4 x 10 1/4 in.

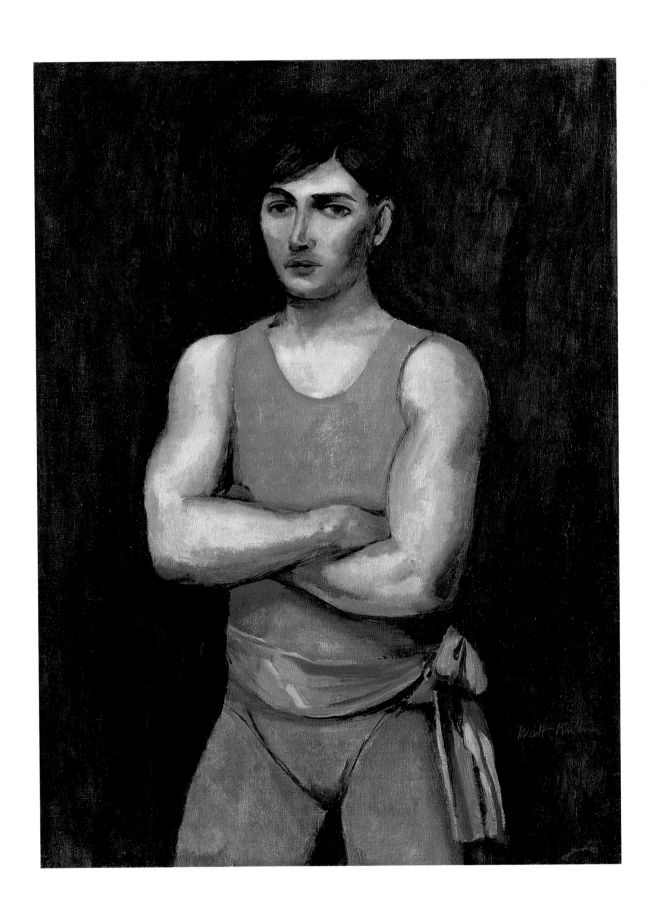

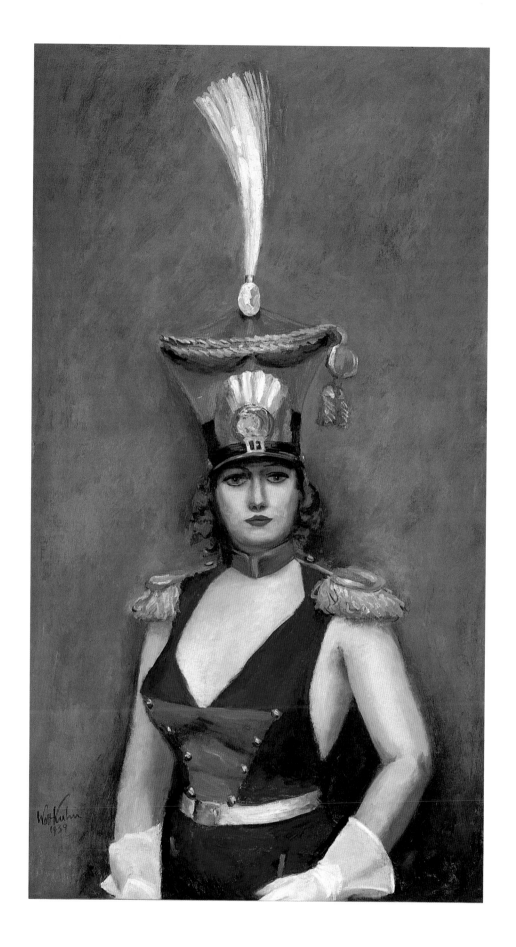

28
Walt Kuhn,
Acrobat in Green,
1927.
Oil on canvas,
40 7/16 x 30 1/4 in.

29
Walt Kuhn,
Lancer, 1939.
Oil on canvas,
45 1/2 x 26 1/4 in.

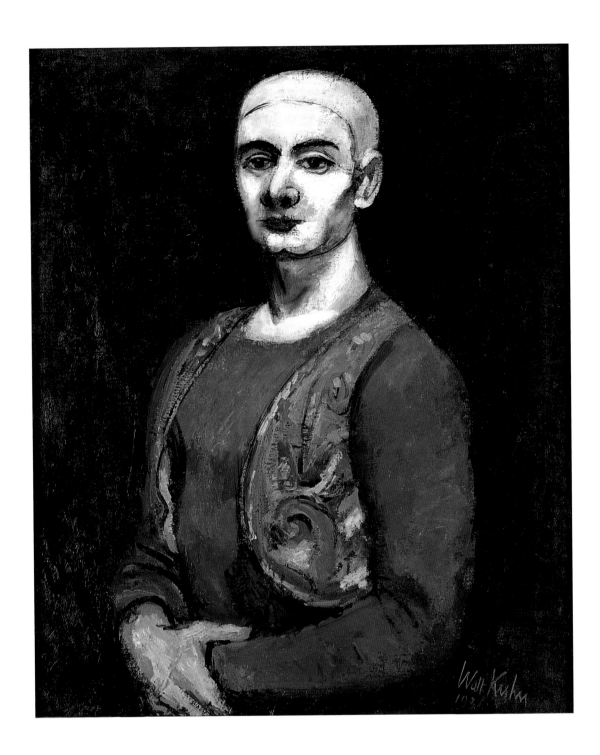

30
Walt Kuhn,
The Blue Clown,
1931.
Oil on canvas,
30 x 25 in.

31
Walt Kuhn,
White Clown, 1929.
Oil on canvas,
40 ¼ x 30 ¼ in.

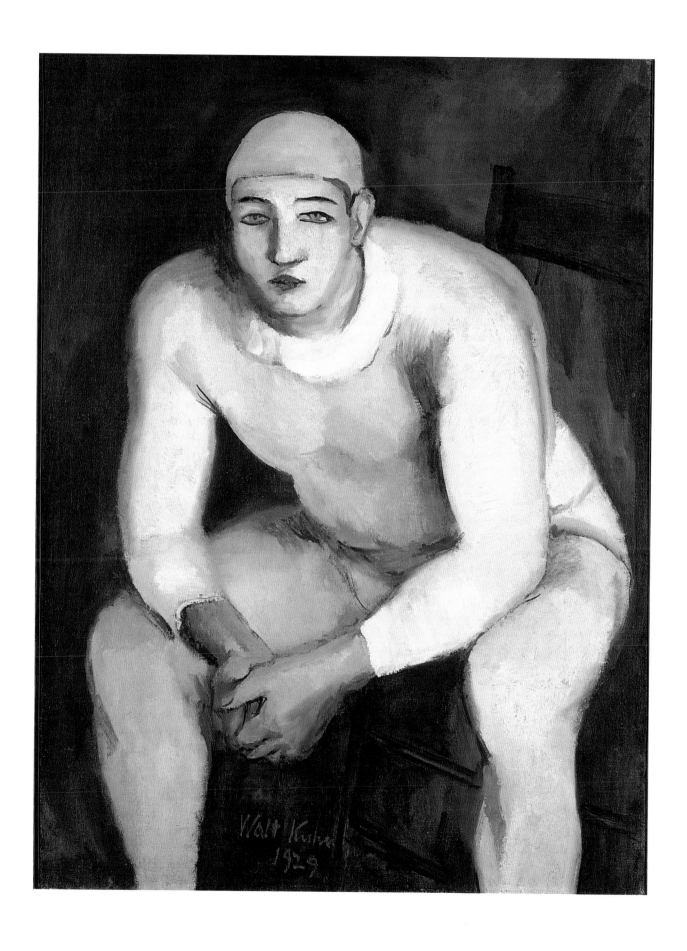

33
Alexander Calder,
Circus Interior, 1932.
Pen and ink on paper,
19 x 14 in.

32
Alexander Calder,
Circus Scene, 1926.
Gouache on canvas,
69 ¾ x 83 ½ in.

34
Alexander Calder,
Tightrope Walker,
1931–32.
Ink on paper,
19 ¹⁄₁₆ x 25 ¹⁄₁₆ in.

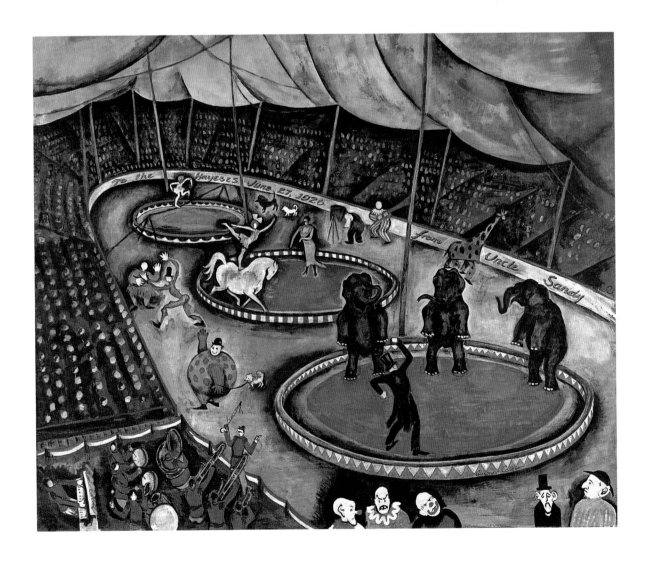

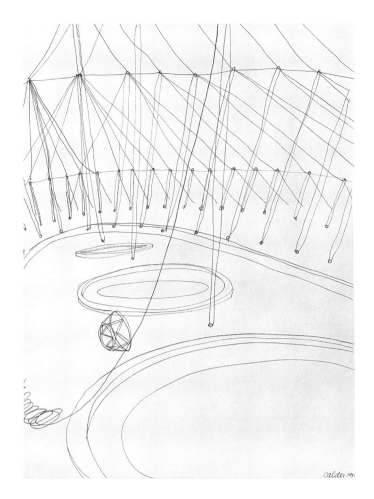

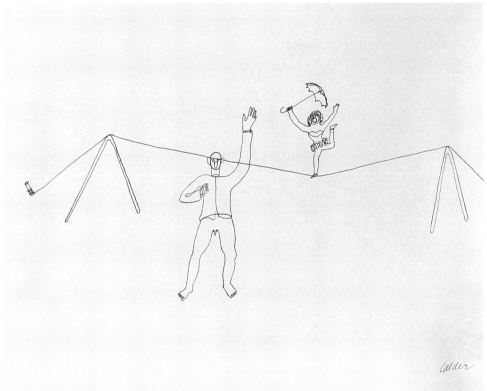

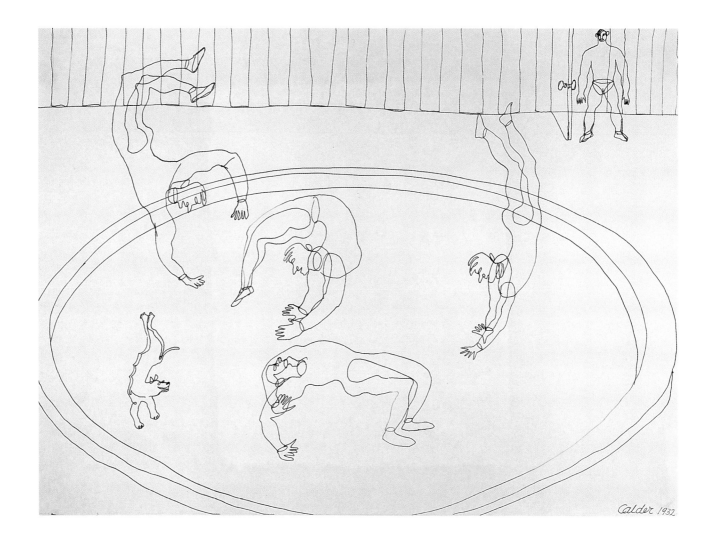

35
Alexander Calder,
Circus Acrobats,
1932.
Pen and ink on
wove paper,
14 1/16 x 19 1/16 in.

36
André Kertész,
Alexander Calder
with "Cirque
Calder," 1927.
Gelatin-silver print,
7 1/2 x 9 1/2 in.
Estate of André
Kertész

37
Alexander Calder,
Lion Tamer, 1932.
Pen and ink on
wove paper,
19 1/16 x 13 15/16 in.

38
Alexander Calder,
The Catch II, 1932.
Pen and ink on paper,
19 1/8 x 14 1/8 in.

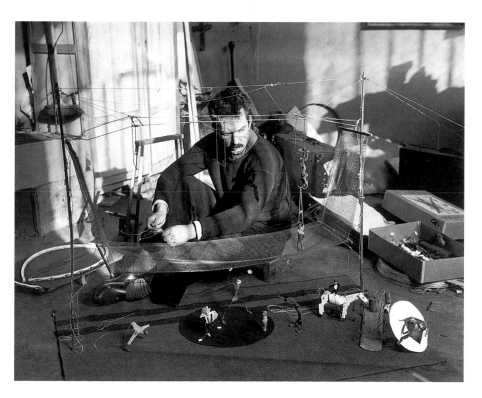

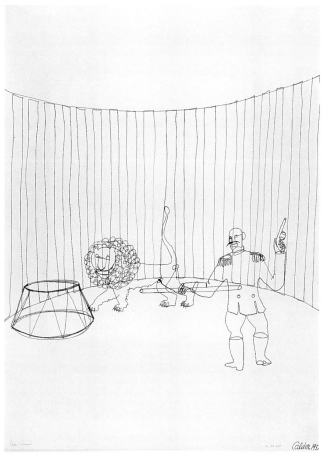

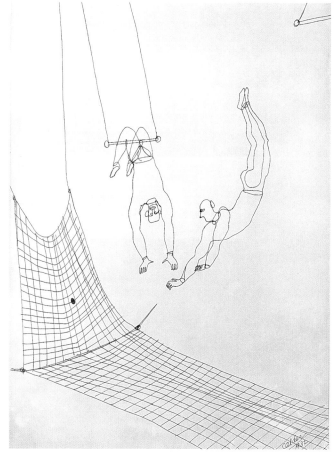

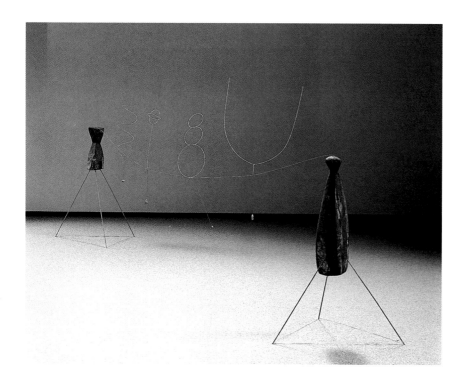

That interest is further confirmed by the great number of gouaches about the circus that Calder produced throughout his career.[51]

In 1931–32, during the period of his first mobiles and stabiles, Calder created a group of nearly one hundred line drawings of the circus including those reproduced in figures 34–38. Like his wire sculptures of circus acrobats done in the late 1920s (fig. 40), the pen-and-ink drawings reduced the complications of solid, animated bodies into uncannily precise linear form. Created in his studio from memory, the drawings are witty abstractions of individual moments culled from his experiences of the Ringling Brothers and Barnum & Bailey Circus, the Cirque Médrano, and his own *Cirque Calder*. By this time, the circus had become a signature subject for Calder (fig. 41).

Paul Outerbridge (1896–1958), a photographer whose aesthetic was influenced by the machinist photographs of Paul Strand, produced a series of epigrammatic pen-and-ink drawings on the subject of the circus in 1934, carrying Calder's expressive line past the boundaries of representation. Using semi-abstract geometric forms, Outerbridge evokes four characteristic elements of the circus: elephant, tightrope walker, aerialists, and clown (figs. 43–46).

The greatest stars of the circus – aerialists Lillian Leitzel and Alfredo Codona, the Flying Concellos, equestriennes May Wirth and Ella Bradna, animal trainer Clyde Beatty, and individual sideshow performers – were themselves the subjects of great public interest. Not surprisingly, they were immortalized by artists both in performance and in the more prosaic circumstances of their lives.

Circus performers combined physical prowess or physical uniqueness with genuine glamour; their stardom was predicated on their ability to succeed where others would fail. Lillian Leitzel (1892?–1931) was probably the most famous woman acrobatic performer in circus history (fig. 42).[52] The darling of an adoring public, she was the first circus star to demand and receive her own private railroad car. Her specialty was performing incredible numbers of one-armed pivots in midair (looping her wrist in a padded rope loop, she would swing her body over her head partially dislocating her shoulder with every turn). In July 1927, at the height of her fame, she married Alfredo Codona, the first aerialist to perform on a regular basis (beginning in 1920) the triple somersault in midair.[53] Star attractions at the Ringling Brothers and Barnum & Bailey Circus, they played off-season dates in Europe. During one of these European engagements, Leitzel fell while performing at the Valencia Music Hall in Copenhagen, on Friday, February 13, 1931; her husband, who was performing in Berlin, rushed to her side. From her hospital bed, Leitzel assured him that she would soon recover and insisted that he return to Berlin to complete his performances. Her injuries, however, proved fatal and her death two days later was cause for widespread public grieving; according to newspaper accounts, airplanes dropped mourning wreaths on the deck of the ship that carried her remains to New York. Codona was overcome by grief, from which he never really recovered.[54] In 1932 he married a second time, to the aerialist Vera Bruce; but the **continued on p. 48**

continued on p. 48

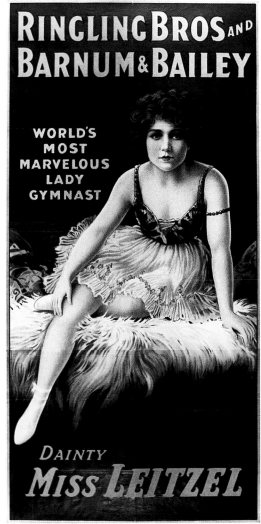

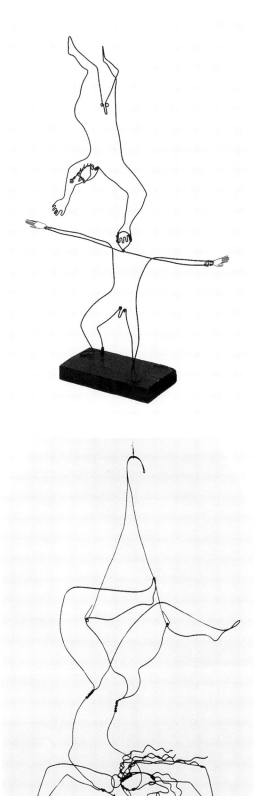

39
Alexander Calder,
Tightrope, 1936.
Ebony, wire, lead
weights, and paint,
45 1/2 x 27 1/2 x 138 1/2 in.
Private collection

40
Alexander Calder,
Two Acrobats, 1929.
Painted steel wire
and wood base,
34 9/16 x 21 5/8 in.
The Menil Collection,
Houston

42
Ringling Brothers
and Barnum &
Bailey Circus Poster
(Lillian Leitzel),
ca. 1920.
Ringling Bros. and
Barnum & Bailey

41
Alexander Calder,
*Wire Sculpture by
Calder*, 1928.
Wire, 48 1/4 x 25 7/8 x
4 7/8 in.
Whitney Museum of
American Art;
purchase, with
funds from Howard
and Jean Lipman
(72.168)

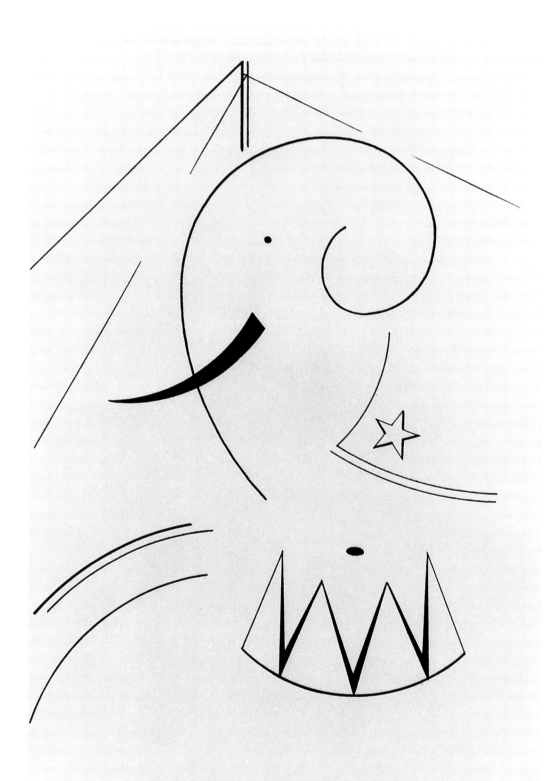

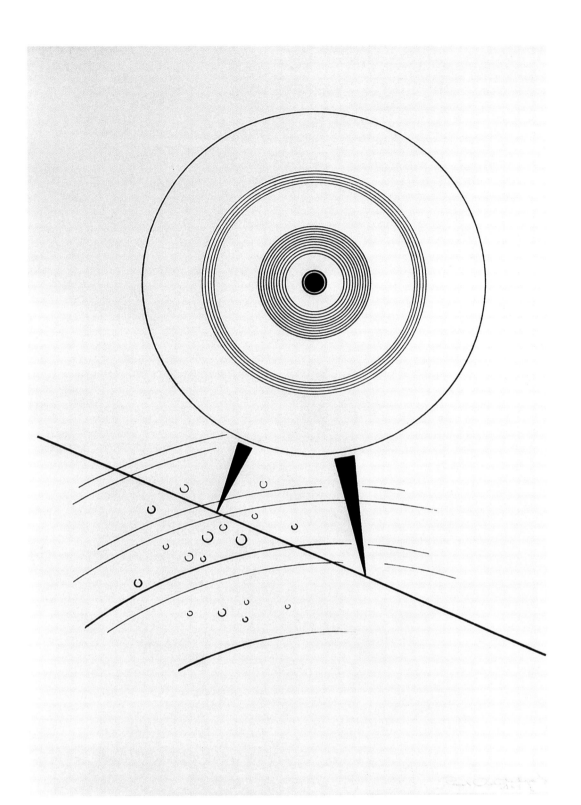

43
Paul Outerbridge Jr.,
Elephant, 1934.
Pen and ink on
paper, 18 x 24 in.

44
Paul Outerbridge Jr.,
Tightrope Walker,
1934.
Pen and ink on
paper, 18 x 24 in.

45
Paul Outerbridge Jr.,
Trapeze, 1934.
Pen and ink on
paper, 18 x 24 in.

46	**47**
Paul Outerbridge Jr.,	Chaim Gross,
Clown, 1934.	*Lillian Leitzel*, 1938.
Pen and ink on	Macassar ebony,
paper, 18 x 24 in.	52 x 14 $\frac{7}{8}$ x 12 in.

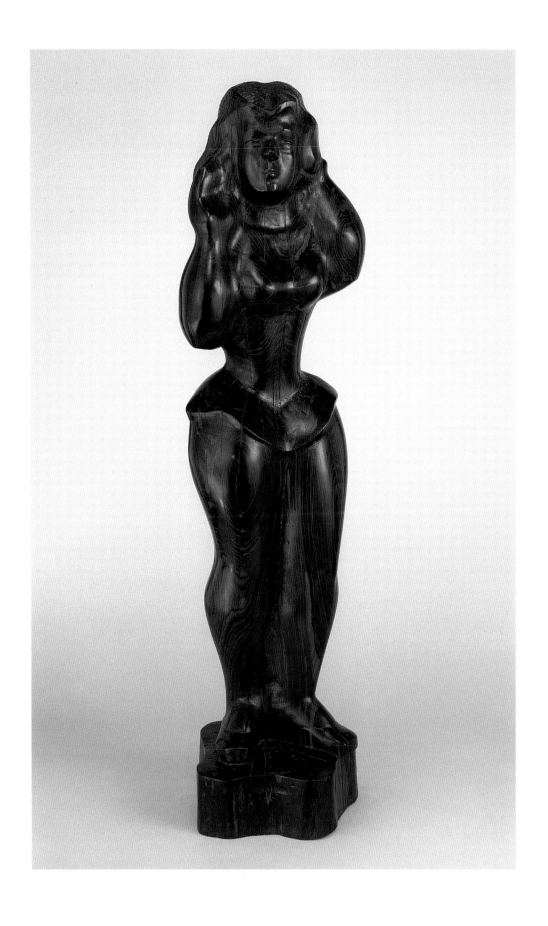

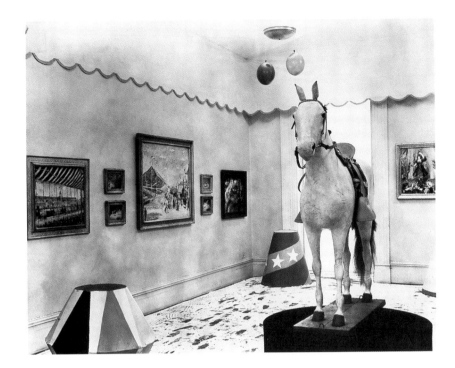

marriage floundered, and when Bruce began divorce proceedings against him in 1937, he shot and killed her and then himself. Chaim Gross's (1904–1991) posthumous portrait of Leitzel (fig. 47) is a testament to the cult that surrounded her even after her death.

In 1929 the newly inaugurated Whitney Studio Galleries (later to evolve into the Whitney Museum of American Art) opened an exhibition titled *The Circus in Paint* (fig. 48).[55] Organized by Juliana Force, with decorations by Louis Bouché, the exhibition was the "critical and social smash of the spring season,"[56] and reviews appeared in American papers from coast to coast. Among the artists included in the exhibition were Beal, John Steuart Curry, Demuth, Pène du Bois, Kuniyoshi, and Marsh.[57] Lloyd Goodrich's brief introduction provided a European pedigree for the works on view and referenced European precedents from Jacques Callot and Antoine Watteau to Picasso, suggesting a continuum, not a distinction, between European and American circus culture.[58] Goodrich also made a case for the modernity of the circus as a subject:

For the modern painter the circus, with its color and light and movement, takes the place of the public spectacles which inspired the artists of former days. It supplies the color and glitter that are lacking in our standardized modern civilization of ready-made clothes, drab uniforms, solemn functions and deplorable lack of public pomp and display. Against all these humorless and anti-artistic tendencies, the circus clown, with his insanely painted face and his grotesque costume stands as a living denial of the commonplace values of everyday life.[59]

He also spoke of female beauty on view at the circus:

Where else, also, can the artist study the human form divine to better advantage? No one will deny that certain types of female

beauty may be best admired in the musical show and the night club, but the charms of the ladies of the circus so much franker and more highly colored than those of their sisters of the stage and the dancing floor, are calculated to interest the painter just as much, if not more. In the circus bodily beauty, both male and female, is displayed not in insipid attitudinizing but in feats that call for the utmost qualities of skill and daring.[60]

Marsh (1898–1954), who was represented in the Whitney Studio Galleries exhibition with a watercolor maquette for a theater curtain, is Goodrich's modern painter in search of the authentic, public spectacle. Along with the images of the beaches at Coney Island, burlesque shows, and the teeming avenues of Manhattan, Marsh drew, etched, and painted images of the circus. Two of his circus paintings, *Wonderland Circus, Sideshow, Coney Island* (fig. 49), and *Pip and Flip* (fig. 50), and an etching, *The Barker* (fig. 51), show Marsh fully in control of the chaos he courted in his representations of modern life. In these images, the circus is represented by the banners and painted backdrops that depict the stars of the midway. The frenzied crowd in *Pip and Flip*, egged on by the sexually provocative dancing girls between the advertisements for "Pip & Flip/Twins from Peru" and "Major Mite/Smallest Entertainer on Earth," represent not simply the torrid underside of the American circus, but also the attraction of the carnivalesque. Marsh's perspective on the circus in these sideshow scenes would prevail later in the century as artists and photographers began to explore the unchoreographed moments of the circus, especially the small mudshows — circuses transported by truck — that continued to bring live entertainment to suburban and rural communities throughout the United States. In another etching, *The Flying Concellos* (fig. 52), Marsh conveyed his enthusiasm for the skills of one of the great aerialist troupes.[61] Here, he presents a dramatic moment in midair featuring Antoinette Concello performing a triple somersault — the feat that had made Alfredo Codona the most famous aerialist in the world.

Pène du Bois (1884–1958) also found the aerialists a congenial subject. Focusing on the absolute dependence of trapeze performers on each other, he uses the circus as a metaphor for social interaction. Investing *Trapeze Performers* (fig. 53) with gravitas, Pène du Bois emphasizes the danger rather than the freedom that the power of flight symbolized to others. The three flyers, situated high above the circus ring are momentarily safe on their perch but are on the verge of swinging from a secure foothold to perform high above the ring.

The Great Depression took an economic toll on the circus as it had on other aspects of American life, causing the Ringling Brothers and other smaller circuses to cut back on performances and personnel. Some of the unemployed circus performers found work in the Federal Theatre Project of the Federal government's Works Progress Administration (W.P.A.) and played circus dates around the country (plays, puppet shows, and vaudeville shows were also performed under the auspices of the W.P.A.).[62] Many artists active in the 1930s who were part of the W.P.A. produced prints and paintings of the circus, in many cases motivated by the subject's popular appeal. Other artists looked to native folk art as a means of exploring the imagery of the circus in order to create works that combined a nostalgia for the circus as it had been in its prime with the formal sophistication of the popular art of an earlier age. The revival of interest in American folk art, which began in the 1920s, was marked by an important early exhibition at the Whitney Studio Club in 1924.[63] Edith Halpert, one of the most important art dealers associated with American modernism in the 1930s, opened her American Folk Art Gallery in 1931, thereby emphasizing the importance of American folk art. She encouraged serious collectors of American art — including Elizabeth Navas, who was putting together an extraordinary collection of contemporary and modern American art for the newly formed Wichita Art Museum, and Mrs. John D. Rockefeller III, one of the founders of the Museum of Modern Art in New York — to collect American folk art and to think of these folk artists as the "ancestors" of contemporary American artists.[64] For Milton Avery (1885–1965), Kuniyoshi, and Elie Nadelman[65] (fig. 54), folk art was a source of innovation that led them to a modern expression that was not directly derived from European abstraction or aesthetic theory.

Avery's paintings of the circus are related to those he produced on the subject of vaudeville. By the 1930s, neither circus nor vaudeville were fashionable pastimes, and Avery's turn to both subjects in his art is part of what Robert Hobbs describes as the artist's "knowing naiveté."[66] His three works in the exhibition present three very different interpretations of the circus. In *Trapeze Artist*, the earliest of the group (fig. 55), the composition's dominant blues suggest the hush of the subdued crowd as a bicyclist navigates the tightrope over a distant ring, an equestrienne performs in the ring, and perhaps beyond the frame of the canvas a trapeze artist flies through the air. In 1933 Avery returned to the subject of the circus to paint *Chariot Race* (fig. 115, page 128), depicting the riotous race of animals, vehicles, and performers around the three rings that characterized the finale of the circus. The grinning clown who confronts us in the foreground, the lack of perspective, and the frenzied animals all coalesce into an orgy of activity. *Three Ring Circus* (fig. 56) returns order to the circus, the horses to their rings, and the performers to their respective apparatuses. This vision of the circus — an American three-ring circus — is serene, sophisticated, and droll.

Kuniyoshi's (1889–1953) first images of the circus date from his first trip to Europe in 1925. They mark an important shift away from his early, naïve genre scenes (which owed much to American folk art) and toward an emphasis on a more fully developed perspective and constructed, solid forms. *Circus Ball Rider* (fig. 124, page 135)

continued on p. 60

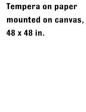

49
Reginald Marsh,
*Wonderland Circus,
Sideshow, Coney
Island,* 1930.
Tempera on paper
stretched on
Masonite,
48 ³⁄₄ x 48 in.

50
Reginald Marsh,
Pip and Flip, 1932.
Tempera on paper
mounted on canvas,
48 x 48 in.

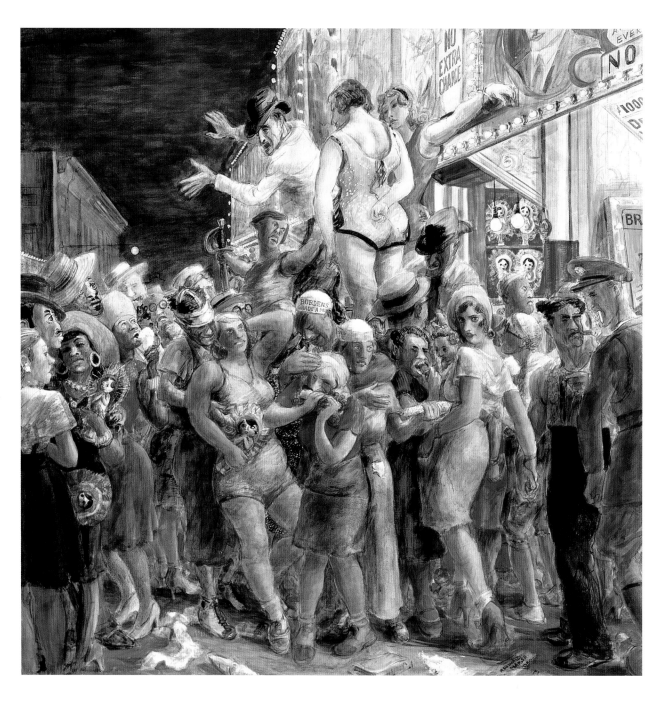

51
Reginald Marsh,
The Barker, 1931.
Etching on paper,
9 3/4 x 7 7/8 in.

52
Reginald Marsh,
The Flying Concellos,
1936.
Etching on paper,
7 7/8 x 9 7/8 in.

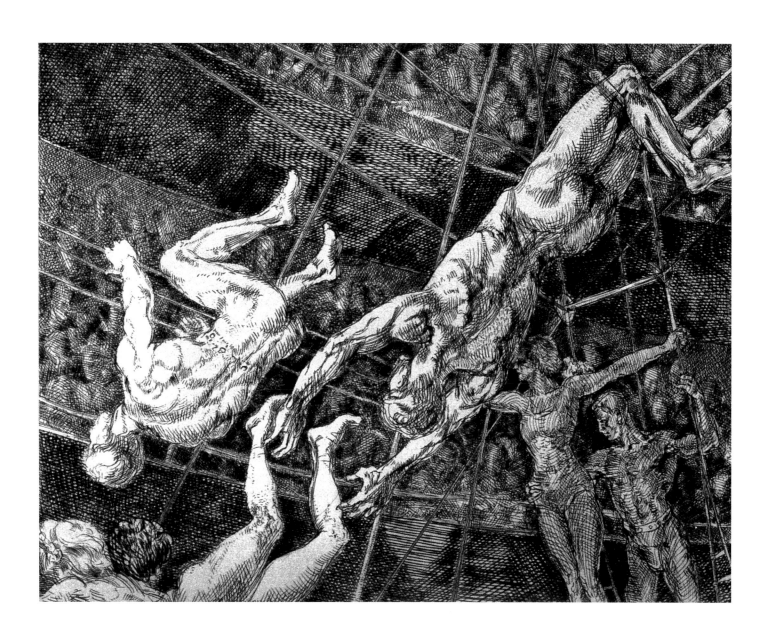

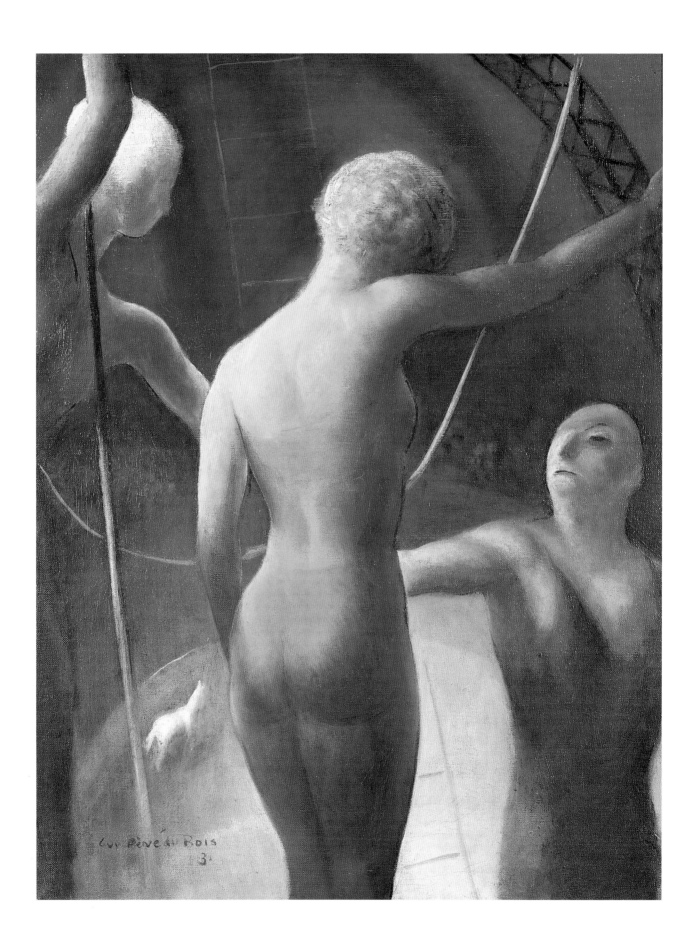

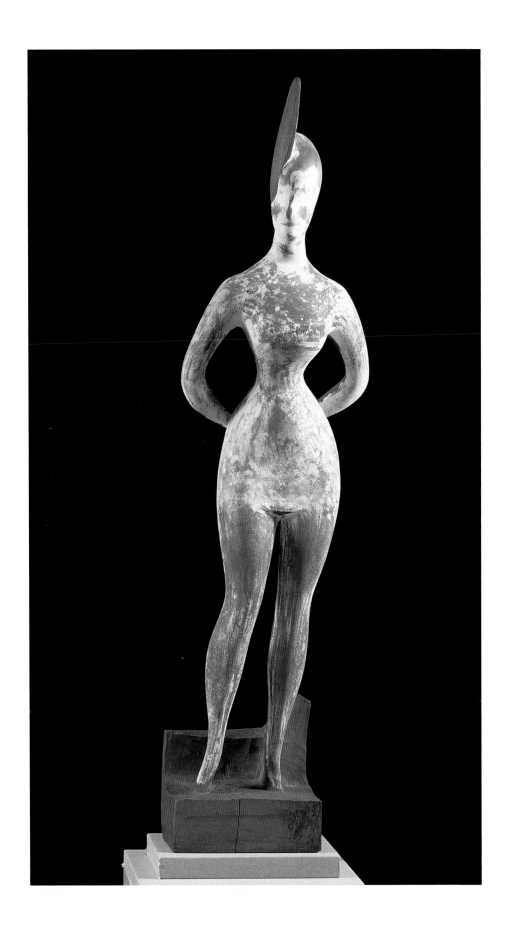

53
Guy Pène du Bois,
Trapeze Performers,
1931.
Oil on canvas,
25 x 20 in.

54
Elie Nadelman,
Circus Performer,
1919.
Painted wood,
33 ¾ x 9 x 5 ½ in.
Carnegie Museum of
Art, Pittsburgh; gift
of the Pace Gallery,
in honor of the
Sarah Scaife Gallery
(74.33.1)

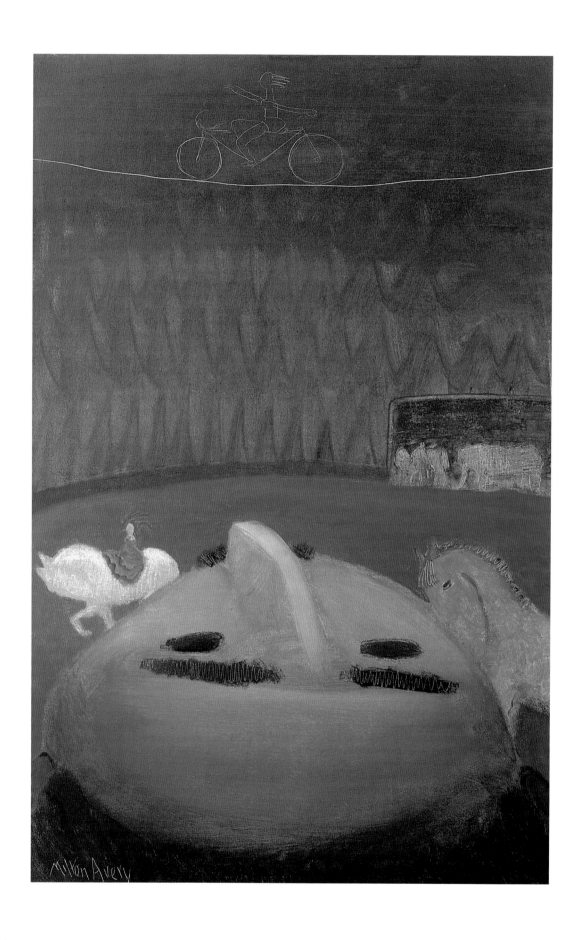

55
Milton Avery,
Trapeze Artist, 1930.
Oil on canvas,
36 x 24 in.

56
Milton Avery,
Three Ring Circus,
ca. 1939.
Oil on canvas,
32 x 48 in.

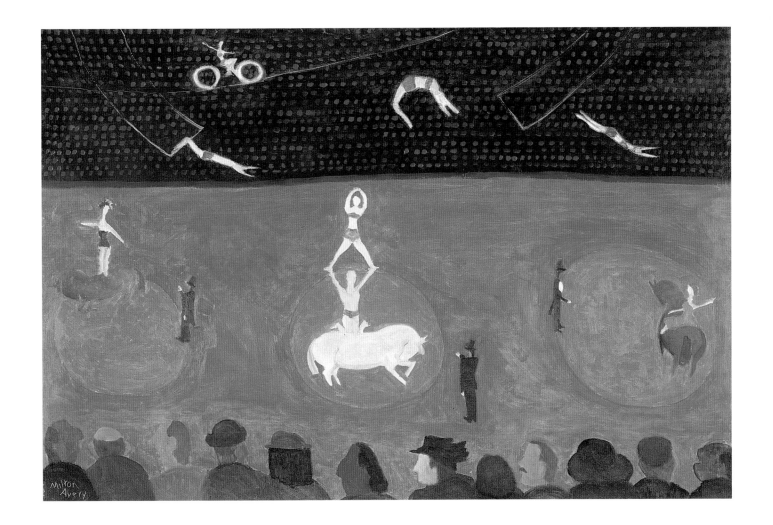

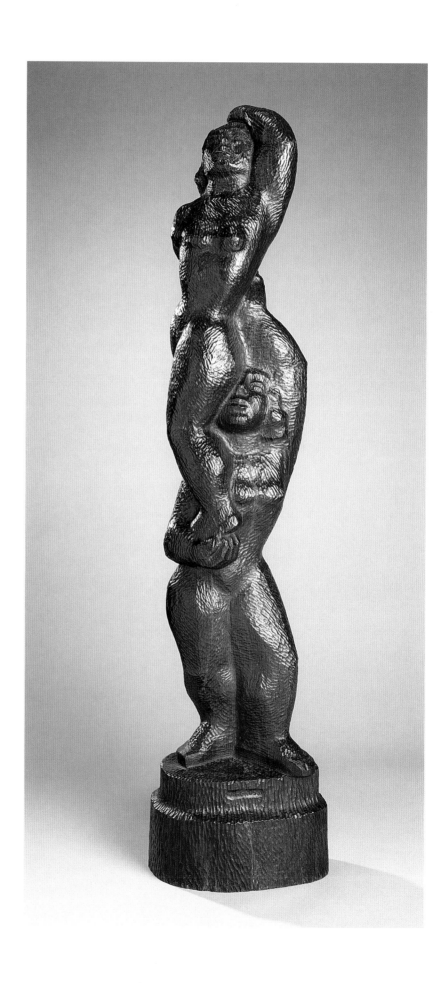

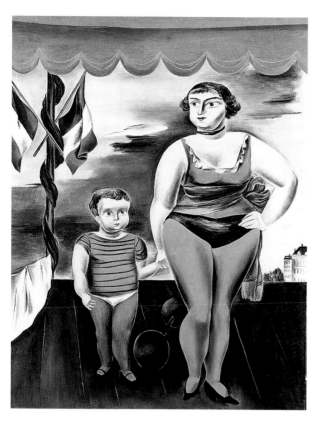

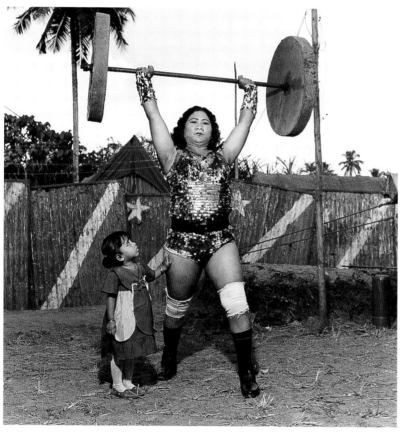

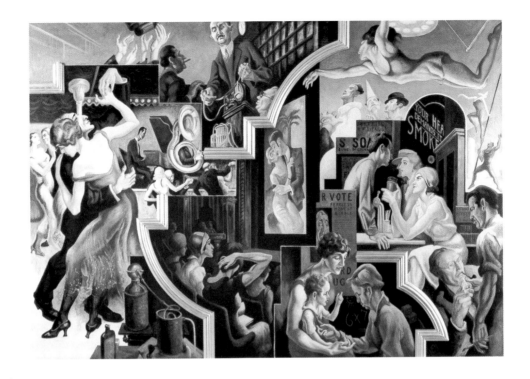

60
**Thomas Hart Benton,
"City Activities with
Dance Hall" from**
America Today,
**1930.
Distemper and egg
tempera on gessoed
linen with oil glaze,
92 x 134 ½ in.
AXA Financial, Inc.
through its sub-
sidiary The Equitable
Life Assurance
Society of the U.S.**

and other lithographs and etchings that Kuniyoshi produced of the circus focus on a female acrobat who fills the foreground space. Balancing on a ball, while an equestrienne performs tricks on a galloping horse, the woman is not the wisp of a girl that Picasso depicted balancing precariously on an enormous ball, but a full-figured woman confident of her physical skill. *Strong Woman and Child* (fig. 58) is one of his most successful circus paintings; in it, the influences of American folk art and European modernism are perfectly balanced. Portraying the circus strong woman as a mother, Kuniyoshi wryly comments on a child's vision of motherhood and on the cultural significance of the strong woman in all spheres. Chaim Gross also focused his attention on the circus strong woman (fig. 57). His sculpture of a woman lifting a second woman updates the many images throughout the history of art of men holding women aloft. The subject of the strong woman, an image that has great resonance for critics of the status quo, continues to intrigue American artists. In 1989 Mary Ellen Mark photographed a circus strong woman in India, *Shavanaas Begum with Her Three-Year Old Daughter, Parveen* (fig. 59). Like Kuniyoshi and Gross, Mark enters the world of the circus to broaden perspectives. The circus strong woman she presents to us in this photograph is a parent who embodies the strengths of both male and female, as in Kuniyoshi's painting. Like the recent phenomenon of the female bodybuilder, the circus strong woman reconfigures feminine attributes and provides alternatives to established roles.[67]

Kuniyoshi's interest in the circus, in carnival, and in masks continued throughout his career. Later in his life he invested his imagery with mysterious veils of glowing color, as in *The Amazing Juggler* (fig. 61). Masks and masking identities were subjects of importance in his art, especially in the 1950s, and Kuniyoshi, whose identity as a Japanese-American in the United States during

World War II imposed certain restrictions on his activities, would have been particularly sensitive to the symbolism of masks and performances.[68]

The Depression, the focus on America's economic recovery, and the W.P.A.'s projects to map the cultural life of the American past all contributed to a new fascination on the part of artists and art critics with the seemingly simple, rugged beauties of the heartland. Among the subjects depicted by regionalist artists such as Thomas Hart Benton (fig. 60) Russell Cowles, John Steuart Curry, and Paul Sample were various aspects of the American circus. Cowles (1887–1979) in *Snake Charmer* (fig. 62) emphasized the frankly sexual display on view. Sample (1896–1974) chose to focus on the nostalgic appeal of the circus as a rural entertainment, in *Country Circus* (fig. 63), and on the strangely surreal character of "clown alley" – a space where clowns applied their makeup, in his *Clown Reading* (fig. 64). The latter, which at first glance seems like a clear-cut portrait of a clown as a working man on a break, taking a moment to relax with a good book, is deceptive. By juxtaposing the clown's made-up face (and those of the clowns in the background) with the face of the ventriloquist's dummy in the valise next to him, the artist creates a slightly sinister air. Is the clown a dummy or an individual with literary tastes? Sample leaves the question open. Weegee's photograph of a clown-faced dummy hanging from the rafters at Madison Square Garden (fig. 65) evokes a similar uneasiness at the close association between clown and dummy. Weegee's humor, however, and his evident glee at capturing an image that resonates with the sensationalism of his street-crime photography temper the horror of the suggestion.

Curry was one of the few artists who acted on the dream to run away with the circus. He traveled with the Ringling Brothers and Barnum & Bailey Circus from April until mid-June of 1932,[69] and painted pictures of the circus elephants (fig. 116, page 129), the Codonas (fig. 121, page 133), the Reiffenach Sisters (fig. 120, page 132), Baby Ruth (fig. 66), and the legendary Clyde Beatty (fig. 117, page 129). One of Curry's most enduring themes is that of struggle against adversity; and it is often found in his regionalist paintings. The paintings that were inspired by his travel with the circus, however, celebrate the achievements of the performers rather than presenting their struggles as they perfect their skills. Although historians have suggested that a crisis in Curry's personal life gave him a reason to join the circus, he explained its attractions in terms that prove his circus interlude was not out of character with his ambitions as a painter of American life, describing the circus as "one of the most colorful phases of the American scene."[70] In Baby Ruth, Curry chose as his subject one of the circus's most famous fat ladies, who, as a sideshow attraction, sat before thousands of passing viewers. Curry's painting is both an engaging portrait of an individual and a document of a performance.

Certainly the vision of America that Curry conjured up in his circus series widens the scope of American Scene painting by

depicting non-native species (elephants), human prodigies, such as Baby Ruth, and the incomparable Flying Codonas. His paintings of the troupe are among his most dynamic, most abstract, and most successful works. Curry himself felt he had achieved a measure of greatness in them and wrote to his dealer Maynard Walker, "I have the possibilities of the greatest work I have ever done."[71]

Robert Riggs (1896–1950), a printmaker of renown whose lithographs of the circus won great recognition in the art world and among circus people, dreamed of running away to join a circus when he was a young boy. Instead, as an adult he visited the circus at every opportunity, filling sketchbooks with detailed drawings of the various acts. Riggs believed that "a good picture should have a feeling of unearthiness – a little of the dream quality,"[72] and the series of prints he produced about the circus beginning in 1933 often achieve the surreal effect for which he strove. Two of the series, *Center Ring* (fig. 67) and *Tumblers* (fig. 68), were reproduced in the Ringling Brothers and Barnum & Bailey Circus Program in 1937, along with a biographical sketch of the artist.[73] The performers represented in *Center Ring* are the Reiffenach Sisters, billed as "two beautiful ladies from the Ural Mountains executing the most novel and unequaled feats of horsemanship." These prints and *Elephant Act* (fig. 69) – for which Riggs won the John Gribble Memorial Prize and the Philadelphia Printmaker's Annual in 1937 – earned him early recognition.

The variety and sheer number of works about the circus created by American artists in the 1930s and 1940s is not a testament to the popularity of the circus so much as it is evidence of the circus itself becoming an American icon. In truth, the circus was in decline, and even "the Big One" was in serious straits. John Ringling's death in 1936 and the complications of his financial affairs caused the Ringling family to lose control of their circus until 1938, when John Ringling North, the nephew of John Ringling, negotiated the return of the Ringling Brothers and Barnum & Bailey Circus to his stewardship. He quickly attempted to bring the circus back to its former glory by investing it with contemporary glamour.[74] Norman Bel Geddes, the designer of one of the 1939 World's Fair's most popular exhibits, *Futurama*, came on board to redesign and modernize the circus.[75] North also hired George Balanchine to choreograph an elephant ballet to the music of Igor Stravinsky, known as the *Circus Polka* (fig. 72). The 1941 tour was a popular and critical success, and in 1942 Bel Geddes's models of the new, streamlined circus were featured in *Sawdust and Spangles: Arts of the Circus*, an exhibition that opened at the San Francisco Museum of Art.[76] Despite the positive popular response to the newly invigorated circus, increasing labor costs, strikes, declining crowds, and the terrible fire in the Ringling Big Top in Hartford in 1944 contributed to the further decline of the circus.[77] In an attempt to harness the power of film for the benefit of the circus, North collaborated with Cecil B. De Mille to **continued on p. 72**

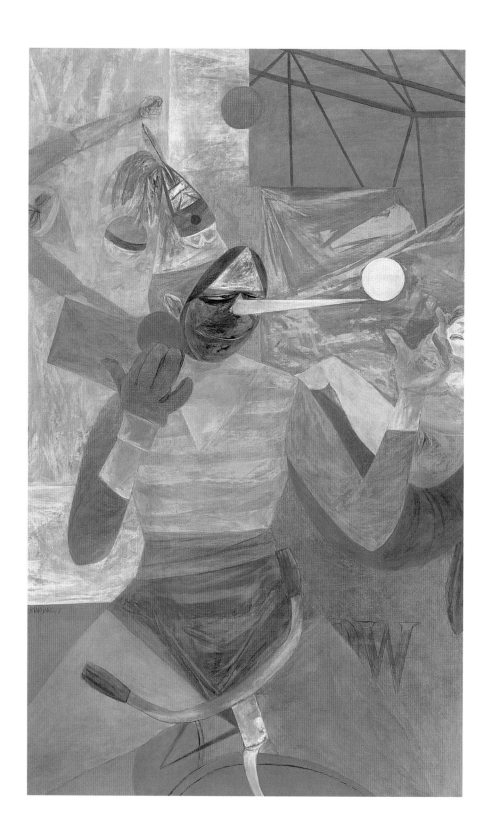

61
Yasuo Kuniyoshi,
*The Amazing
Juggler*, 1952.
Oil on canvas,
65 x 40 ¼ in.
**Des Moines Art
Center Permanent
Collections;
Purchased with
funds from the
Edmundson Art
Foundation, Inc.
(1954.24)**

62
Russell Cowles,
Snake Charmer, n.d.
Oil on canvas,
27 ⅞ x 30 ½ in.

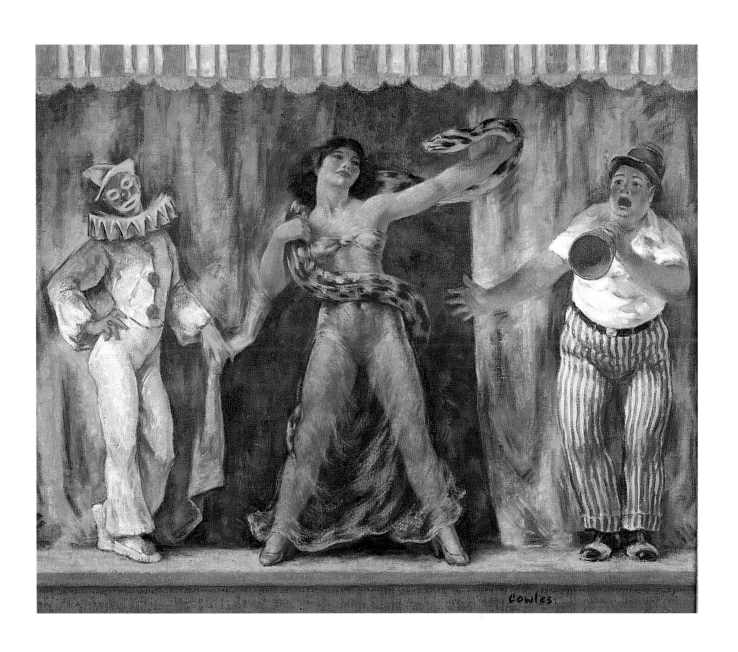

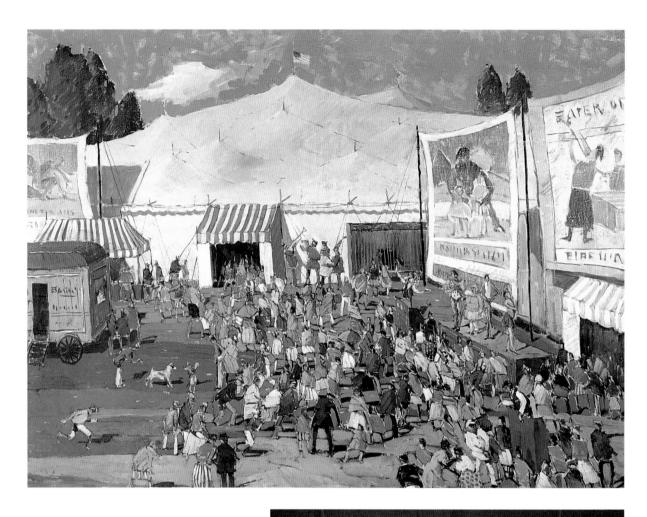

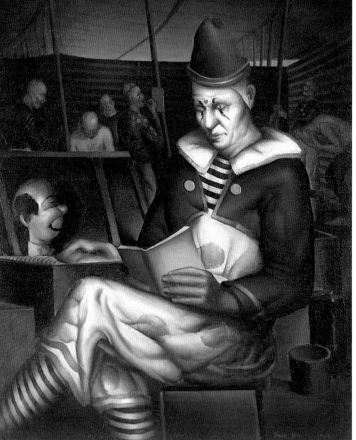

63
Paul Sample,
Country Circus,
1929.
Oil on canvas,
36 x 48 in.

64
Paul Sample,
Clown Reading,
1933.
Oil on canvas,
25 x 30 in.

65
Weegee,
*Danger: Do Not Walk
on Ceiling (Hanging
Clown Effigy)*,
ca. 1945.
Gelatin-silver print,
13 $\frac{1}{8}$ x 10 $\frac{5}{8}$ in.

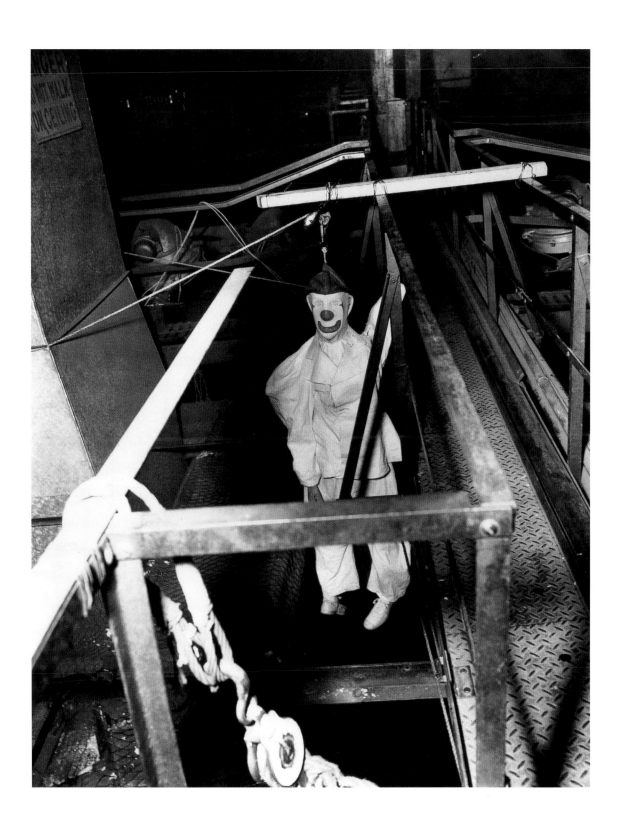

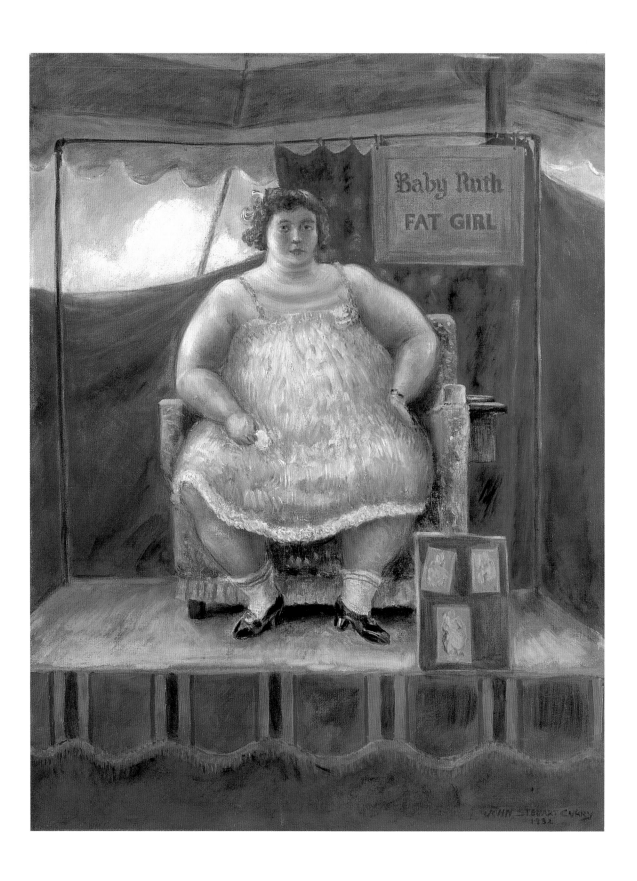

66
John Steuart Curry,
Baby Ruth, 1932.
Oil on canvas,
26 x 30 in.

67
Robert Riggs,
Center Ring, 1933.
Lithograph on
paper,
14 ½ x 19 ½ in.

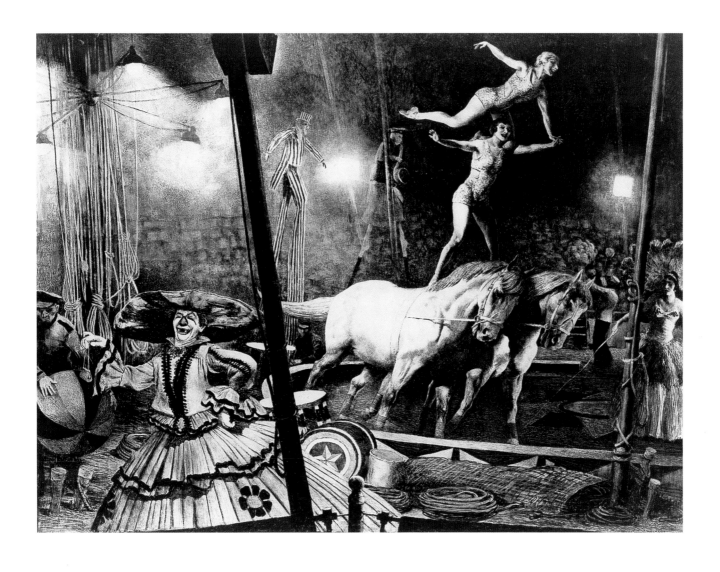

68
Robert Riggs,
Tumblers, 1936.
Lithograph on
wove paper,
14 ¼ x 18 ¹⁵/₁₆ in.

69
Robert Riggs,
Elephant Act, 1935.
Lithograph on
paper,
14 ¼ x 19 ½ in.

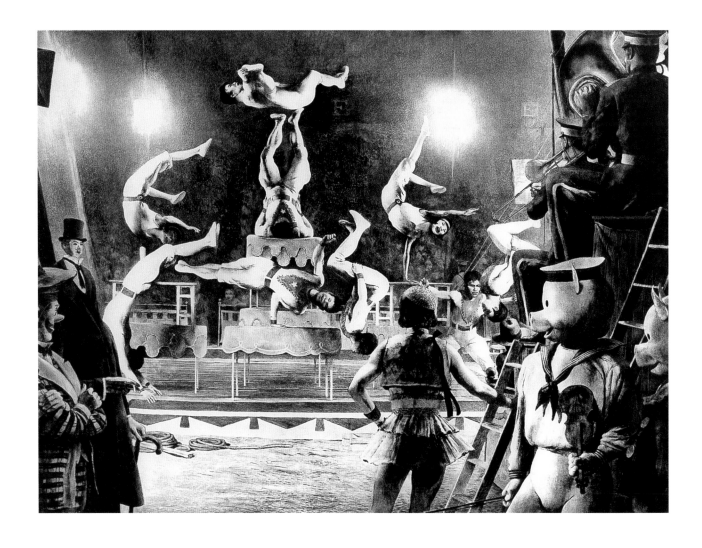

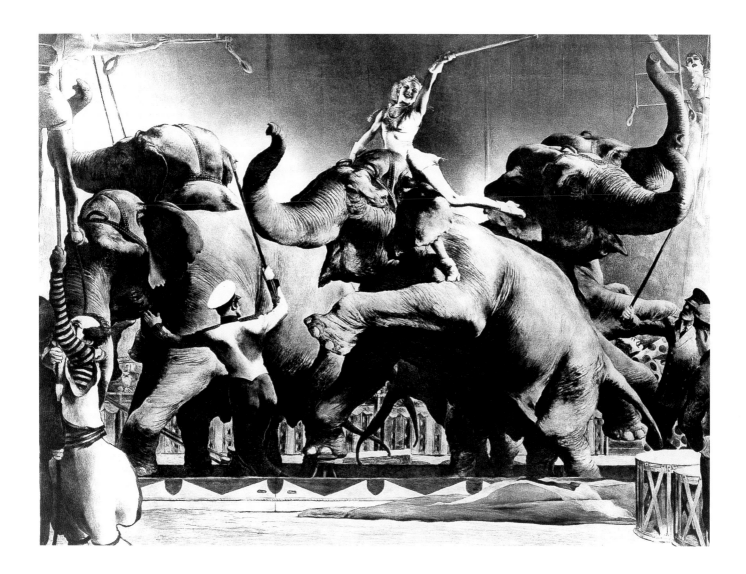

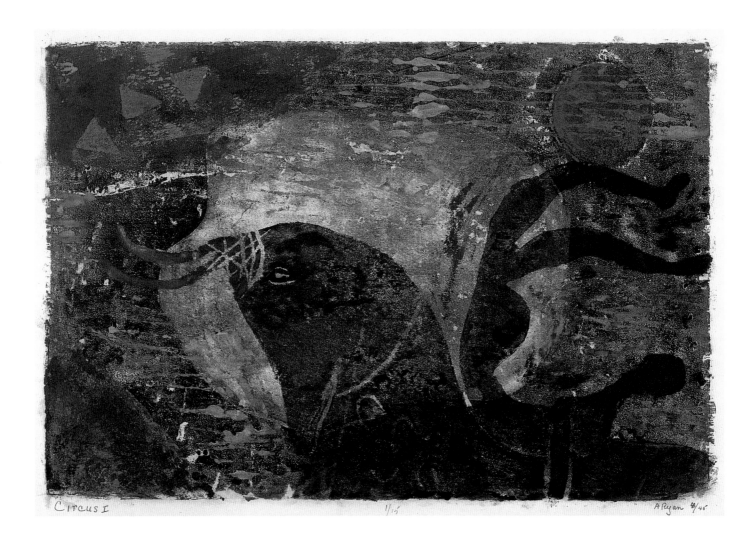

"CIRCUS I 1/15 A Ryan ⁴/₄₅

70
Anne Ryan,
*Circus I
(Equestrienne) 1/15,*
1945.
Color woodcut on
rice paper,
12 x 18 in.

71
Anne Ryan,
*Circus V (Monkey
and Lamp) 26/30,*
1945.
Color woodcut on
paper,
17 ½ x 11 ½ in.

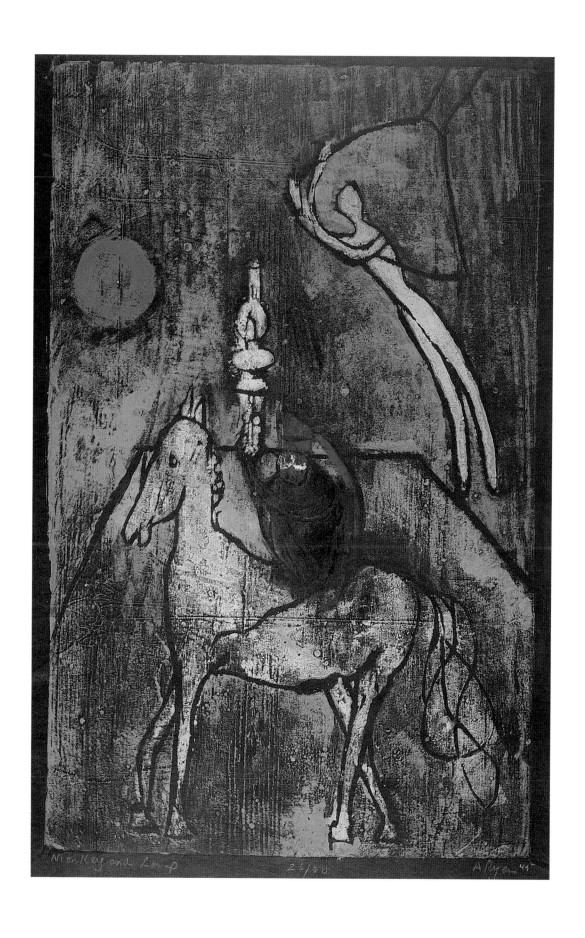

create the movie *The Greatest Show on Earth*, which won Academy Awards for best picture and best original screenplay in 1952. Rather than using the circus spectacle as the subject of the film, De Mille made the circus a symbol for American community life with the usual stock characters — the tough guy (played by Charlton Heston), the two women who love him (Betty Hutton and Gloria Grahame), a sensitive clown who is really an outlaw on the run (James Stewart) — and a train wreck that nearly stops the show. De Mille wrote in 1950:

I found the circus the most unifying force in American life.... The circus is emphatically American in that it rejects the concept that any one class of Americans is naturally hostile to any other class. I looked upon the circus as a microcosm in which all peoples and all governments may find an example of the enormous strength that can lie in cooperation, tolerance and unity.... That to me, is the circus, truly the greatest show on earth.[78]

North also arranged for the performances of the Ringling Brothers and Barnum & Bailey Circus to be broadcast over television in the 1950s. However, bringing the image of the circus into American living rooms did not convey the power of the live circus, and certainly contributed to the sense that the circus was, like vaudeville, an entertainment of the past, relegated to nostalgia and childhood. The golden age of the American circus ended in 1917; the golden age of art about the circus ended right about mid-century. Only Emmett Kelly, the most popular American circus clown since Dan Rice, was able to bridge the gap between the circus and other forms of entertainment during the 1940s and '50s. His "Weary Willie" character (fig. 74) captured all that Americans in the midst of an economic boom wanted to remember about the hard times that had so recently beset them. Kelly's hobo, a direct descendant of Charlie Chaplin's little tramp, was a beloved figure of popular culture who appeared on television and at sports games, as well as at the circus.

At mid-century, a documentarian's perspective began to dominate images of the circus in American art. Photographers were chief among those who mined the circus for its outsider status, reveling in the transgressive, rather than the celebratory aspects of the circus. For photographers Diane Arbus (figs. 104 and 105, pages 114 and 115) and Bruce Davidson (figs. 106 and 107, pages 116 and 117) and for artist Joe Coleman, the circus was a place where extraordinary human stories with real relevance to contemporary life unfolded. Coleman's richly detailed, profoundly disturbing images confront the darkness of the human psyche. His painting of P. T. Barnum (fig. 75) is a compendium of historical facts about the circus and the famous showman. The circus and the carnivalesque play a role in all of Coleman's works, and even in the studio that he has aptly named "The Odditorium." Itself a work of art, the Odditorium combines elements of a waxwork museum, reliquary, and side show.[79]

The fall of the clown from a figure of veneration to one of fear and even contempt is a preoccupation of contemporary popular culture. In art, it is vividly and horrifically described in Bruce Nauman's video installation *Clown Torture* (fig. 136, page 145) and related works. Polly Apfelbaum's *Drown the Clown* (fig. 76) is unsettling in a quiet way. She has taken the clown out of the picture, so to speak, and shows us only the costumes, presenting just the remnants of lives lived as a clown. David Pagel convincingly described the effect of Apfelbaum's clown costumes and the trepidation with which many adults view clowns, especially those found outside of the circus:

Stained and patched, soiled and ultimately abandoned, these suits speak of the unglamorous backside of the circus, parties, and kiddie entertainment in general.... Too much like evidence to be whimsical, and too intimately related to the body of the missing owner to be generalized, each of these garments leads one to wonder how the part-time clown made a living, and to ponder what it must have been like to repeatedly perform the role of the buffoon. More suspicious than respected, the fact that clowns attempt to steal into the world of children by becoming the butts of jokes gives Apfelbaum's well-worn outfits a creepy aura radically at odds with their pretense to happiness and merriment.[80]

Some artists, however, continued to see the circus as an arena of human achievement. George Segal, known for his white-plaster sculptures of human figures in everyday settings, has shown an intermittent interest in the circus, manifested in life-size figures of acrobats and trapeze artists caught in the midst of what may be a performance, a rehearsal, or simply a momentary rest (fig. 77).[81] Segal's circus performers bring the circus back from the outer limits of human experience and return to the metaphor of circus activity as life's activity. Similarly, Charles and Ray Eames, two of the most dynamic designers of the post–World War II period, mined the circus as a model for a style of living (fig. 73). Their staged photograph of themselves balancing on a steel girder of their unfinished house clearly states their ambitions as acrobats of a new age. For the Eameses, the circus was architecture, theater, and a model of efficiency, combining life and work seamlessly. Charles Eames photographed the circus from the 1940s through the 1970s and used his photographs for many purposes, including slide lectures that he periodically gave. In the first of his Charles Elliott Norton Lectures at Harvard in 1970, he used his circus images as a visual point of comparison for the ideas he wished to express.[82] In that lecture, and again in a lecture to the American Academy of Arts and Sciences in 1974, he commented on the nomadic society of the circus and the discipline that made the performances seem spontaneous, and he compared the tented circus to the Acropolis.[83] At the request of Bill Ballantine, director of the now closed Clown College of Ringling Brothers and Barnum & Bailey Circus (1968–97), Eames

produced a film focusing on the art of applying makeup, which was
meant to be both a documentary and a training film to be used at
the college. *Clown Face* (fig. 79) includes footage of Otto Griebling,
Frosty Little, and Lou Jacobs — all famous clowns from the Ringling
Circus — in their preparations for a show. The film artfully returns
to the questions of transformation that Sloan raised in his portrait
of a clown applying his makeup (fig. 13, page 22). It also suggests
the art of everyday life in the circus.

Rhona Bitner, an American artist who photographs the circus
in both Europe and the United States, would agree with the
Eameses that the circus is a symbolic representation of the essential
elements of human life. Among the basic human types found
there, according to Bitner, are "the ringmaster, our Virgil; the
tightrope-walker, the precarious decision maker; the trapeze artist,
the lofty aristocrat; and of course, the clown, a cryptic lampooner
who both revels in and unmasks joy and despair."[84] Bitner captures
many specific moments of the spectacle in series of photographs
that she then systematically groups together to make a virtual
re-creation of the visual experience of the circus (fig. 109, page 119).
Her installations suggest the circus's anti-narrative, circular
quality, the visual collage of individual acts that are at the heart of
the circus.

In 1971 Federico Fellini announced the death of the circus in his
satiric documentary film *The Clowns*. While he was premature in
his announcement, his perception was true enough to warrant the
renewal or rebirth of the circus that began in 1974. More than
entertainment, the circus is a remnant of a pre-industrial world,
where transformations between animal and human nature are pos-
sible, where anarchy and precise choreography reign in perfect
harmony, where clowns are alternatively grotesque and silly, and
where human performers pit themselves against real danger on
a regular basis. Here today and gone tomorrow, the circus is visual
proof of the eternal cycle of birth, death, rebirth. Therein lies its
mystery and its longevity.

72
*Ballet of the
Elephants, Ringling
Brothers and
Barnum & Bailey
Circus*, 1942.

73
Charles and Ray
Eames on the newly
constructed steel
frame of their house
in the Pacific
Palisades,
California, 1949.

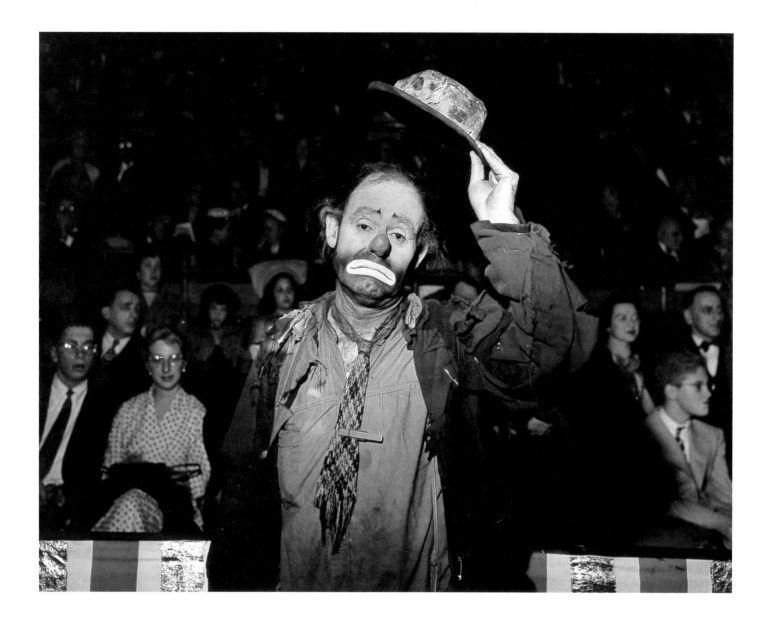

74
Weegee,
Emmett Kelly at
Madison Square
Garden, ca. 1945.
Gelatin-silver print,
10 5/8 x 13 3/8 in.

75
Joe Coleman,
Phineas T. Barnum,
1999.
Acrylic on Masonite,
26 x 32 in.

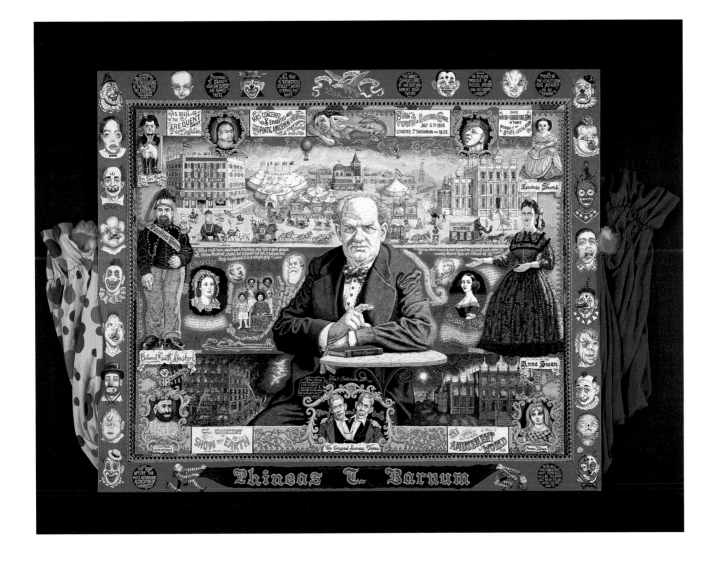

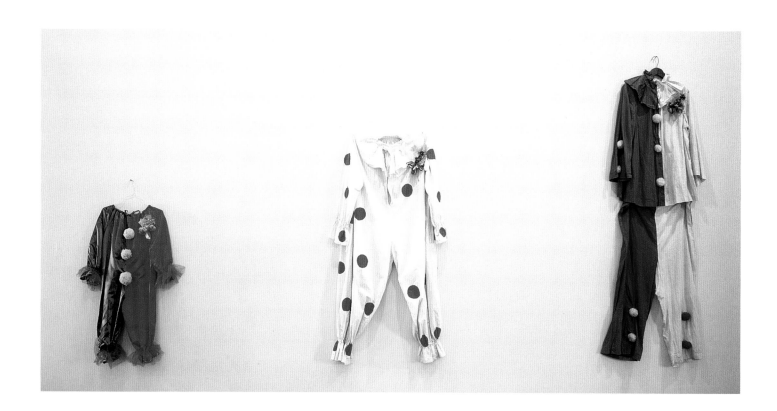

76
Polly Apfelbaum,
Drown the Clown,
1990.
Fabric, live flowers,
and hanger.
Three clown suits in
various sizes

77
George Segal,
Trapeze, 1971.
Plaster, wood,
metal, rope,
H. 71 in.

78
John O'Reilly,
A Field of View,
1969.
Paper montage
and casein,
44 1/4 x 40 1/2 in.

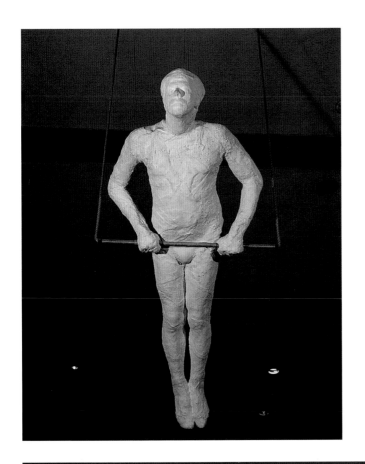

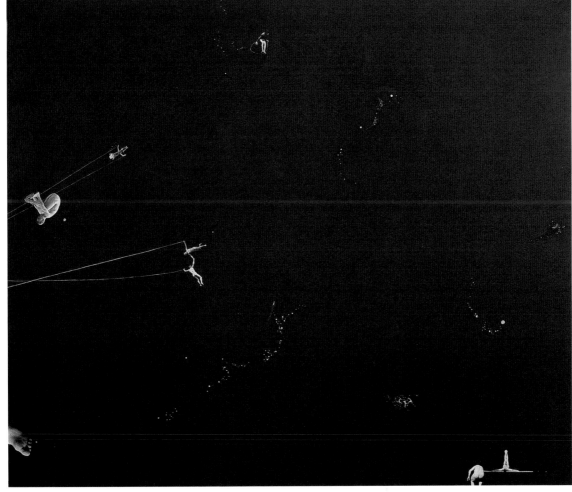

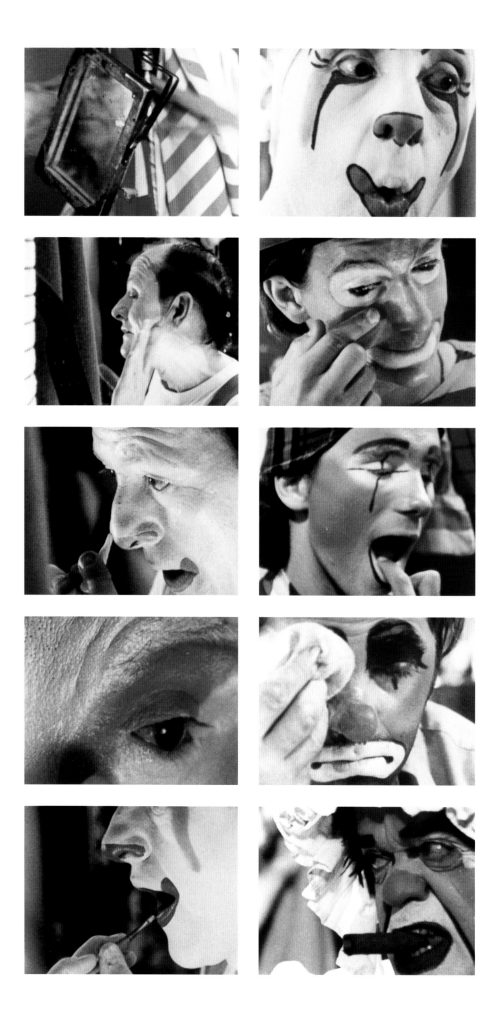

79
Charles and Ray
Eames, stills from
Clown Face, 1971.
Videotape

Notes

1
Ernest Hemingway, "The Circus,"
Ringling Brothers and Barnum &
Bailey Program, 1953, p. 7. My thanks
to Erin Foley of Circus World Museum
who brought this to my attention.

2
Henry Miller, epilogue to *The Smile at
the Foot of the Ladder* (New York:
New Directions Press, 1974), 48. "The
circus is a tiny closed off arena of
forgetfulness. For a space it enables
us to lose ourselves, to dissolve in
wonder and bliss, to be transported
by mystery. We come out of it in a
daze, saddened and horrified by the
everyday face of the world. But the
old everyday world, the world with
which we imagine ourselves to be
only too familiar, is the only world,
and it is a world of magic, of magic
inexhaustible. Like the clown, we go
through the motions, forever simulat-
ing, forever postponing the grand
event. We die struggling to get born.
We never were, never are. We are
always in process of becoming,
always separate and detached.
Forever outside."

3
See Jackson Lears, *Fables of
Abundance: A Cultural History of
Advertising in America* (New York:
Harper Collins, Basic Books, 1994),
which explores the American dual
obsessions of Puritanism and the
carnivalesque and tracks their
influences in the history of advertis-
ing and on American culture.

4
Since 1974, a new generation of pio-
neers has reinvented the circus in
North America, including Guy Caron
of Cirque du Soleil, Paul Binder of the
Big Apple Circus, Larry Pisoni of the
Pickle Family Circus, and Ivor David
Balding of Circus Flora. See Ernest
Albrecht, *The New American Circus*
(Gainesville: University Press of
Florida, 1995), for a detailed discus-
sion of the circus revival in America
and its relationship to European and
Canadian circuses.

5
On the history of the circus in
America, see George Leonard
Chindahl, *A History of the Circus in
America* (Caldwell, Idaho: Caxton
Printers, 1959); John Culhane, *The
American Circus: An Illustrated
History* (New York: Henry Holt, 1990),
which contains a useful chronology
of the circus in America from 1785 to
1991 (pp. 393–408); Tom Ogden, *Two
Hundred Years of the American
Circus: From Aba-Daba to the Zoppe-
Zavatta Troupe* (New York: Facts on
File, 1993); and Don Wilmeth, intro-
duction in Edwin Martin, *Mud Show:
American Tent Circus Life*
(Albuquerque: University of New
Mexico Press, 1988), 1–36. In addi-
tion, there are many biographies of
individual circus stars, impresarios,
and entrepreneurs (P. T. Barnum,
Clyde Beatty, etc.) that provide a
wealth of information about the cir-
cus in America. A great variety of
materials is located at Circus World
Museum in Baraboo; my thanks to
Fred Dahlinger and Erin Foley at that
institution for their advice and assis-
tance. I also wish to thank Deborah
Walk, archivist at the Circus Museum
of the John and Mable Ringling
Museum of Art in Sarasota, Florida,
for her help in locating articles and
photographs.

6
"Viewed from 1810, the year of his
birth, Barnum's circus forms only
one of his many show business
achievements, a satisfying but by no
means unexpected triumph. Viewed
from the middle of the twentieth cen-
tury, however, the circus stands as
Barnum's one enduring monument to
fame, the legacy his name left for the
future." Neil Harris, *Humburg: The Art
of P. T. Barnum* (Boston: Little Brown,
1973), 235. On Barnum and popular
culture, see also Philip B. Kunhardt,
Jr., et al., *P. T. Barnum: America's
Greatest Showman* (New York: Knopf,
1995) and Bluford Adams, *E. Pluribus
Barnum: The Greatest Showman and
the Making of U.S. Popular Culture*
(Minneapolis: University of Minnesota
Press, 1997).

7
The Ringlings figure in all accounts of
the history of the circus in America.
For information on their early years
and successful rise, see Fred
Dahlinger and Stuart Thayer, *Badger
State Showmen: A History of*

Wisconsin's Circus Heritage (Baraboo, Wis.: Circus World Museum; and Madison: Grote Publishing, 1998). For a discussion of John Ringling North and the end of the Ringlings' control of the circus, see David Lewis Hammarstrom, *Big Top Boss: John Ringling North and the Circus* (Urbana and Chicago: University of Illinois, 1992). For the Ringling family's view of their legacy, see Henry Ringling North and Alden Hatch, *The Circus Kings: Our Ringling Family Story* (Garden City, N.Y.: Doubleday, 1960).

8
According to Ogden, this comic act was invented by Philip Astley and brought to the United States by a British rider who performed with Astley's rival in London, Dibden and Hughes' Royal Circus; it was supposedly based on the true misadventures of John Gilpin. "In the act, the clown equestrian would first have difficulty getting onto the horse. Next the horse wouldn't move. Then the nag wouldn't go fast enough; then it galloped at full speed. The rider would have trouble staying on the horse, segueing into the usual trick riding that proved the equestrian's skill." Ogden, *Two Hundred Years*, 336. A variant of this act was performed by Dan Rice and described by Mark Twain in *The Adventures of Huckleberry Finn.*

The Dibden and Hughes' Royal Circus is an important link between Astley and the circus in America. John Bill Ricketts learned his craft with Dibden and Hughes. Charles Hughes traveled to America with other British riders and performed in Boston, Philadelphia, and New York. Hughes also introduced the modern circus to the court of Catherine the Great in Russia.

9
Ogden, *Two Hundred Years*, 289.

10
Ibid.

11
In January 1797, Washington sold Ricketts the horse he had ridden during the Revolutionary War, which had enormous value as a circus attraction. Ibid. For a discussion of Washington's friendship with Ricketts and his appreciation of the circus, see Culhane, *American Circus*, 4–6.

12
On the importance of New York State in the evolution of the circus, see ibid., 14–25, and Wilmeth, Introduction. Old Bet, the most famous of the early elephants to be exhibited in the United States was owned by a native resident of Somers named Hachaliah Bailey. The success that Bailey realized in exhibiting Old Bet led to the establishment of The Zoological Institute, a monopoly of menagerie owners (also known as the Flatfoots) who controlled the importation and exhibition of exotic animals in New York State. The menagerie and the circus were combined in the 1830s.

13
Dahlinger and Thayer, *Badger State Showmen*, v.

14
"The circus was one of the few and certainly the largest of the live entertainments to reach the rural public, which found it highly entertaining. The displays of horseflesh, the muscular dexterity of the athletes, and even the antics of the clowns appealed to the largely inhibited and credulous audience." Ibid., vi.

15
Coup, quoted in Harris, *Humbug*, 238.

16
Dan Rice (1823–1900) was the first great American clown. He was associated with various circuses throughout his life and also ran for political office. Known as "the modern Shakespeare jester," he would answer questions with quotes from Shakespeare and declaim passages from *Romeo and Juliet* in backwoods dialects. He billed himself as "America's favorite clown," and his costume – top hat, chin whiskers, and a suit decorated with the Stars and Stripes – was immortalized by Thomas Nast in his caricature of

"Uncle Sam." For a summary of his life, see Culhane, *The American Circus*, 47–58, and Ogden, *Two Hundred Years*, 286–89. For an early biography of Rice, see Maria Ward Brown, *The Life of Dan Rice* (Long Branch, N.J.: published by the author, 1901). For a short while in the mid-1850s, Rice and the foremost English clown of the day, William Wallett (1808–1892), played together in Rice's circus, switching the roles of ringmaster and clown with Wallett declaiming Shakespeare and Rice responding with a parody. See Culhane, *American Circus*, 56, 58.

17
After an insignificant early career as a store clerk and newspaper editor, Barnum moved with his family to New York and acquired the American Museum from the heirs of John Scudders in 1840. He improved the old displays and added exotic animals and live entertainment, including magicians, ventriloquists, Punch and Judy puppet shows and knife throwers, and reopened as Barnum's American Museum on New Year's Day in 1842. It was a great popular success. Barnum's next innovation was to expand his list of exhibits to include human oddities: Tom Thumb, a 25-inch-tall midget; Anna Swan, who, at 7 foot 11 inches, was known as the Nova Scotia Giantess; Madam Clofulia, a bearded lady; and most famously, the Siamese twins Chang and Eng. On the American Museum, see Odgen, *Two Hundred Years*, 10–12, and Harris, *Humbug*, 31–57. On Chang and Eng, see Darin Strauss, *Chang and Eng* (New York: E.P. Dutton, 2000).

18
Ann Douglas, *Terrible Honesty: Mongrel Manhattan in the 1920s* (New York: Farrar, Straus and Giroux, 1995), 153.

19
Harris, *Humbug*, 245.

20
Ibid., 240.

21
In *Fables of Abundance*, Lears presents the Puritan ideal as the man of few words, upon whom stability, law, and order depend, and the carnivalesque as personified by the legendary showman and circus owner P. T. Barnum. Barnum and his counterparts, who include itinerant peddlers, magicians, hucksters of all types, are garrulous to an extreme, theatrical, and in constant movement. They urge good, stable folk to part with their hard-earned money in the pursuit of pleasure; they argue in favor of exoticism and luxury – for "artifice over authenticity," in Lears's words (p. 53) . On the Ringlings, see Dahlinger and Thayer, *Badger State Showmen*, 71–86.

22
There were seven Ringling brothers: Al (Albrecht C. Ringling, 1852–1916); Otto (William Henry Ringling, 1858–1911); Alf T. (Alfred Theodore Ringling, 1863–1919); Charles (Carl Edward Ringling, 1864–1926); John (John Nicholas Ringling, 1866–1936); Gus (Augustus Albert Ringling, 1854–1907); and Henry (Henry Willliam George Ringling, 1868–1918). While all the brothers were involved in circuses at some point or another, the five oldest – Al, Otto, Alf, Charles, and John – created the Ringling Brothers circus. On the Ringling Brothers' moral principles, Dahlinger and Thayer (in *Badger State Showmen*, 80–81) quote Charles Ringling: "I recall that in the profession they used to call us 'The Sunday School Boys' because we eliminated the grafters (or grifters, as one pleases), and refused to let them travel in our wake....our success, I firmly believe, came from our recognition of the rights of the public by doing away with the many impositions that had been practiced against it. There was no shortchanging at the windows of our ticket wagons. We advertised exactly what we had. We discountenanced the presence of crooks, and cooperated with the local authorities in their prosecution ... It took time, but eventually the people of the country came to realize that our coming to town was not a grand rally of confidence men, and worse."

23
The phrase is Phillip Dennis Cate's; see Phillip Dennis Cate, "The Cult of the Circus," in Barbara Stern Shapiro, *The Pleasures of Paris, Daumier to Picasso* (Boston: Museum of Fine Arts and David R. Godine, 1991), 38–45. For a short summary of nineteenth-century interest in the circus as a subject in art and literature, see Geoffrey Wagner, "Art and the Circus," *Apollo* n.s. 82 (August 1965), 134–36.

24
For example, the Goncourt brothers, Edmond and Jules, wrote a novel about the circus, *Les Frères Zemganno*, which was first published in 1879. As many have noted, the central characters, the two acrobat brothers, stand for the two Goncourt brothers themselves. Geoffrey Wagner (in "Art and the Circus," 134) calls the leap to death of the younger Zemganno a symbol for the death of Jules de Goncourt.

25
I am using the term high art in the sense that Kirk Varnedoe and Adam Gopnik use it in *High and Low: Modern Art and Popular Culture* (New York: Museum of Modern Art, 1991). They define high art as "the primary materials with which any history of art in this century must contend" (p. 15).

26
See Cate, "The Cult of the Circus," 42. For additional information on this painting, see D. Brooke, "James Tissot's Amateur Circus," *Boston Museum Bulletin* 67 (1969), 4–17.

27
See Richard Thomson, *Seurat* (New York: Phaidon Universe, 1990), 216.

28
Ibid., 70.

29
The analogy between alienated artist and clown was already common by the time of Seurat's painting; see Thomson, *Seurat*, 155–56, 220. For a thorough tracing of the history of this idea through the nineteenth century in France, see Louisa E. Jones, *Sad Clowns and Pale Pierrots: Literature and the Popular Comic Arts in 19th-Century France*. (Lexington, Ky.: French Forum, 1984). For an abbreviated but persuasively argued account of the clown from medieval to modern times, see Wolfgang M. Zucker, "The Image of the Clown," *Journal of Aesthetics* 12 (March 1954), 310–17.

30
See John Richardson, *A Life of Picasso*, vol. 1, 1881–1906. (New York: Random House, 1991), 369–87. For a discussion of Picasso's images of clowns and harlequins, see Theodore Reff, "Harlequins, Saltimbanques, Clowns, and Fools in Picasso's Art," *Artforum* 10 (October 1971), 30–43

31
The Eight were Arthur B. Davies, William Glackens, Robert Henri, Ernest Lawson, George Luks, Maurice Prendergast, Everett Shinn, and John Sloan. For a discussion of popular urban culture and The Eight (also known as the Ashcan School), see Rebecca Zurier et al., *Metropolitan Lives: The Ashcan Artists and Their New York* (New York: National Museum of American Art, in association with W. W. Norton, 1995). Wanda M. Corn (in *The Great American Thing: Modern Art and National Identity, 1915–1935* [Berkeley and London: University of California Press, 1999], 173) makes the point that the Ashcan School artists created a new language appropriate to the representation of what she terms as the "city delirious," including such subjects as boxing, vaudeville, and the circus.

32
Robert Henri, *The Art Spirit*, compiled by Margery Ryerson (New York: Harper & Row, 1984), 212.

33
On Everett Shinn, see Edith DeFazio, *Everett Shinn: 1876–1953* (New York: C.N. Potter, 1974); on spectacle and Shinn's urban vision, see Sylvia Yount, "Consuming Drama: Everett Shinn and the Spectacular City," *American Art* (Fall 1992), 82–109.

34
An inscribed copy of *Toby Tyler* is in the collection of the Beinecke Library, Yale University, New Haven. I thank Christina Ferando for bringing Shinn's introduction for that text to my attention.

35
Zucker, "The Image of the Clown." In this survey of the clown as an archetype of Western culture found in ancient Rome and contemporary life, Zucker presents evidence of the historical connections between the clown and the devil and argues that the humbling of the clown in the nineteenth century is a direct result of the lessening power of religion. In the nineteenth century, Zucker argues (p. 315), "clowning was the incidental profession of a man with whom the spectator would identify himself, and his grotesque costume was only a self-denying disguise, under which brave hearts beat passionately for women, children, or professional success. With this development the clown ceased to be comical. He now became psychological and tragic."

36
Corn, *The Great American Thing*, 217, and see Gilbert Seldes, *The Seven Lively Arts* (New York: Sagamore Press, 1957), 251–54.

37
For a study of Demuth's figurative early work and his early training in Philadelphia, see Eunice Mylon Hale, "Charles Demuth: His Study of the Figure," Ph.D. dissertation, New York University, 1974.

38
Hartley, "The Greatest Show on Earth: An Appreciation of the Circus from One of Its Grown-Up Admirers," *Vanity Fair*, August 1924, 88.

39
Marsden Hartley, *Somehow a Past: The Autobiography of Marsden Hartley*, edited by Susan Elizabeth Ryan (Cambridge and London: MIT Press, 1998), 87.

40
For a discussion of the significance of Marin's circus pictures, see Ruth Fine, *John Marin* (Washington, D.C.: National Gallery of Art; and New York: Abbeville Press, 1990), 256–59.

41
Helen Torr is an artist who has received little attention. For information on Torr, see Anne Cohen DePietro, *Arthur Dove and Helen Torr: The Huntington Years* (Huntington, N.Y.: Hecksher Museum of Art, 1991).

42
On Calder and the circus, see Alexander Calder, "Voice une petite histoire de mon cirque," in *Permanence du Cirque* (Paris: Revue Neuf, 1952), 37–42; *Alexander Calder: Circus Drawings, Wire Sculptures, and Toys* (Houston: Museum of Fine Arts, 1964) and Cleve Gray, "Calder's Circus," *Art in America* 52 (October 1964), 23–48; Jean Lipman and Nancy Foote, *Calder's Circus* (New York: E.P. Dutton, in association with Whitney Museum of American Art, 1972); Joan Marter, *Alexander Calder* (Cambridge: Cambridge University Press, 1991); Marla Prather et al, *Alexander Calder: 1898–1976* (Washington, D.C.: National Gallery of Art, 1998); Elizabeth Hutton Turner, *Americans in Paris (1921–1931): Man Ray, Gerald Murphy, Stuart Davis, Alexander Calder* (Washington, D.C.: Counterpoint, in association with the Phillips Collection, 1996).

43
For Kuhn, see Philip Rhys Adams, *Walt Kuhn, Painter: His Life and Work* (Columbus: Ohio State University Press, 1978).

44
Some of Calder's drawings of the circus appear in the May 23, 1925, issue of the *National Police Gazette*.

45
Marter, *Alexander Calder*, 17.

46
According to Hayes (p. 60), Calder's *Circus Scene* of 1926 was a gift from Calder to his sister and brother-in-law to celebrate their tenth wedding anniversary. For early references to the circus, theater, and performances seen and enjoyed by the young Calder, see Margaret Calder Hayes, *Three Alexander Calders: A Family Memoir*, introduction by Tom Armstrong (Cupertino, Calif.: De Anza College Press, 1998).

47

Marter, *Alexander Calder*, 20.

48

Ibid., 48. As many have noted, the toys that Calder designed are part and parcel of his sculpture oeuvre. Alexander Rower notes in his chronology in Prather et al., *Alexander Calder* (p. 30), that Calder had previously "embellished a humpty-dumpty circus" made by a Philadelphia-based toy company.

49

Calder, quoted in Marter, *Alexander Calder*, 63.

50

Calder, quoted in Prather et al, *Alexander Calder*, 17. "It wasn't the daringness of the performers, nor the tricks or gimmicks; it was the fantastic balance in motion that the performers exhibited."

51

In 1975, for example, the Perls Galleries in New York staged an exhibition titled *Alexander Calder: Recent Mobiles and Circus Gouaches.*

52

Ringling Brothers Barnum and Bailey Circus Program of 1930 described Leitzel as "the world's foremost and most daring aerial star"; Circus Museum Archives (File 1, Box 2), Sarasota. *The New Yorker* published a two-part profile on Leitzel on April 21, 1956, and April 28, 1956; these essays and others about circus people published in *The New Yorker* are reprinted in Robert Lewis Taylor, *Center Ring: The People of the Circus* (Garden City, New York: Doubleday, 1956).

53

Alfredo Codona was called "The King of the Flying Trapeze."

54

Leitzel and Codona are buried together in Inglewood Park Cemetery, California, under the marble monument that Codona erected in her memory in 1931. The marker is inscribed "Reunion."

55

Avis Berman, *Rebels on Eighth Street: Juliana Force and the Whitney Museum of American Art* (New York: Atheneum, 1990), 256–57. The catalogue, which is little more than a two-page pamphlet with a short essay by Lloyd Goodrich, is at the Whitney Museum of American Art Library archives.

56

Ibid., 256.

57

The complete list of artists, according to the brochure for the exhibition, is as follows: Gifford Beal, Reynolds Beal, Ben Benn, Lucile Blanche, Julius Bloch, Louis Bouché, Henri Burkhard, Blendon Campbell, John S. Curry, Charles Demuth, Guy Pène du Bois, Ernest Fiene, Karl Free, Fillon, William Glackens, Isabel Howland, Florence W. Ivins, Georgiana Klitgaard, Max Kuehne, Yasuo Kuniyoshi, Richard Lahey, Reginald Marsh, Joseph Pollet, Charles Rocher, Caroline S. Rohland, Paul Rohland, Henry Schnakenberg, Dorothea Schwarcz, Simka Simkhovitch, John Sloan, and Carl Waters. A work by John Flannagan is on the price list for the exhibition but not listed in the brochure.

58

This perspective would prevail in later exhibitions that focused on circus in art, notably the exhibitions at the Ringling Museum of Art in 1959; the Milwaukee Art Museum in 1981, and the Boston Public Library in 1985.

59

Goodrich essay in *The Circus in Paint*, n.p.

60

Ibid.

61

Art and Antoinette Concello, known as the Flying Concellos, had begun performing with the Sells-Floto Circus in 1929. When John Ringling purchased that circus, they temporarily became end-ring performers at the Ringling Brothers and Barnum & Bailey Circus, because the center ring already belonged to the Flying Codonas.

62

See William E. Leuchtenburg, *Franklin D. Roosevelt and the New Deal, 1932–1940* (New York: Harper and Row, 1963), 126. There was even a W.P.A. Circus from 1935 to 1939; see Culhane, *The American Circus*, 214.

63

The exhibition was called *Early American Art* and was selected by artist Henry Schnakenberg. Lenders to the exhibition included Peggy Bacon, Charles Demuth, Yasuo Kuniyoshi, Elie Nadelman, Charles Sheeler, and William Zorach. See Berman, *Rebels on Eighth Street*, 201.

64

For more on Elizabeth Navas and the Murdock Collection of the Wichita Art Museum see Novelene Ross, in Novelene Ross and David Cateforis, *Toward an American Identity: Selections from the Wichita Art Museum Collection of American Art* (Wichita: Wichita Art Museum, 1997). For a discussion of Edith Halpert's suggestion that Mrs. Rockefeller purchase "ancestors" for her contemporary collection, see Robert Hobbs, *Milton Avery* (New York: Hudson Hills Press, Inc., 1990), 70.

65

For a discussion of Nadelman's work and the influence of folk art on Nadelman, see John I. H. Bauer, *The Sculpture and Drawings of Elie Nadelman* (New York: Whitney Museum of American Art, 1975).

66

Hobbs, *Milton Avery*, 63.

67

A recent exhibition at the New Museum focused on female body builders and drew a connection between them and circus strong women by exhibiting circus posters in the exhibition. See Jan Todd, "Bring on the Amazons: An Evolutionary History," in Joanna Frueh et al., *Picturing the Modern Amazon* (New York: Rizzoli and The New Museum, 1999), 48–61.

68

See Tom Wolf, "The Late Drawings of Yasuo Kuniyoshi," *Drawing* 13, no. 5 (January–February 1992), 100–03.

69

See Patricia Junker, *John Steuart Curry: Inventing the Middle West* (New York: Hudson Hills Press, in association with the Elvehjem Museum of Art, University of Wisconsin at Madison, 1998), 155–63.

70

Curry, quoted in ibid., 156.

71

Ibid., 162.

72

Ben Bassham, *The Lithographs of Robert Riggs with a Catalogue Raisonné* (Philadelphia: Art Alliance; and London: Associated University Presses, ca. 1986), 41.

73

My assistant Dolores Pukki pointed this out to me in one of our many discussions about the circus.

74

See Hammarstrom, *Big Top Boss*, 71–80.

75

The circus designed by Bel Geddes opened in New York on April 7, 1941, and received much praise. See ibid., 79, and Jane Preddy, "Costumes and Clowns: Bizarre Projects of Norman Bel Geddes," *Journal of Popular Culture* (1987), 37–39.

76

A review of the exhibition *Sawdust and Spangles* appeared in *ARTnews*, April 15, 1942, 6–7.

77

The Hartford fire resulted in the deaths of more than one hundred people, mostly women and children, who were attending a matinee performance. A recent book gives an account of the tragedy: see Stewart O'Nan, *The Circus Fire: A True Story* (New York: Doubleday, 2000).

78

DeMille, quoted in Hammarstrom, *Big Top Boss*, 165.

79

For Coleman, see Jim Jarmusch et al., *Original Sin: The Visionary Art of Joe Coleman* (New York: HECK editions/Gates of Heck, 1997).

80

David Pagel, "Fortune's Orbit: Polly Apfelbaum's Evocative Arrangements," *Arts Magazine* (January 1991), 39–43.

81
Segal's other circus-related works are *Tightrope Walker* (1969; Carnegie Museum of Art), *The Circus Flyers* (1980; Butler Square West, Minneapolis), and *The Girl on the Flying Trapeze* (1969; Collection Robert B. Mayer, Chicago).

82
On Eames and the circus, see Beatriz Colomina, "Reflections on the Eames House," in Donald Albrecht et al., *The Work of Charles and Ray Eames: A Legacy of Invention* (New York: Harry N. Abrams, in association with the Library of Congress and the Vitra Design Museum, 1997), 127–29; and John Newhart et al., *Eames Design: The Work of the Office of Charles and Ray Eames* (New York: Harry N. Abrams, 1989).

83
Ibid., 128.

84
Rhona Bitner, unpublished statement.

PHOTOGRAPHING THE "SPLENDIDEST SIGHT THAT EVER WAS"

CRUELTY, ALIENATION, AND THE GROTESQUE
IN THE SHADOW OF THE BIG TOP

ELLEN HANDY

THE CIRCUS HAS ALWAYS BEEN SEEN AS A MAGICAL, LIMINAL REALM. HEINZ POLITZER'S CHARACTERIZATION OF THE CIRCUS AS "A WORLD BETWEEN," WHICH PROVIDES THE TITLE OF THIS EXHIBITION, RECALLS THE "FLOATING WORLD" DEPICTED IN JAPANESE PRINTS, IN WHICH GEISHAS, PERFORMERS, AND REVELERS PARTICIPATE IN THE PLEASURE INDUSTRY.[5] LIKE THOSE PRINTMAKERS, MANY AMERICAN PHOTOGRAPHERS OF THE TWENTIETH CENTURY HAVE FOUND THEIR SUBJECTS IN AND AROUND THE CIRCUS, AND THEY ARTFULLY RENDERED THEM THROUGH A MEDIUM NOT ALWAYS IDENTIFIED AS FINE ART. WHEN PHOTOGRAPHERS, WHOSE MEDIUM LIES IN BOTH HIGH AND LOW CAMPS, TURN TO SUBJECTS REDOLENT OF MASS ENTERTAINMENT SUCH AS THE CIRCUS, THEIR IMAGES ARE SUFFUSED WITH MIXED ALLEGIANCES AND INTERNAL CONTRADICTIONS WELL SUITED TO THE DEPICTION OF THE PROTEAN SUBJECT OF THE CIRCUS.

"You enjoy the theatre and you enjoy art, but do you enjoy the circus? Did you go to the circus this year? And if so, did you have a really good time?"[1]

Frank Crowninshield

"It was a real bully circus. It was the splendidest sight that ever was, when they all come riding in, two by two, a gentleman and a lady, side by side … And then one by one they got up and stood, and went a-weaving around the ring so gentle and wavy and graceful, the men looking ever so tall and airy and straight, with their heads bobbing and skimming along, away up there under the tent-roof, and every lady's rose-leafy dress flapping soft and silky around her hips, and she looking like the most loveliest parasol."[2]

Mark Twain

"If there really is to be a Heaven hereafter, let me go straight by the pelican air service to that division of it set apart for the circus and go pellmell for the rings and bars, till I can join the splendid horde … and merge myself in the fine pattern which these superior artists make in what will no longer be 'The Greatest Show on Earth.'"[3]

Marsden Hartley

"Damn everything but the circus! … The average 'painter' 'sculptor' 'poet' 'composer' 'playwright' is a person who cannot leap through a hoop from the back of a galloping horse, make people laugh with a clown's mouth, orchestrate twenty lions."[4]

E. E. Cummings

When Frank Crowninshield, editor of *Vanity Fair*, asked his readers in 1925 whether they had "a really good time" at the circus, it was certain that his writers did, yet it is not immediately apparent whether the same could be said for their contemporaries among photographers. Many of these seem to have been drawn to the less cheerful aspects of the circus than its enthusiasts at *Vanity Fair* and other writers, and the same can be said of a current photographer Kimberley Gremillion, who today describes the circus as "a dark microcosm both visually and emotionally."[6] When Cummings compared painters, poets, composers, and playwrights to circus performers, whose performance skills he believed far excel those of the fine artists, photographers might well have been mentioned among the incapable artists. In fact, not only couldn't they "orchestrate lions" and leap "through hoop," it seems that they didn't even always capture the images of those who can.

Like photographers, filmmakers have also inclined more readily toward the circus's darker side than most painters or writers. Hollywood's circus only hints at its shadows — but it does not fail to hint. Although Cecil B. De Mille's film *The Greatest Show on Earth* (1952) is a relentlessly wholesome narrative (even featuring a parade of Disney characters through the ring at one point), it nonetheless includes sundry crooks and a disbarred doctor/murderer, a serious trapeze accident incapacitating a performer, complex sexual intrigues and jealousies, and various other menaces. De Mille followed venerable precedent: Charlie Chaplin, in his 1928 film *The Circus*, pitted the gallant little tramp against a cruel ringmaster and a team of drearily repetitive clowns, crooks, and pickpockets. In film as in photography, the circus is inherently contradictory. These examples drawn from literature and film afford wider perspectives on the problems and characteristics of representing the circus in photography.

The circus is a more frequent subject in American photography than one might at first realize, but it usually appears sporadically in the work of photographers better known for their representations of other subjects. What, then, do photographs of the circus tell us? Highly varied in style, they shed light on significant issues in photography's own history, the emergence of avant gardes, the coming of age of American art on the world scene, and the relationship of photography to film, literature, and experience.

The beginning of this century saw a dedicated circle of photographers, including disciples of Alfred Stieglitz such as Harry Rubincam, struggling to establish photography's parity with drawing, painting, engraving, and other fine-art mediums. The end of this century finds artists esteeming photography's qualities as an applied rather than an artistic medium to rejuvenate their art practice through its style, subjects, and idiom, as in the work of artists like Rhona Bitner, John O'Reilly, and others. For many contemporary artists, status of a very different order is paradoxically conferred upon their work through the photographic medium's extra-artistic allegiances, its role in the worlds of advertising, mass media, and reportage, and its ability to replicate and appropriate images of all kinds.

Although the modernist project of the first third of this century largely involved the appropriation of the energies of mass culture to the ends of high culture, the earliest artistic crusaders among photographers tended to mimic the look, syntax, and subjects of traditional painting as part of their bid for legitimacy. By the 1920s, however, for many painters and photographers, these opposite directions were converging, and dynamic alliances were forged between mediums and subjects variously "high" and "low." During the 1930s, the dominance of documentary practices in photography mitigated much of the skepticism about the artistic credentials of the photographic medium, allowing photographers to form syntheses of documentary and artistic expression uniquely suited both to photography's own dual nature and to the theme of the circus. While the photographic medium had to steer between fine-art and documentary idioms, other dichotomies were at work in the larger cultural field, including the venerable divide between high and low art. In just those years when photography began to be widely acknowledged as a medium of significance among the other arts, so too did the circus enter the realm of serious critical discourse.

Tensions between mass culture and avant-garde practice became codified as divergent aesthetic positions through heated debates in the first quarter of the twentieth century. Purists rejected the low cultural forms and the new media of mass-produced culture while others embraced these enthusiastically, turning them to avant-garde ends through their practice. Largely of a stringently purist bent, the American pioneers of art photography held an elevated conception of art that did not engage with photography's other identity as a handmaiden to the mass media, advertising, and reportage. In Europe, however, by the 1920s, many of the most advanced photographers delighted in the medium's flexibility, novelty, and allegiances to areas typically outside the purview of art.

Though seldom esteemed as an art form in itself until the 1920s, the circus as a joyous place of spectacle, adventure, and virtuosity is a staple of the American vernacular imagination, as well as a favorite trope for writers, artists, and illustrators. As a symbol of transience and freedom, the circus is unequaled; the surprisingly large number of memoirs that have been earnestly penned by writers, social scientists, artists, and others who somehow gained admission to the chosen company of a professional circus and traveled with it for a season or so, attests to this.[7] Yet while many accounts and images of circus life retain a childlike view of the magical realm, others hint of decadence and darkness, or reduce it to a fragmentary and static depiction. In a formulation that might equally apply to photographs, Yoram S. Carmeli has described circus literature as "reification of an illusionary real circus, a circus 'outside' of social time and social relations," a "carnivalesque

continued on p. 92

80
Walker Evans,
Relief Carving,
Ringling
Bandwagon, Circus
Winter Quarters,
Sarasota, 1941.
Gelatin-silver print,
8 3/8 x 6 1/2 in.

81
Kimberly Gremillion,
Shadow #3, 1997.
Gelatin-silver print,
12 x 18 in.

82
Luke Swank,
Circus: Otto
Griebling, Head
Clown, ca. 1934.
Gelatin-silver print,
5 5/16 x 4 7/16 in.

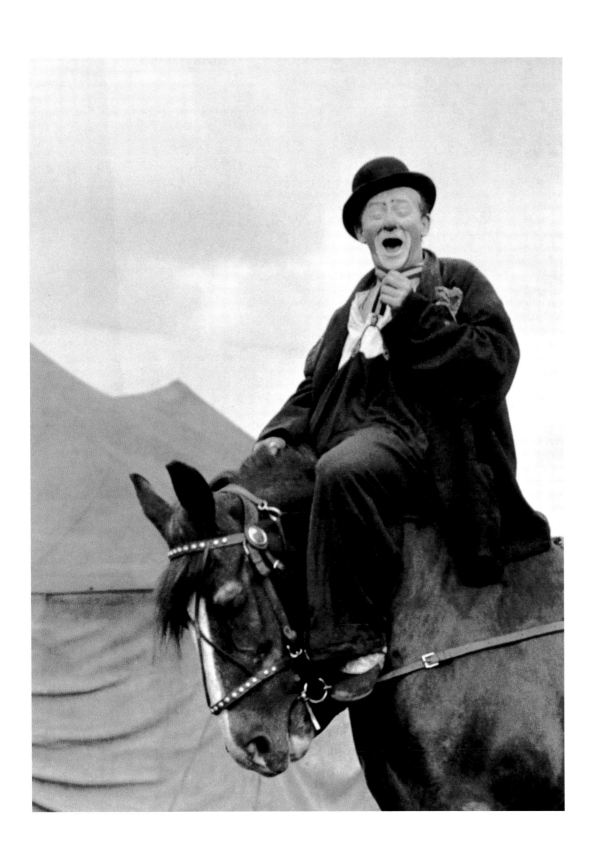

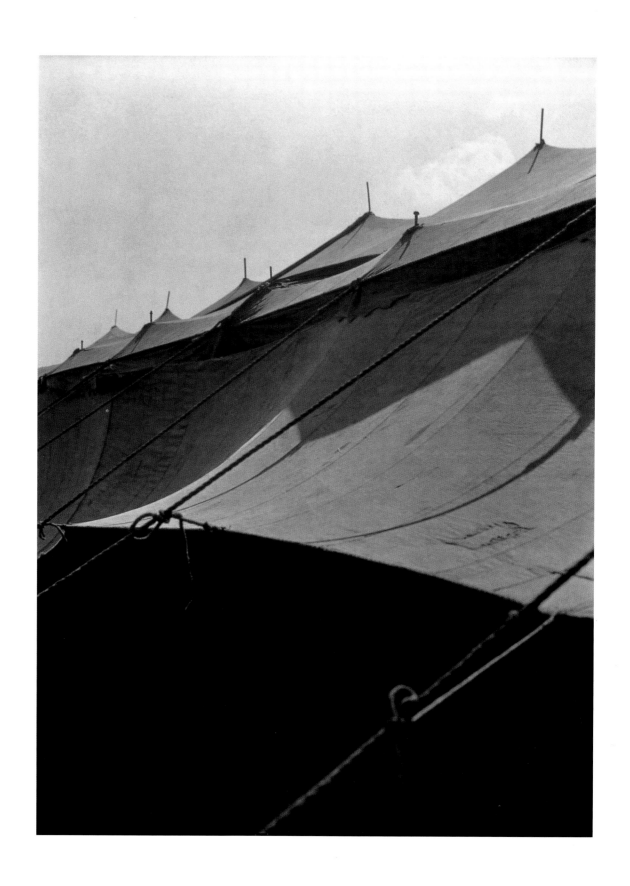

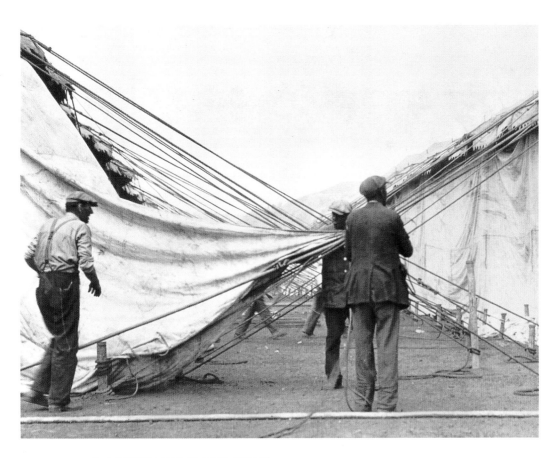

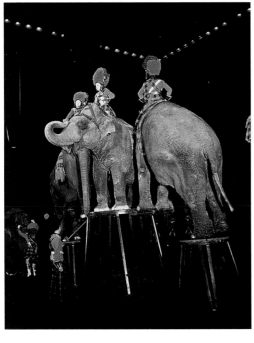

83
Luke Swank,
Circus: Tents, 1934.
Gelatin-silver print,
6 $^{1}/_{16}$ x 4 $^{5}/_{16}$ in.

84
Luke Swank,
*Circus: Workmen
with Tent*, ca. 1934.
Gelatin-silver print,
6 $^{1}/_{16}$ x 4 $^{11}/_{16}$ in.

85
Harold Edgerton,
*Elephants at
Circus*, 1940.
Dye transfer print,
12 $^{3}/_{4}$ x 10 in.
Harold & Esther
Edgerton
Foundation, 2000

form" comprising "an 'other' by which the bourgeois define their own identities."[8] Thus, the circus is imagined as a zone of difference whose very existence, by contrast, affirms the stability of the established order of society. Photographs celebrating or hinting at the grotesque by Bruce Davidson, Diane Arbus, and Mary Ellen Mark underscore this point vigorously, identifying such contrast as the essence of the circus.

The circus is a theater of contradictions, a place where a melange of performers' precisely calibrated routines dazzles viewers and creates an overall impression of exciting chaos, a place where both fear and pleasure are juxtaposed, a popular entertainment that has inspired numerous avant-garde artists, a site for visceral response to visual spectacle. The smells of the sawdust in the ring and the popcorn in the stands, the elusive taste of cotton candy purchased among the sideshows on the midway, the sounds of stirring marches played by the circus band and the growls of the big cats, the avidly imagined textures of glittering sequins, elephant hide, horses' manes, and the polished hard bar of the trapeze are all precise sensory cues, just as the death-defying feats and knee-slapping antics of the performers also elicit very specific somatic responses from onlookers. The circus demands bodily participation from its audience, affording each viewer an emotional workout through physical response to the vicarious experiences on display. Mary Ellen Mark recalled her time with the circuses of India in these terms: "I have such strong memories of the wonderful sounds, often Western popular music … interspersed with lion roars and bells announcing acts. I think about the pungent smell of tiger urine and the exotic perfume of burning incense tinged with jasmine floating from every tent."[9]

The circus's arresting dramas are enacted so rapidly that the adrenaline of anxiety, the endorphins of relief, and the throat catching of joyous aspiration that they stimulate follow each other in immediate succession. Such bodily participation in the spectacle, coupled with its ambitious multisensory stimulation, makes the audience's experience unusually intense, something like the effect Wagner's operas strove to provide: emotional saturation through a total artistic experience achieved through the synthesis of several art mediums. The visual is but the most immediate dimension of the circus experience, so photography necessarily takes unusual paths in its depiction of the circus and often represents circus personnel outside the performance arena. Such images typically preclude the inclusion of spectators within the frame. This has the effect of situating the viewer of the photograph as the only spectator, and divorcing such scenes from their full performance context.

The iconography of the circus in most literary accounts and circus promotional images codifies the variables of joy, excitement, diversion, energy, light, color, speed, and wonder. Circus posters typically present a delightfully implausible array of circus acts simultaneously in mid-performance. Circus poster artists skillfully deployed all the illusionism and artistic license that was unavailable to the photographer. The iconography of the circus, in American photography, often offers quite different pictures: either a static and abstracted realm, or one of cruelty, exhaustion, duplicity, stillness, alienation, and sheer alterity. The circus depicted in literature and graphic design tends to capture the experience of the audience in performance – particularly a juvenile audience – while the photographic record typically insists on going behind the scenes, as in the photographs of Arbus, Davidson, and Mark. For writer Djuna Barnes, the circus suggested instability, hollow gaiety, and unobtainable glamour, a "splendid and reeking falsification," while even for the enthusiastic Cummings, allusions to artillery fire and praise of the circus's raw danger underlie his paeans to its innocent pleasures, and Twain's circus is artfully presented as a spectacle endlessly repeating its gambits, some dependent upon the deception of a willing crowd.[10] In each case, exhaustion and chicanery, danger and violence are not very far away.

How is it that the subject of the circus turns out to offer so many different aspects to consider? What properties of the circus itself explain the disparate visions of its many visual interpreters? Itself a hybrid and episodic entertainment or spectacle evolved from a variety of ancient forms, the circus exhibits close kinship to a wide range of modern forms, including vaudeville, zoos, carnivals, fairs, stripteases, tent-revival meetings, and even the educational programs of the Chatauqua circuit. If excitement is the purest response sought by the circus from its spectators, it is not unmixed with awe, edification, desire, laughter, fear, fascination with what is alien, and other powerful reactions. The subject of the circus in art may include the performers and the performances, the preliminary parade and advance marketing of the show, the animals and their acts, the behind-the-scenes personnel, and the performance space, while painters and writers consistently favor the spectacle of performance itself.

The circus is a compendium of beauty, danger, virtuosity, and the grotesque, which combine to create a unique mixture of motion, spectacle, exoticism, and a dazzling simultaneity. The beauty of the circus is often either shabby or excessively flashy, but its glitter creates an indelible impression. It is most often shown in details: the rose-leafy dresses of the equestriennes admired by Huck Finn, tightrope walkers' arms outstretched in arabesques, or flashes of sequins on an elephant's headdress. The depiction of the circus's beauty typically excludes the perception of danger from what are actually quite perilous practices. Yet danger is one of the most potent aspects of the circus, the one that engages the attention of adults (those old enough to have confronted the inevitability of mortality) with particular force. The grotesque is an equally significant aspect: the presentation of "freaks," the cruel antics of the clowns, and the occasional subjection of animals to comic indignities (dancing bears, for example) are all elements of the grotesque face of the circus. Beauty is confronted starkly with its inverse, and virtuosity is the glue that binds the whole together, controlled by the omnipotent ringmaster.

The circus distinguishes itself from nearly all other types of performance through the remarkable simultaneity of its diverse occurrences, and through almost unceasing motion. Cummings went so far as to identify movement as "the stuff out of which this dream is made," arguing that "one may say that the movement is the content, the subject-matter of the circus-show, while bigness is its form; provided that we realize that here (as in all the 'works of art') content and form are aspects of a homogenous whole."[11] Circus movement has particular idiosyncratic attributes. The constant flow of often circular patterns determines much of the performance's rhythm. Twain's account of the equestrian act that fascinated Huck also captures this quality well. Cummings's and Twain's descriptions, like the circus's self-representations in its advertising posters, capture the joy of the circus as a series of fleeting impressions, a succession of marvels that appear and disappear with a rapidity that enhances their glamour. Yet few of the photographs of the circus in this exhibition capture or evoke motion to any perceptible degree, which seems odd, since photography possesses an eloquent repertoire of devices for the suggestion of the motion it arrests.

Even Harold Edgerton, doyen of motion analysis in photography, made curiously static-looking photographs at the circus. His *Elephants at Circus* (fig. 85) scarcely resembles his signature images of objects in motion, including a bullet piercing an apple, a football player's foot connecting with the pigskin, and a baton twirler's intricate gyrations — all characterized by an almost childlike desire to stop the fleeting, pleasurable spectacle. It is actually Edgerton's motion studies of these other subjects that most resemble circus performances: using a strobe light, he captured dazzling displays of split-second motion that the unaided eye would have missed. In these photographs, each gesture multiplies itself as if in a funhouse mirror. Motions that if stopped by a single photographic exposure might paradoxically appear leisurely are here faithfully described through the broken syntax of the image as fully dynamic. They thus evoke the circus's characteristic motion, simultaneity, and sometimes danger. As a photographer, Edgerton failed at depicting the motion of the circus, but excelled at depicting the ways in which motion itself can suggest the very flavor of the circus.

The circus's perpetual motion is closely linked to its allied properties of simultaneity and its enormity. Cummings is the most acute observer of these qualities; he remarkably links them in a description mingling elephants and skyscrapers in a vivid suggestion of the circus as an exotic city in itself:

the bigness of the circus show is intrinsic — like the bigness of an elephant or of a skyscraper — not superficial, as in the case of an enlarged snapshot. The nature of this bigness becomes apparent when we perceive that it is never, for so much as the fraction of an instant, motionless. Anyone who has stood just across the street

continued on p. 96

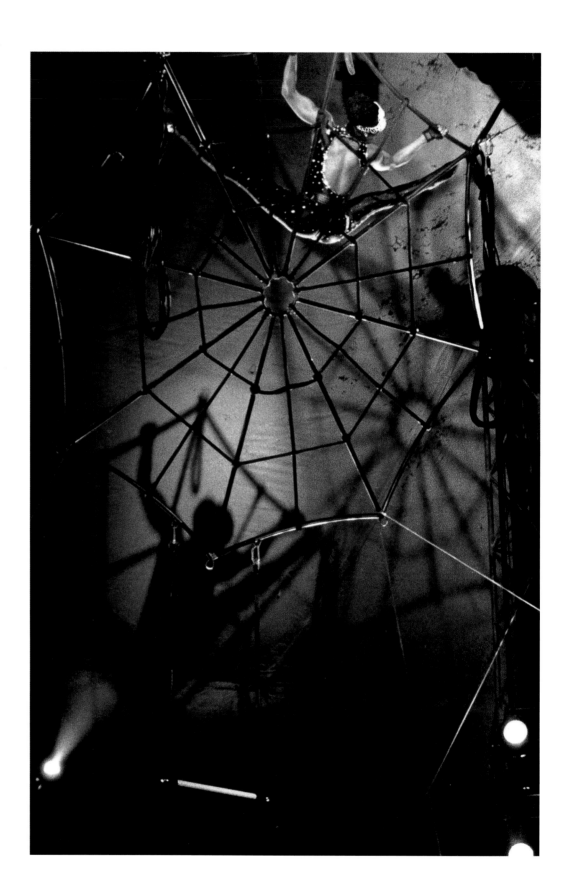

86
Kimberly Gremillion,
Shadow #25, 1997.
Gelatin-silver print,
12 x 18 in.

87
Kimberly Gremillion,
Horse #13, 1997.
Gelatin-silver print,
12 x 18 in.

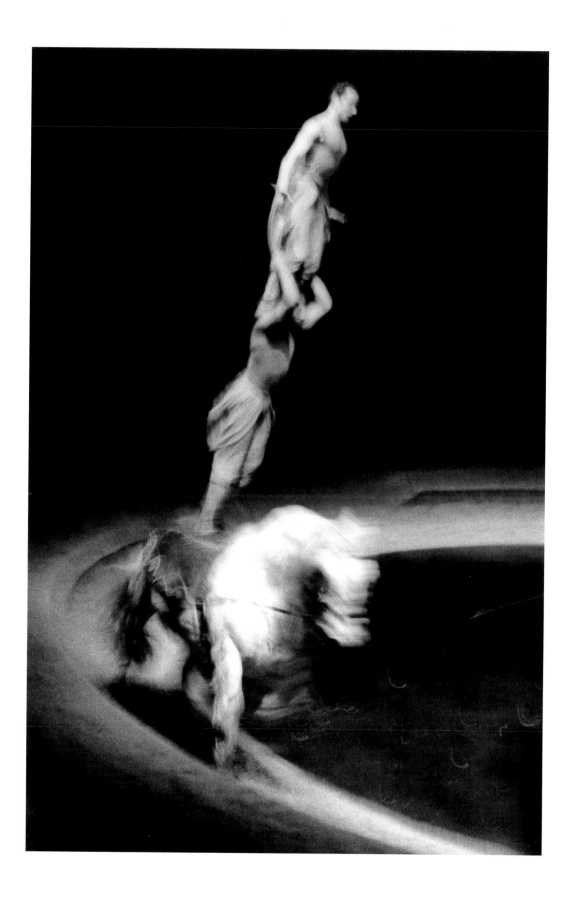

*from the Woolworth Building and has watched it wiggle upward
like a skyrocket, or who has observed the irrevocably, gradually
moving structure of an elephant which is "standing still" – anyone
who has beheld these miracles, will understand me when I say
that the bigness of the circus-show is a kind of nobility."*[12]

The sheer scale of the circus elephants substantially affected
many observers. Barnes wrote fancifully of their enormity: "An ele-
phant, like an uninhabited mansion, is majestic. It is the religion of
the acre. It has the unproductiveness and the austere presence of
a sand dune. It is implacable and enormous."[13] These tributes to
elephantine vastness express a perception not easily conveyed in
photography; however, Richard Avedon's widely reproduced fashion
photograph *Dovima and the Elephants, Cirque d'Hiver, Paris* (1955)
enshrines the sense of elephants as incommensurably large. The
model Dovima, clad in a sleekly superb gown, throws back her head
while posing with two elephants whose scale is of an entirely differ-
ent order of magnitude than her own.

The potential motion suggested by a stationary elephant or a
skyscraper is a paradox. Barnes's characterization of the elephant
as magnificent in its unproductiveness hints at the contradictions,
richness, and overwhelming nature of the circus as spectacle: vast
and useless but fascinating phenomena compel attention. As
Cummings put it:

*[the spectator] feels that there is a little too much going on at
any given moment. Here and now, I desire to point out that this is
as it should be. To the objection that the three ring circus "creates
such a confused impression," I beg to reply: "Speaking of confused
impressions – how about the downrush of a first rate roller
coaster… not to mention the solemn visit of a seventy-five centime-
tre projectile and the frivolous propinquity of shrapnel?"*[14]

The nonstop change, variety, and motion of a three-ring circus,
as well as its dangers and glamour, are also attributes of the
modern metropolis. The circus is a portable tent city, a microcosm
of the metropolis, a drama of urban complexity that plays in small
towns across the country, bringing big-city thrills to quintessential
small-town America. A comparison between the circus and the
Woolworth Building is less unlikely when the circus is understood
in these terms. De Mille's *The Greatest Show on Earth* pictured
the circus as part machine and part traveling city, emphasizing
its identity as an autonomous migratory society, and including
repeated shots of the enormous powerful trucks and other heavy
equipment engaged in breaking down and setting up the big top
and moving the vast circus caravan along its way. Poet Robert Lax
celebrated the circus's every aspect in a book-length homage
roughly contemporaneous with De Mille's film: "This is our camp,
our moving city; each day we set the show up: jugglers calm amid
currents, riding the world, joggled but slightly as in a howdah, on

the grey wrinkled earth we ride as on elephant's head."[15] For many of the New York street photographers of the 1940s through the 1960s (such as Lisette Model, Weegee, Davidson, and Arbus), the circus revealed itself to the camera in the same strange and poignant figures and irreconcilable fragments as did the city.

The traveling city of the circus was a startling phenomenon in rural areas and small towns. Its parade through town before performances simulated the street traffic of a great city, and the acts under the big top had all the strangeness, drama, motion, and danger of urban life. Staged for provincial farmers and towns-folk, the circus was a spectacle entirely dependent upon those audiences. Visible in photographs or not, the circus audience was an essential constituent element, as Cummings insisted:

Having cast rapid glances at the menagerie and the freaks, we enter "the big top" – where dwells the really-truly circus-show. This may be described as a gigantic spectacle, which is surrounded by an audience *as were the tragedies of Aeschylus and the come-dies of Aristophanes – in contrast to our modern theatres, where an audience and a spectacle merely confront one another.*[16]

Once the audience has been so distinguished, it is hard not to consider the circus performers as the audience of the audience – a striking inversion of roles and of authority, which Barnes noted in verse and then dismissed:

A circus, if of pleasant kind,
Doth give the animals a chance
To note the foolishness of pants,
And so it brings content of mind.
And so, having established the fact that there is something
to be said for both sides of the bars, let us pass on.[17]

Many critics have mourned the decrease in live-performance spectacles such as the circus, in which the audience is central, and the ascendance of new, mass-media forms such as the cinema, where public viewing precludes audience participation. Laura Winkiel, for example, writes of "what was lost when public culture underwent its transformation from the rowdy, participatory crowds that attended popular cultural events to the modern audi-ence of the spectacle."[18] Winkiel idealizes the circus audience as a "collective, interactive public that was ethnically diverse, class-specific, socially unruly, sexually mixed, and mutually desiring" and argues that it was "uneven, local, and contested."[19] Yet for many viewers, circus-spectacle and film-spectacle functioned similarly; in photographic images of the circus, its spectators appear in much the same position as moviegoers, often stunned to inaction by overstimulation.

The traditional American traveling circus, widely understood by circus historians to have entered a period of decline immediately after World War II, was forced to adopt more streamlined, corpo-rate, media-savvy tactics to survive. (The abandonment of free circus parades before performances is often cited as one instance of the end of the golden age of the circus.)[20] *The Greatest Show on Earth* presents the stiff economic challenges faced by a passion-ate ringmaster answerable to an unsympathetic management. De Mille's film unfolds as a series of attempts to vindicate the cir-cus by re-establishing its economic success, a premise that implicitly suggests distance from the vanished golden age of the circus. Yet Chaplin's film *The Circus*, set in what should be precisely that golden age, also displays tensions and enervation in circus life. Constantly under the threat of failure, the circus was closely linked with nostalgia in many viewers' perceptions, its flowering always just slightly out of reach in the past.

It is often at just such points that nostalgia turns into critical engagement. Gilbert Seldes's adoption of the cause of the circus, which he included among what he called the "lively arts," created a critical furor in 1924.[21] His then radical embrace of vaudeville, comic strips, jazz, the circus, and other popular arts was a curious mixture of support for the new forms coming to dominate American mass culture, and for disappearing remnants of forms of popular culture soon to become extinct. The process by which avant-garde art practice is reinvigorated with subjects and techniques appro-priated from the realm of mass culture is a fundamental pillar of modernism's history, but one that can operate in diverse ways.[22] Cummings's embrace of the circus was a marriage of the avant garde and popular pleasure, whiles Seldes's enthusiasm was that of an intelligent spokesman for middlebrow culture who rediscov-ered popular forms of entertainment. Twain's loving evocation of the circus is not unlike that of a folklorist, while Barnes's apprecia-tion is that of a refined decadent simultaneously attracted and repelled by the circus.

The attitudes of photographers weave thickly through this tap-estry of modernist and populist threads. Photography differenti-ates itself most from film in two regards: the stillness of its images that stop time, and the singularity of its audience. Even in a mass-circulation magazine, a photograph is typically viewed by one per-son at a time. Film's ability to convey the circus's dazzling motion would appear to make it the ideal medium for the subject of the cir-cus, and the audience for a film may be similar in scale to a circus audience. It might seem that still photographs of the circus would continually aspire to the condition of films, but in fact they are notable for not accomplishing anything of the kind. They are instead typically static, isolating single figures or elements, and represent-ing still or solitary moments; the raucous moving spectacle is lim-ited to a single frame, and often one not taken during the performance.

Among the earliest of American circus photographs are celebrity portraits made by commercial photography studios in
continued on p. 100

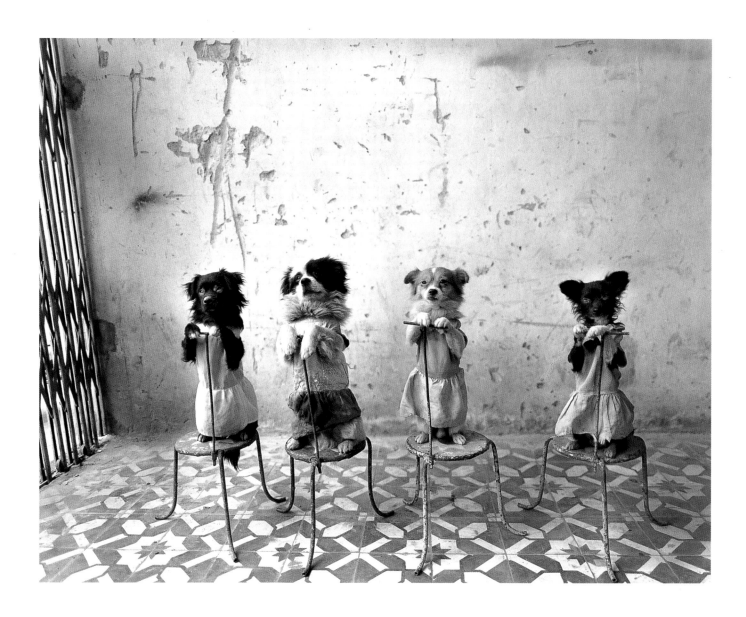

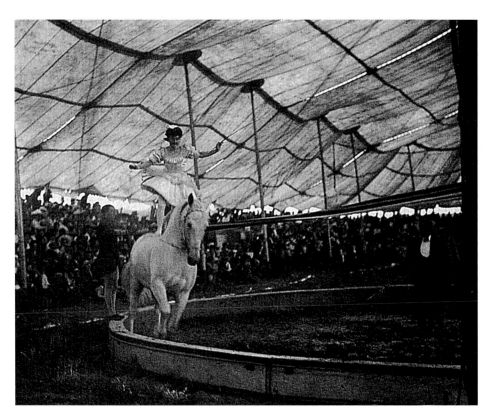

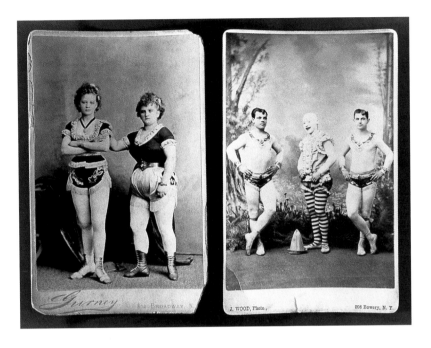

91
**Gurney Studio
and J. Wood Studio,
New York**
Circus Performers,
ca. 1880.
Albumen silver
prints from glass
negatives,
6 ½ x 4 ¼ in. each.
Private collection

large cities from the 1860s to the 1890s. These follow the conventions of theatrical portraits in which renowned performers are posed before the same backdrops used for ordinary portraits, but always in costume or with attributes suggestive of their roles (fig. 91). At a time when legs (masculine or feminine) were seldom on public display, the visibility of these stout limbs faithfully outlined by tightly clinging cloth was redolent of the circus ring. During this period of history, when making photographs involved cumbersome photographic equipment, long exposure times, and labor-intensive developing in on-the-spot darkrooms, the circus had to come to the photographer rather than vice versa. These portraits served as simple identification of individual performers (somewhat like baseball cards) and as promotional materials: the beginning of celebrity-driven media culture and advertising as we know it.

When looking at early studio portraits of circus performers, the viewer was required to imaginatively recreate the subjects' performances, which could not be shown because long exposure times prevented the depicting of action. But by the turn of the century, photographers with smaller cameras and faster film were better able to capture motion in their pictures. Harry Rubincam's *In the Circus* (fig. 89) depicts an equestrienne at work in a tent illuminated by gentle daylight, photographed from the vantage point of a child in the front row looking up, at an admiring angle. The bareback rider is engrossed in her work and doesn't acknowledge the camera. The accomplishment of capturing an image during performance, let alone one so graceful, was a considerable one during this period of long exposures and unsteady cameras.

The Pictorialist circle to which Rubincam belonged took its cues in all things from the photographer and impresario Alfred Stieglitz, in whose celebrated magazine *Camera Work* this image appeared in 1907.[23] Stieglitz was a convivial man who was conversant with the urban pleasures and diversions available at the turn of this century; however, the form of popular entertainment he favored most was the race track rather than the circus. Stieglitz's lack of spontaneity and appreciation for such follies as the circus is indicative of the high seriousness with which he — and the leading members of the following generation of American art photographers — viewed the world. In Rubincam's rendering, the circus is calm, static, balanced, benign — an almost classical image of a decidedly baroque subject.

Rubincam's photograph of the circus points the way to those of two later photographers, Edward Weston and Tina Modotti. Not entirely willing heirs to the Pictorialist style of which Rubincam's image is so typical an example, Weston and Modotti made circus photographs in 1924. Weston's *Circus Tent* (fig. 90) aptly demonstrates his frequent use of close framing as a tool for creating abstraction. The image depicts only a section of the canvas tent, without performers, spectators, or animals. Rendered as a flat surface rather than as an inhabitable volume, the image explores the translucence of the canvas as a vehicle for abstract form rather than engaging with the whole notion of the circus as an entertainment.

On March 2, 1924, Weston reported an excursion in his diary:

"Club" night last night. Some thirty of us went en masse to a circus ... The circus as always was poignantly sad with little children swirling through space, with sorry clowns, and contorting gymnasts, with all its depressing glitter. Home to dance and tea, but I left the party and went to bed, slightly weary, and rather sad.[24]

The following day, he returned in order to recast the grim experience as art:

A recent morning I took my Graflex to the circus, made negatives which please me of the graceful folds, the poles and ropes of the tent. One, "shooting" straight up, recalls a giant butterfly. At least two of them are interesting as experiments in abstract design. Tina too made several good things of the circus.[25]

In these passages, Weston reveals a complex set of ideas about his photographic practice and personal experience at the circus. Drawn there by a light-hearted group of cultural sophisticates in search of simple pleasure, he finds the spectacle "depressing." Returning alone by daylight, he photographs the interior of a circus tent, as if it were empty (thus leaving out those aspects of the circus that saddened him) and presents it as a graceful butterfly, an

"experiment in abstract design." A few days later, he writes that he has rendered the circus in a "satisfactory" manner.[26] His transformation of the circus into a stylized abstraction may be seen either as a triumph in the subjection of reality to pure form, or as an aloof response to human experience. While Marsden Hartley wanted to merge himself with the "fine pattern" of circus acrobats' performance, Weston wanted to eliminate such distractions from the fine pattern he discerned or created in the circus tent itself. For the other members of the circle in which Weston moved, folk culture, identification with the proletariat, and enjoyment of group endeavors ensured an enthusiasm for the circus that he found it difficult to share until he had visually transformed it. This emphasis on radical subjectivism is characteristic of classical American modernism in photography. Weston's photograph is magisterial and handsome, if a trifle anemic: the tent suggests a Greek ruin more than a noisy, bustling performance venue. Something of a puritan in outlook, Weston was not very comfortable with mass culture. For him, nature and universal themes were fitter subjects for high art — and his art was very high indeed.

For Weston, engagement with popular culture was only possible when he was fully in control; indeed, control is the leitmotif of his aesthetic theory as a whole. The circus as a site of licensed loss of control (or of the control of the audience by the performers) did not appeal to him as readily as did the simple forms of the tent that served as its container. Modotti's photographs often resemble Weston's in compositional strategy but typically differ from his in the quality of the emotional response to their subjects. Where Weston habitually framed his images with a cool and detached scrutiny, Modotti typically selected hers with unqualified enthusiasm. Her involvement in the folk culture of Mexico was extensive, and she became increasingly engaged with leftist politics there. Her identification with Mexico, Mexicans, workers, peasants, and their pleasures was direct and immediate.

In *Untitled* (circus tent and spectators, Mexico) (fig. 92) Modotti presents an interior view of what is clearly the same tent that Weston photographed in *Circus Tent*. Her elegant rhythms of tent seams and segments show her absorption of Weston's compositional dictates, but her image remarkably sets itself apart from his by the judicious inclusion of members of the audience as a frieze of figures in the left foreground. Modotti's presentation of the visibly working-class audience members is as typical of her preoccupations as Weston's exclusion of them is of his. Her calm composition embraces some of the vitality of circus performers by suggesting the unfolding action through the inclusion of spectators who serve as our surrogates at the spectacle that remains out of sight to us.

Rubincam, Weston, and Modotti chose to portray aspects of the circus performance or its arena. But many other photographers have chosen to depict instead the personnel of the circus, typically behind the scenes or between performances. Both August Sander and Bill Brandt (European photographers whose work thus falls

outside the scope of this exhibition) made remarkably intimate photographs of this type. Their work was based on typological structures of inquiry that are characteristically European, just as the development of a formalist idiom of abstract imagery was typically American. Both Sander and Brandt were engaged in producing visual ethnographies of their own people. Sander's *Circus People, Düren* (fig. 93) is part of his larger study of German society organized according to social class and profession. In the strictly defined and largely hierarchical system Sander created, we find most poignant those who are excluded from the vast determining schema of society, like the unemployed man, while Sander himself was evidently drawn to those (like circus folk) who stood on the margins of the system. Migratory, exotic, skilled, and bohemian, the circus performers are here portrayed as fixed and almost bourgeois, seated outside the tent at a small table set for tea. Whereas most of Sander's subjects are depicted in their workplaces as if pausing in their daily routines to pose, these tidily respectable circus burghers are exotics who have been comfortably domesticated and are shown at leisure.

Brandt's *Circus Boy* (fig. 94) depicts an engaging urchin with a mop of fair curls who is seated on a precariously tilted crate and drinking a cup of tea. The use of tiny details in the minimal setting beside a discolored tent, which reads as a neutral backdrop almost like that of a portrait studio, is extremely effective. The child's deliberate grasp on a humorously oversize cup suggests the length of the pose and also Brandt's typical collusion with the reality he documented by directing, structuring, or remaking it without hesitation. As in Sander's photograph, we see circus folk at leisure behind the scenes rather than engaged in the spectacle or illusion of the ring. These pictures employ the allure of the everyday; the English circus boy and his adult counterparts in Germany make a charming parody of the fixed order of ordinary life. André Kertész's *The Circus, Budapest* (fig. 95) shares this affectionate mood, but its subject differs from Sander's and Brandt's for it depicts busily engaged members of the audience rather than performers at leisure: two country folk with their backs to the camera engrossed in watching the circus through what must be a very small peephole in the wall. The very lines of their bodies suggest rapt, unwavering attention to a scene invisible to us. The naïve onlookers, too poor to afford tickets, become the subject of our regard; we are their audience.

The work of Kertész, Brandt, and Sander occupies a fertile middle ground between fine art and reportage. So too does much of the work that American Walker Evans did in the 1930s and 1940s, which included several circus photographs. Evans, like Weston and Steiglitz, was not attracted to the pleasures of the circus. Instead, he focuses primarily on ephemeral traces of its passing, in the tattered remains of circus posters plastered on brick walls and the sides of barns, which first anticipated and then commemorated the brief passage of the spectacle of the circus through workaday rural America. Such posters commemorated a provincial longing for glamour and excitement, which appear only as distant memories by the time Evans recorded these images, using the syntax of advertising to represent a vanishing past. In these photographs, such as *Circus Signboard* (1930), *Minstrel Showbill* (1936; shot in Alabama while Evans was employed as a documentary photographer in 1935–37 for the Farm Services Administration), and *Torn Ringling Brothers Poster* (fig. 96), Evans rendered the circus not simply as an abstraction, as Weston did through elegant perspectival ambiguity, but as an abstraction of an abstraction. The pleasures of the circus are remote in these depictions of mass-produced posters attesting to long-gone performances before long-gone crowds. Whereas Weston reduced the circus to its tented space, Evans made of it a mere portion of a sign: the remnants of a poster serving as a portent.

While Evans's photograph flattens and abstracts the idea of the circus in a manner typical of much of his work, Lisette Model's 1945 circus photographs are unusual in her oeuvre in that they describe the magic of circus performance without locating tensions or ironies in the experience. Most of these images (figs. 98–101) depict the immense arena in which the performance occurs. Across wide shadowy spaces, shafts of dramatic light pick out the acrobat, making viewers feel as if they were attending the spectacle – from the cheap seats. Model's work is often seen as a forerunner of that of her famous pupil Diane Arbus, who shared with her teacher a fascination with the unconventionality of both street people and professional performers in carnivals and elsewhere. Both women display powerful curiosity and compassion, but Model's images use darkness expressionistically, positing it as a resonant corollary of light, while Arbus's strive for open neutrality. While Arbus's images are highly static, Model's are often rapidly formed and evocative of motion. Her circus photographs seek to capture the sparkling evanescence of the trapeze artists' complex movements in space defined by light. Model's images identify the performance in the spotlight as the center of attention, but the details of that performance are difficult to see, since she cannot employ the tactics of the illustrator. Like the telephoto effect of memory, her circus photographs show that much is happening in the dark distance, while isolating fragments of events from their larger contexts.

The self-effacing Model's contemporary and fellow aficionado of the odd underside of New York life was Weegee (Arthur Fellig), a tabloid news photographer and larger-than-life personality. Known for his graphic depictions of crime, violence, accident, and tragedy of all dimensions, with a specialization in murders, fires, accidents, and strippers, Weegee often portrayed the city as a circus of depravity. Yet in his many photographs of the circus, his point of view is strangely innocent and unquestioning. Weegee, who all too often saw the darker side of everyday life, found childlike release in the circus. Referring to his depiction of one of his favorite circus subjects, the "human cannonball," he described it as simply "a pretty picture of a girl being fired out of a cannon."[27] There

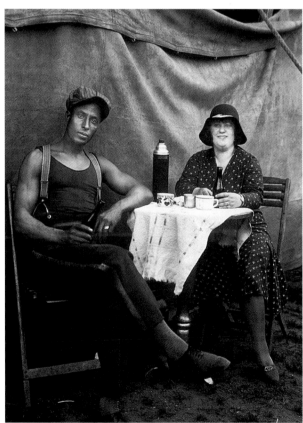

92
Tina Modotti,
*Untitled (circus tent
and spectators,
Mexico)*, 1924.
Platinum print,
9 1/4 x 7 in.
Center for
Creative
Photography,
The University of
Arizona, Tucson
(85.082.001)

93
August Sander,
*Circus People,
Düren*, 1930.
Gelatin-silver print,
11 x 8 1/3 in.
Die Photographische
Sammlung/SK
Stiftung Kultur-
August Sander
Archive, Cologne/
ARS, NY

94
Bill Brandt,
Circus Boy, 1933.
Gelatin-silver print,
7 3/4 x 9 1/2 in
Bill Brandt
Archive, Ltd.,
London

is no irony in Weegee's "pretty picture," but rather heavy-handed sincerity.

Weegee was quick to see through pretension, unflinching in the face of tragedy and violence, and superbly confident in the face of the city's myriad bizarre occurrences. Yet he was also incorrigibly romantic, sentimental, and warmly affirmative. While much of his work is dependent upon his refusal to be a naïve member of the audience at the city's spectacles, the circus was for him a privileged zone of freedom from cynical skepticism. He was, at times, surprisingly innocent for a tough guy — shrewd but innocent: a very American combination, rather like an urban Jewish Huck Finn.

Twain's Huck describes one of the circus's most frequently repeated routines with breathless excitement, unaware that he is watching a tightly scripted and choreographed performance when one of the equestrian performers first pretends to be a drunk townsman begging to ride the fierce horses, then reveals himself as a superbly skilled expert, to the delight of the crowd and the feigned shock of the ringmaster. The bravura passage of description concludes with these musings:

Then the ring-master he see how he had been fooled, and he was the sickest ring-master you ever see, I reckon. Why, it was one of his own men! He had got up that joke all out of his own head, and never let on to nobody. Well, I felt sheepish enough, to be took in so, but I wouldn't a been in that ring-master's place, not for a thousand dollars.[28]

Weegee, like Huck, was happy to believe in the world of the circus on its own terms. The circus, after all, is where the viewer wants to be taken in, where much depends on his or her suspension of disbelief and the distraction of attention by fast, unexpected spectacles.

Arbus, like Weegee, was passionately curious about the alien worlds she explored in her photographs. Her identification with her subject matter veers from the desire to be taken into the world depicted to a recognition of the cruder desire to ogle its exotic subjects. Arbus's work elicits an immediate emotional reaction from viewers, since it situates them as voyeurs observing often taboo spectacles. The people whom Arbus portrayed are all seen with a cool fascination that does not discriminate between those whose difference was established at birth and those who have embraced it as a choice. In Arbus's world, the "normal" and the "deviant" all inhabit a level playing field, and all reveal depths of strangeness. Arbus's circus photographs are intimate scenes without audiences; she took these photographs only in private contact with the performers, not during the public spectacle of performance. The girl in Arbus's poignantly awkward *Girl in Her Circus Costume, Maryland* (fig. 104) poses as if she were an imposter, an ordinary person pretending to be a circus performer, while the *Albino Sword Swallower at a Carnival, Maryland* (fig. 105) appears ecstatic, liter-

ally transfixed, as she offers a private performance for Arbus and her camera.

Arbus's photographs are almost exclusively of people; she made only a handful that are unpopulated. But her sensibility is strikingly akin to that of Djuna Barnes, who captured the exotic, slightly tawdry quality of the empty backstage portions of the circus when she described a conducted tour of the Hippodrome. Barnes characterized the empty space as a "supreme abyss of adventure" and was struck by the stacks of discarded costumes and the absence of its performers:

I might have groped among the dust of tarnished memories girt with rows on rows of silent, immovable, resting garments that had long ceased to glorify color upon legs with but little reverence for the laws we know. Helmets lying drunkenly upon armored shoulders, birds' heads whereon not one moth-eaten feather rustled, fripperies and golden bands for heads that rest somewhere in a darker alley, perhaps, upon the sheeting of a skylit room six flights up in Mrs. O'Grady's boardinghouse.[29]

Arbus was an admirer of Tod Browning's notorious 1932 film *Freaks*, which was revived during the 1960s and became an underground classic, attracting widespread critical attention for its use of actual circus sideshow freaks as performers in a shocking tale of violence and retribution.[30]

Browning's film forced into prominence the dark current running through the romance of the circus, which becomes a theater of cruelty. The "drunken" performer in Twain's account of the circus, Cummings's likening of the circus's overstimulation of audiences to the trenches of World War I, and Barnes's use of the circus milieu to suggest instability and deception in her fictional characters are all mild adumbrations of Browning's revelation of the evil, duplicity, and menace in the circus. Many of the photographers of the circus are Browning's heirs, members of a different family than the painters and writers who idealized the circus. Browning, like many of these photographers, revealed an attraction to the violence and darkness of circus spectacles, and in particular of their licensing of an audience's scrutiny of deviance. Freak shows, circus clowns, and carnival sideshow performers all represent a principle of attraction-repulsion based on viewers' visual encounter with difference. The logic of such encounters parallels that of many photographic transactions; photographs emphasize the aspect of voyeurism in that they presume audiences, and the photographer is already in the position of audience as an image is captured.

Bruce Davidson, a photographer whose work has always effortlessly bridged the sometimes wide divide between magazine journalism and fine-art expression, was a friend of Arbus's whose sensibility differed greatly from hers despite certain shared subjects. In their explorations of private, personal realms, Davidson and Arbus are at opposite ends of a continuum: he is essentially

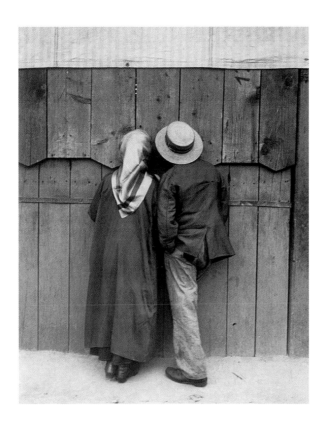

a humanist, just as she was essentially a voyeur. Unlike Arbus, who normally made single portraits of individual figures, Davidson worked in the journalistic manner, creating extended pictorial narratives, in particular a photo-essay on the circus. His distinguished 1958 series of portraits of Jimmy the clown in a traveling circus (figs. 106 and 107) depicts the marginal life of a circus employee as if from the inside, from the stance of the journalist on the story rather than from Arbus's favored position as a fascinated outsider looking in. The muddy grounds in the distance, Jimmy's casual gesture as he smokes in full makeup between shows, and the entirely unromantic rendering of the subject all contribute to Davidson's enormously powerful demystification of the circus, a direct contradiction of all that Cummings, Hartley, and Twain cherished. Davidson's circus pictures are the quintessence of its dark microcosm. As Seldes pointed out, "Clowns are the most traditional of all entertainers," but Davidson has radically redefined our understanding of the life of a clown.[31]

The melancholy clown is among the traditional figures, but the tawdry and quotidian setting of Davidson's depiction of a clown established a tougher vision of the alienated performer. Clowns, the most joyous and effervescent of circus performers, are also the most sinister. Their double nature is at once functional and metaphorical. When a trapeze flyer accidentally falls, as dramatized in *The Greatest Show on Earth*, the ringmaster sends in the clowns so that the audience will laugh at their simulated humiliations and injuries rather than notice the real ones of the aerial performers. Cummings suggested more subtly that, in fact, the clowns' humor underscores our perceptions of danger: "At positively every performance Death Himself lurks, glides, struts, breathes, is. Let any agony be missing, a mob of clowns tumbles loudly in and out of that inconceivable sheer fabric of doom, whose beauty seems

continued on p. 112

95
André Kertész,
The Circus,
Budapest, 1920.
Gelatin-silver print,
8 x 10 in.
Estate of André
Kertész

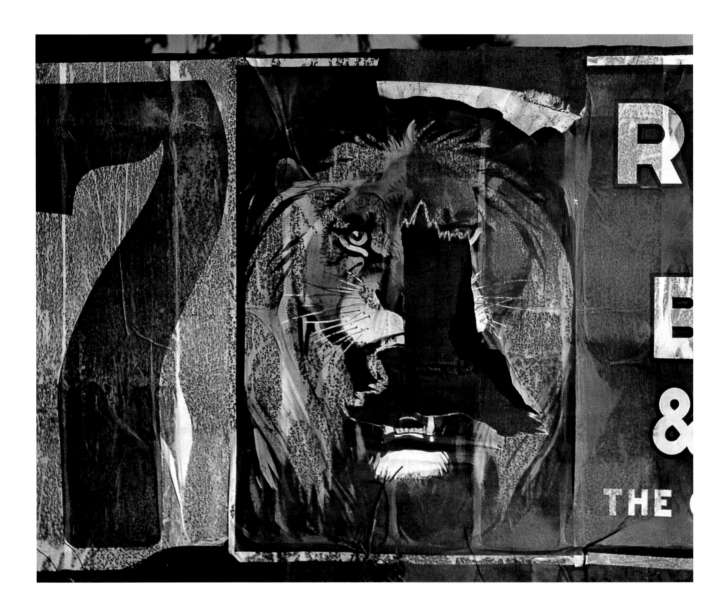

96
Walker Evans,
*Torn Ringling
Brothers Poster*,
1941.
Gelatin-silver print,
6 ½ x 8 ¹/₁₆ in.

97
Walker Evans,
*Circus Trainer
Leading Elephant,
Winter Quarters,
Sarasota*, 1941.
Gelatin-silver print,
6 ⁹/₁₆ x 7 ½ in.

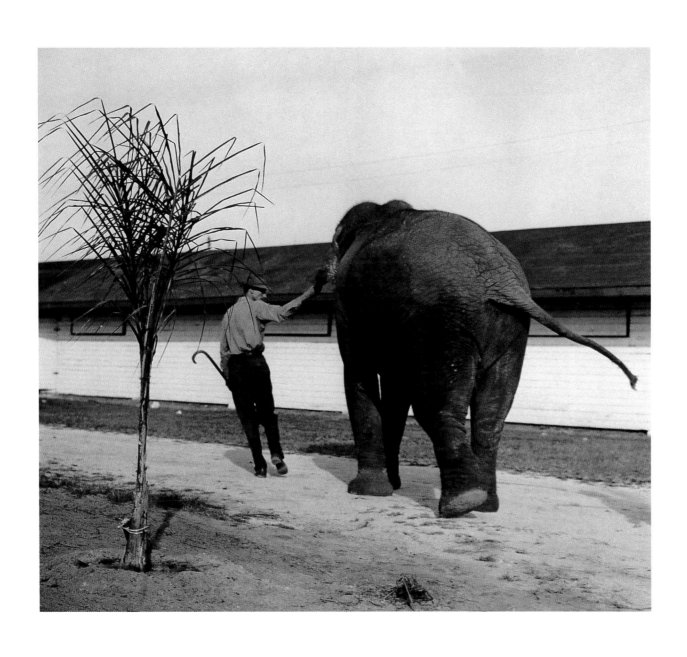

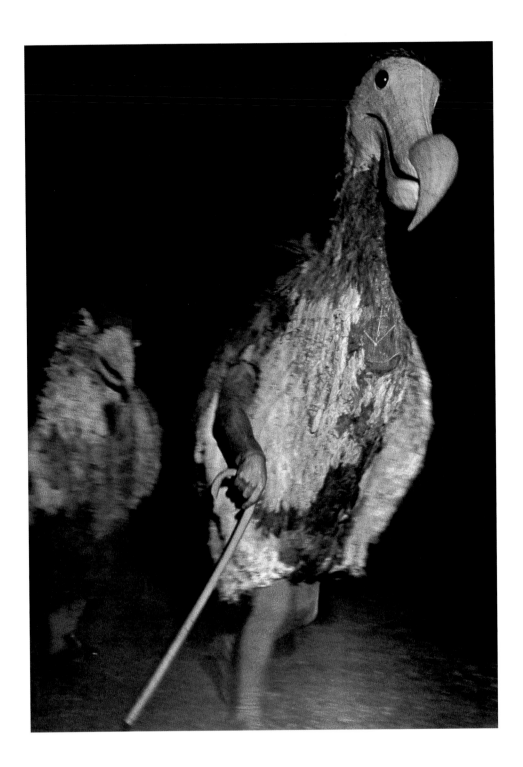

98
Lisette Model,
Circus, New York,
1945.
Gelatin-silver print,
24 x 18 in.

99
Lisette Model,
Circus, New York,
1945.
Gelatin-silver print,
24 x 20 in.

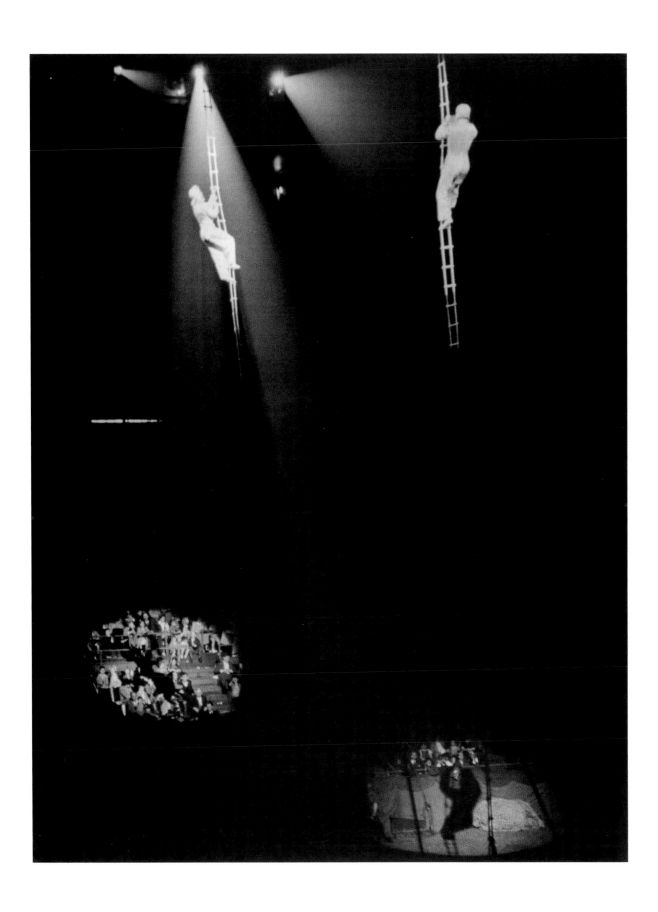

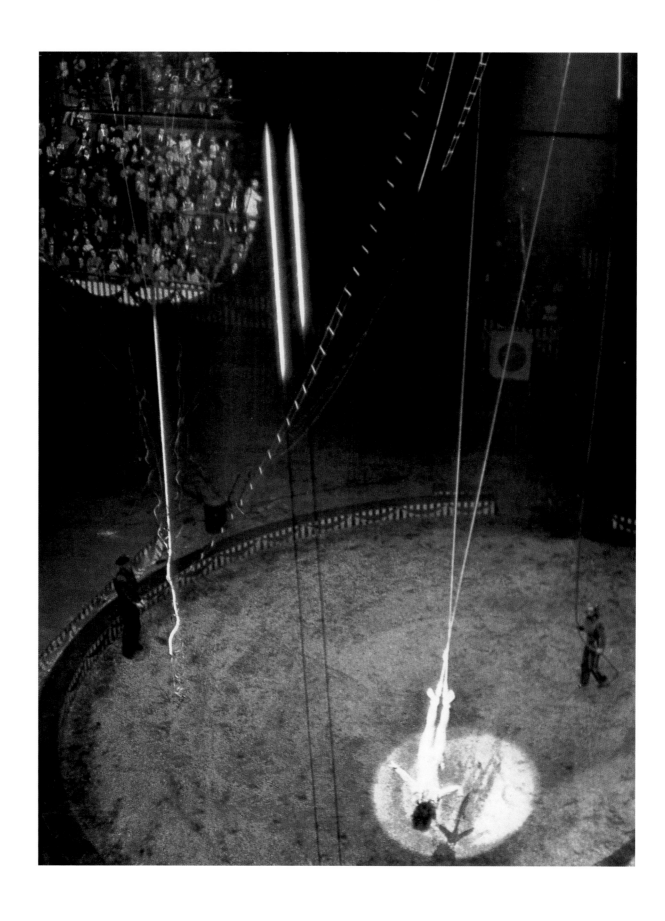

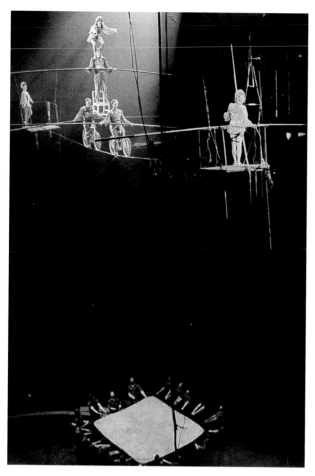

101
Lisette Model,
Circus, New York,
1945.
Gelatin-silver print,
24 x 20 in.

100
Lisette Model,
Circus, New York,
1945.
Gelatin-silver print,
24 x 20 in.

102
Weegee,
*Circus, New York
(Sleeping Man and
Giraffe)*, 1945.
Gelatin-silver print,
13 ½ x 10 ¼ in.

endangered by the spectators' least heart-beat or whisper."[32] Clowns are our surrogates in the company of virtuoso performers, and our laughter at their travails is a reassurance that it is only they, not us, who suffer. Bruce Nauman's video *Clown Torture (I'm Sorry and No, No, No)* (fig. 136, page 145) follows further in this vein, stripping away the last veneer of sentiment about the circus to reveal hideous rituals of sadism and desperation.

Like Davidson, Mary Ellen Mark is a photographer whose magazine work and personal documentary photography are both imbued with the same fine-art sensibility. Mark photographed the circus in India, where she had previously worked on an extended series of portraits of prostitutes. She described the circus as "full of ironies, often humorous and sometimes sad, beautiful, and ugly, loving and at times cruel, but always human."[33] Mark's circus photographs present her subjects backstage or behind the scenes during moments of practice or leisure, as do Arbus's and Davidson's. Thus, her subjects display themselves to a camera, not an audience, in what seem like private command performances. Many of the performers are young girls, as in *Contortionist with Sweety the Puppy, Raj Kamal Circus, Upleta, India* (fig. 108), a circus ingenue who twists her body into a striking arched shape, through which the circus tents are visible in the distance. Tucked between her heel and her head is Sweety, a slumbering ball of fur whose consoling presence counters the apparently painful twisting of her delicate body. This sustained project, which must be counted among Mark's most accomplished works, accentuates the otherness of the circus that Arbus, Davidson, and others sought and found much closer to home. Edwin Martin's photo-reportage of the American circus, such as *Center Pole Holes, Lake Isabella, California* (fig. 110) and *Setting the Flag, Rainelle, West Virginia* (fig. 111), provides quite a different point of view. His images function as documentary in its most direct

form, unlike Mark's portrait series. Martin evenhandedly chronicled the entire process of the circus's yearly cycle of activity, and recorded many key scenes that are less emotionally charged than the subjects preferred by Mark and others.[34]

Kimberley Gremillion's circus work unambiguously belongs to the world of fine art rather than of reportage. Gremillion addresses her subjects with all the verve of fashion photography that is nonetheless tempered by darkness. She turns the performers into shadowy subjective forms, flickering abstractions of self, very different from what we would see in glittering color when watching an actual circus. As she explains, "People are seduced by the vivid color and frenzied movement of a circus performance. Contrasting blurred images with crisp detail develops tension within the composition, while photographing in black and white reveals the drama."[35] Gremillion's work is a series of stylized abstractions of the circus, very different from Weston's in their dynamism and in the quality of tension and menace in each, which she describes as "dangerous, yet beautiful."[36]

Although beauty is far easier to capture than danger in photographs, Gremillion's *Tiger #1* (fig. 103) precisely expresses both these qualities. In renderings of the circus, danger is typically expressed in images of animal acts and suppressed in images of equally dangerous acts performed solely by people, such as trapeze work. The profoundly non-human wildness of the big cats and the audience's perception of lions and tigers as large-scale versions of familiar household pets are central to the significance of the acts performed. These disjunctions, combined with the unequal balance of power between animals and humans, afford a titillating possibility of danger and potential mutual cruelty. Carmeli suggests that the circus offers a simulacrum or performance of cruelty that becomes a representation of the "spectators' predicament of modernity," which allows them to "tie and confirm" their own sense of authenticity.[37]

Among contemporary artists belonging to a less purely photographic tradition are John O'Reilly and Rhona Bitner. O'Reilly's depiction of the circus (fig. 78, page 77) is surprisingly unironic for an artist whose other work has dealt with war and homosexuality as marginalized experiences that are made central in his art by creating collages of appropriated images. The circus as a refuge that does not entirely repress the threats of the outside world is, after all, an enduring motif of this century. Bitner's grouped installation of brilliantly hued images (fig. 109), like a flock of separate movie stills, identifies specific instances of performance and renders them in close-up. These many parts deployed simultaneously function as freeze-frame views of the circus's overwhelming simultaneity. As with Model's pictures, the entrancing spectacle appears somewhat remote and detached, but the viewer of the photograph is definitely in the position of a spectator at the performance.

The American circus's salient quality is its dizzying excess, its three rings in constant frenetic action, and it is correspondingly

photography's essential quality that it captures motion and stops time. To perform these interruptions upon the circus without rendering it meaningless requires that photographers portray a very different circus than those of Twain, Cummings, or Hartley. Rather than the dazzlingly inassimilable spectacle, they most often represent motionless details and isolated images, a circus of disillusionment and ennui. It is not the circus we would run away to join, but rather a circus from which we might well wish to escape. These photographers seem to have been presiding over the decline and fall of the traditional big-top circus in America, and to have announced and recorded its demise in appropriately somber tones.

If photography, then, offers an incomplete expression of the charm and complexity of the circus experience, where in the visual arts can we look for circus analogies? Critic Robert Bogdan has provocatively suggested that the traditional freak show has been replaced by the television talk show; we might similarly consider the ways in which new digital multimedia projects and installation art have become analogues of the classic circus performance.[38] In particular, artists such as Judy Pfaff, Jonathan Borofsky, Cady Noland, and Garry Hill, among many others, evoke the festive, multifarious qualities of the circus in their installation works. While the circus may no longer constitute a standard fantasy escape for average Americans, its properties as entertainment certainly live on in other forms.

Photography, the most temporally exacting of mediums, has pictured many aspects of circus life, if not often its essence as a whole. And it appears to have looked more at the underside of the circus than at its joyous façade. Somehow, the subject of the circus has paradoxically inspired an extensive body of photographic representations that contradict the public consensus about the circus's basic characteristics, portraying it as a dark existential place of alienation. Whereas Twain described "the splendidest sight that ever was" in terms of rapid movement, Rubincam, Weston, and Evans stripped it of its bright colors, hurdy-gurdy atmosphere, and lively motion; and unlike Cummings, who wanted to "damn everything but the circus," Davidson and others presented it as a mirror of society itself. The circus that crowds have loved for centuries may indeed have come to an end or been changed into new forms. But no mourning is appropriate; it is in the nature of the circus to fold its tents and move away. Poet Robert Lax, in his 1959 *Circus of the Sun*, tenderly described the inevitable denouement that follows a circus's grand finales:

Have you seen the circus steal away?
Leaving the field of wonders darkened,
Leaving the air, where the tent stood, empty,
Silence and darkness where sight and sound were,
Leaving early in morning?[39]

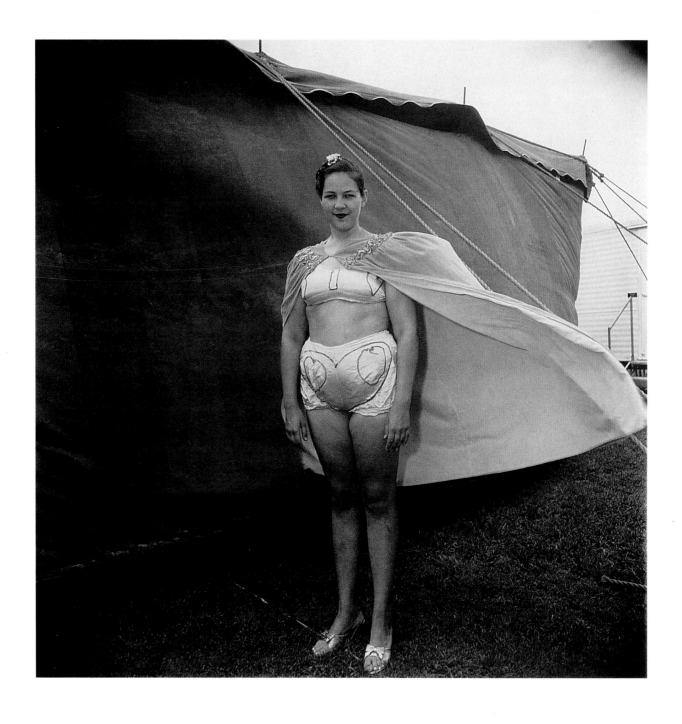

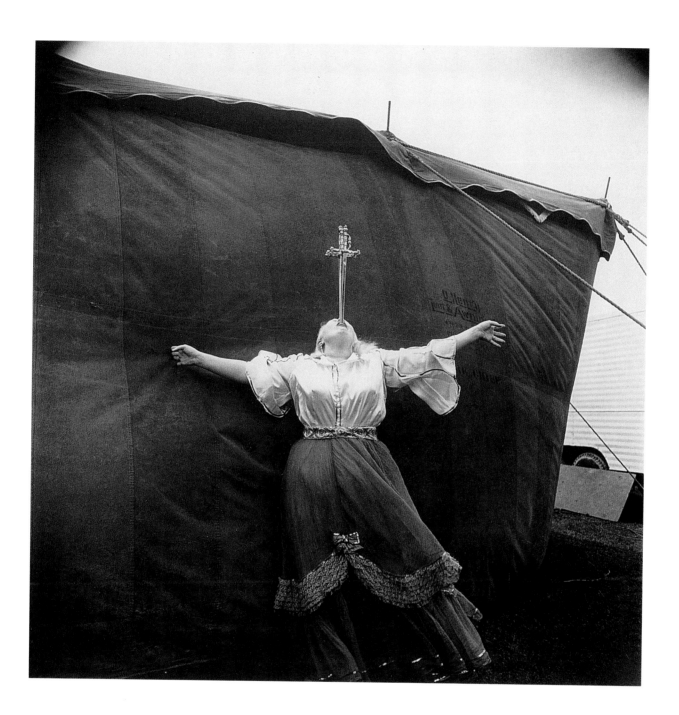

104
Diane Arbus,
*Girl in Her Circus
Costume,
Maryland 46/75,*
1970.
Gelatin-silver print,
14 ½ x 14 ½ in.

105
Diane Arbus,
*Albino Sword
Swallower at a
Carnival,
Maryland 10/75,*
1970.
Gelatin-silver print,
14 ½ x 14 ½ in.

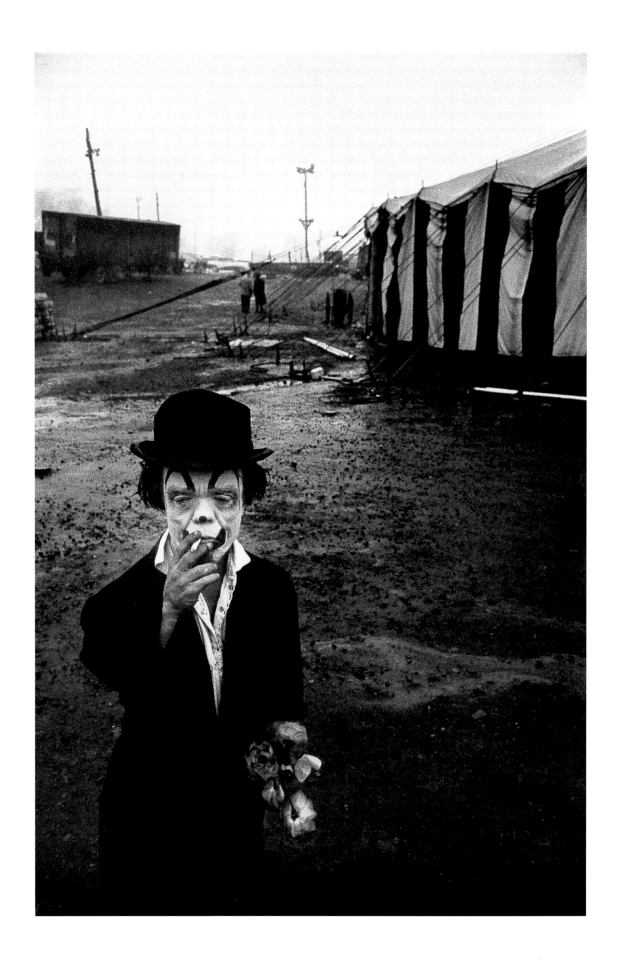

106
Bruce Davidson,
Clown with Flowers
(from the Dwarf
Series), 1958.
Gelatin-silver print,
11 x 14 in.

107
Bruce Davidson,
*Clown Outside of
Tent with Coca-Cola
Vendor* (from the
Dwarf Series), 1958.
Gelatin-silver print,
11 x 14 in.

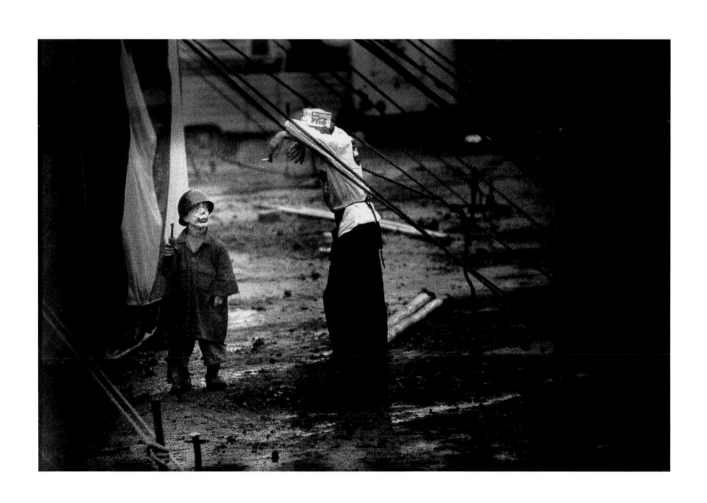

108
Mary Ellen Mark,
*Contortionist
with Sweety the
Puppy, Raj Kamal
Circus, Upleta,
India*, 1989.
Gelatin-silver print,
16 x 20 in.

109
Rhona Bitner,
11 photographs
from *Circus Series*,
1991–99.
Color photographs,
8 x 10 in. each

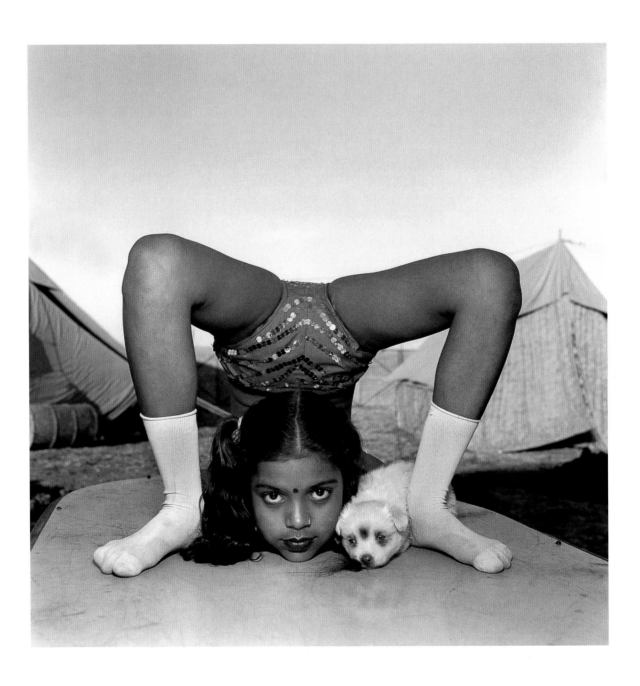

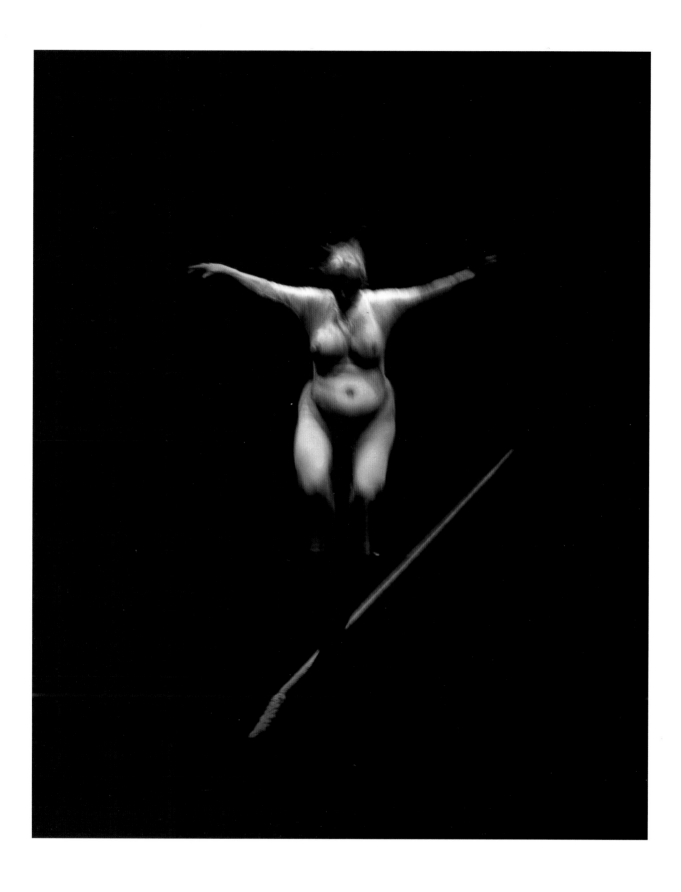

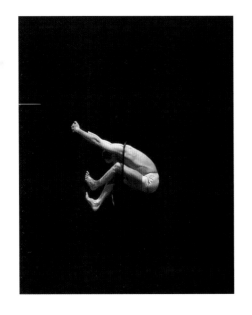
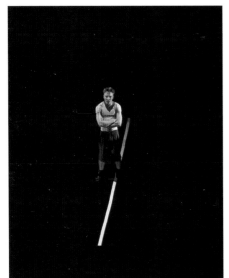
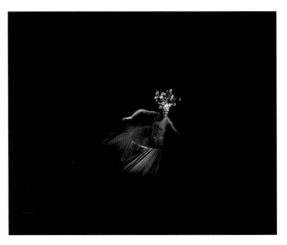
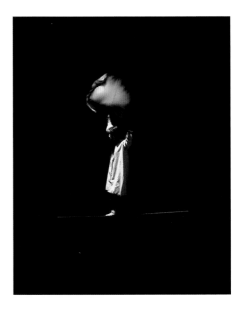
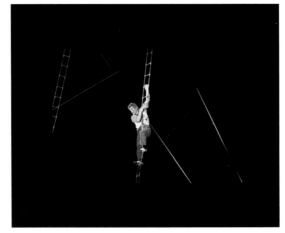
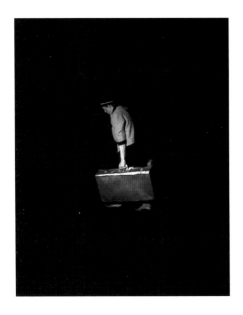

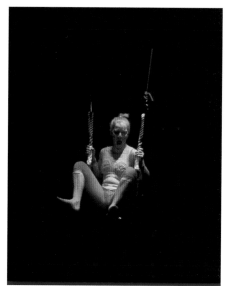

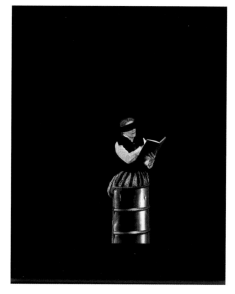

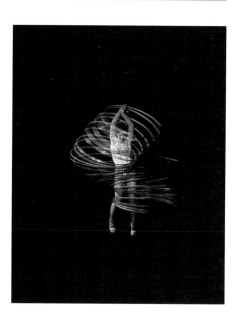

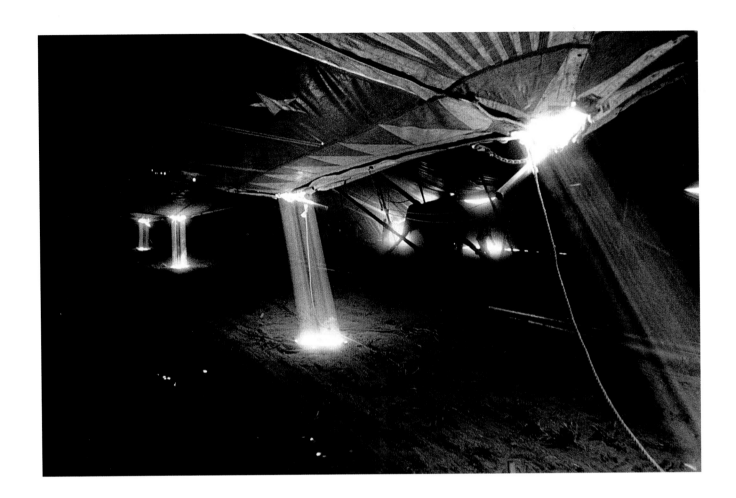

110
Edwin Martin,
Center Pole Holes,
Lake Isabella,
California, 1984.
Gelatin-silver print,
8 x 10 in.

111
Edwin Martin,
Setting the Flag,
Rainelle, West
Virginia, 1986.
Gelatin-silver print,
8 x 10 in.

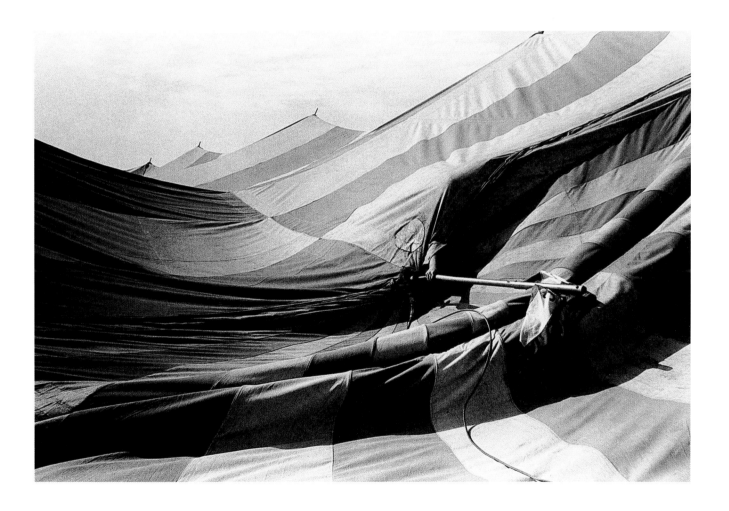

Notes

I owe special thanks to Donna Gustafson for good circus conversations and for her patience in answering my many queries. Michael Young and Peter Woit both generously provided valuable research assistance and encouragement of various kinds in connection with this essay.

1
Frank Crowninshield, editorial note preceding E.E. Cummings article, "The Adult, the Artist and the Circus," *Vanity Fair*, October 1925, 57. Although Cummings often spelled his name without uppercase letters, in *Vanity Fair* the orthography is traditional, and this usage has therefore been followed in this citation.

2
Mark Twain, *The Adventures of Huckleberry Twain* (New York: Charles L. Webster and Company, 1885), 192.

3
Marsden Hartley, "The Greatest Show on Earth: An Appreciation of the Circus from One of Its Grown-up Admirers," *Vanity Fair*, August 1924, 88.

4
E. E. Cummings, *Him* (New York: Liveright Publishing Corporation, 1927), 12.

5
Heinz Politzer, *Franz Kafka, Parable and Paradox*, (Ithaca, N.Y.: Cornell University Press, 1962), reprinted in 1965 as *Franz Kafka der Kunstler*.

6
Kimberley Gremillion, "Interview," *Aperture* 154 (Winter 1999), 36.

7
Among numerous books of this kind are Michael Mardon, *A Circus Year* (London: Putnam, 1961), Fred Lord, *Little Big Top* (Adelaide: Rigby, Ltd., 1965), Fred Powledge, *Mud Show: A Circus Season* (New York: Harcourt, Brace, Jovanovich, 1975), and Bruce Feiler, *Under the Big Top* (New York: Scribner's, 1995).

8
Yoram S. Carmeli, "The Invention of Circus and Bourgeois Hegemony: A Glance at British Circus Books," *Journal of Popular Culture* 29 (Summer 1995), 214.

9
Mary Ellen Mark, *Indian Circus* (San Francisco: Chronicle, 1993), 14.

10
Djuna Barnes, *Nightwood* (New York: New Directions, 1937), 11, quoted in Laura Winkiel, "Circuses and Spectacles: Public Culture in *Nightwood*," *Journal of Modern Literature* (Summer 1997), 8.

11
E.E. Cummings, "The Adult, the Artist and the Circus," 57.

12
Ibid. Curiously, Marsden Hartley also made this striking comparison between the circus and the Woolworth Building in his *Vanity Fair* circus article of the previous year (see n. 3 above).

13
Djuna Barnes, "Djuna Barnes Probes the Souls of Jungle Folk at the Hippodrome Circus," *New York Press*, February 14, 1915, reprinted in Djuna Barnes, *New York* (Los Angeles: Sun and Moon Press, 1989), 193.

14
Cummings, "The Adult, the Artist and the Circus," 57, 98.

15
Robert Lax, *Circus of the Sun* (New York: Journeyman Books, 1959; reprinted Zurich, Pendo, 1981), n.p.

16
Cummings, "The Adult, the Artist and the Circus," 57.

17
Barnes, "Djuna Barnes Probes the Souls," 191.

18
Winkiel, "Circuses and Spectacles," 9.

19
Ibid., 10.

20
See for instance, John Culhane, *The American Circus, an Illustrated History* (New York: Henry Holt, 1990), Tom Ogden, *Two Hundred Years of the American Circus* (New York: Facts on File, 1993), and Earl Chapin May, *The Circus from Rome to Ringling* (New York: Dover, 1963, reprint of 1932 original).

21
Michael Kammen, *The Lively Arts: Gilbert Seldes and the Transformation of Cultural Criticism in the United States* (New York: Oxford University Press, 1996).

22
Kirk Varnedoe and Adam Gopnik, *High and Low: Modern Art and Popular Culture*, (New York: Museum of Modern Art, 1990).

23
Marianne F. Margolis, ed., *Camera Work, A Pictorial Guide* (New York: Dover, 1978).

24
Nancy Newhall, ed., *The Daybooks of Edward Weston* (New York: Aperture, 1981), 20.

25
Ibid., 21.

26
Ibid., 59.

27
Weegee (Arthur Fellig), *Naked City* (New York: Da Capo, 1973, reprint of 1945 original), 228.

28
Twain, *Adventures of Huckleberry Finn*, 193–94.

29
Djuna Barnes, "Interviewing Arthur Voegtlin Is Something Like Having a Nightmare," reprinted in Djuna Barnes, *Interviews* (College Park, Md.: Sun and Moon Press, 1985), 79.

30
Patricia Bosworth, *Diane Arbus: A Biography* (New York: Avon, 1984), 189. According to Bosworth, Arbus "would go in the afternoon and sit in the dark, cavernous, almost empty theater smoking pot" while viewing Browning's *Freaks*.

31
Gilbert Seldes, "The True and Inimitable Kings of Laughter" in Seldes, ed., *The Seven Lively Arts* (New York: 1957, reprint of 1924 edition), 255.

32
Cummings, "The Adult, the Artist and the Circus," 57.

33
Mark, *Indian Circus*, 11.

34
Edwin Martin's photographs appear in book form in a collection titled *Mud Show: American Tent Circus Life* (Albuquerque N.M.: University of New Mexico Press, 1988), which also includes an essay by Don B. Wilmeth.

35
Gremillion, "Interview," *Aperture*, 36.

36
Ibid.

37
Yoram S. Carmeli, "The Sight, of Cruelty: The Case of Circus Animal Acts," *Visual Anthropology* 10, no. 1 (1997), 1.

38
Robert Bogdan, "Freak Shows and Talk Shows," *Parkett* 46 (1996).

39
Lax, *Circus of the Sun*, n.p.

CLOWNS

WITH **BAD** ATTITUDES

POPULAR CULTURE GOES TO THE CIRCUS

KARAL ANN MARLING

HOW THE CIRCUS BIRTHDAY CAKE CAME TO BE INVENTED IS ONE OF THOSE GREAT MYTHIC IMPONDERABLES IN THE HISTORY OF THE CULINARY ARTS, LIKE THE QUESTION OF WHO FIRST DOMESTICATED LIGHTNING TO CHAR THE FAMILY DINNER. IN THE CASE OF THE "MERRY-GO-ROUND CAKE," BETTY CROCKER ILLUSTRATED ONE IN THE FIRST EDITION OF HER INFLUENTIAL PICTURE COOK BOOK BACK IN 1950, IN AN ERA OF EXTRAVAGANT "THEME" CAKES WHEREBY MOTHERS AIMED TO ASSUAGE THEIR GUILT OVER PREPARING THE REST OF THE MEAL FROM CONVENIENT FROZEN PACKAGES.[1] BUT IT IS CLEAR THAT A TALL, FROSTED CAKE SURMOUNTED BY A TENT CREATED WITH A PAPER DOILY HELD ALOFT BY STRIPED SODA STRAWS (OR PEP-PERMINT STICKS) – WITH PLASTIC LIONS AND ELEPHANTS FROM THE DIME STORE MARCH-ING AROUND THE OUTSIDE EDGE AND BEARING THE REQUISITE NUMBER OF CANDLES – HAD ALREADY ATTAINED THE STATUS OF A CLASSIC AMONG BIRTHDAY-PARTYGOERS BEFORE BETTY CROCKER EVER ISSUED HER HOW-TO-DO-IT DIAGRAM. DURING MY CHILDHOOD, IN THE EARLY POSTWAR YEARS OF FRIVOLITY AND PROSPERITY, A BIRTHDAY PARTY WAS SIMPLY NOT A PARTY AT ALL WITHOUT WHAT WE ALWAYS CALLED "THE CIRCUS CAKE."

Perhaps it was inevitable. The routine party decorations stocked by Woolworth's and its competitors were pretty much alike in those days: balloons, crepe paper bunting, plastic candleholders in the shapes of animals, and a small supply of paper plates and napkins decorated with pictures of grinning clowns (or performing elephants and lions). The best party foods were ice cream (of course) and the cake, along with peanuts in the shell and popcorn: festive occasions always seemed to conjure up a circus, with everything but the steam calliope. The year I first had a beautiful circus cake of my own — when I was six or seven, perhaps — the best birthday present was a set of rubber molds that, when filled with plaster of Paris, yielded up statues of all the characters needed to "play circus": a ringmaster with a top hat, two clowns, a snarling tiger, a lion, and an elephant. Once dry, the figures were to be painted with watercolors (included in the package) and posed in front of a striped tent drawn on a sheet of stiff white paper according to directions printed inside the lid of the box. My playmates and I also discovered that other play sets could be cannibalized for props. The sixty-five-piece cut-out "Wild West Rodeo" that came free with mom's new General Electric refrigerator contained a grandstand and a ticket booth suitable for circus use.[2] Young Norman Rockwell's second cover for the *Saturday Evening Post*, on June 3, 1916, had shown children staging a backyard circus (admission: "3 pins"); in my neighborhood, almost forty years later, this was still a great way to enliven a dull weekend, albeit the price of admission had risen to three cents.[3]

So that "Merry-Go-Round Cake," whatever Betty Crocker chose to call it, was really a circus cake after all: the alternate versions, listed underneath her recipe, consisted of circus cupcakes, decorated like familiar sideshow characters, and "clown surprise" cupcakes, with pointed hats, faces drawn in raisins, and a scoop of ice cream hidden inside. The real question isn't whether these were gustatory tributes to a perceived bond between childhood merriment and the circus — kids and clowns always seemed to go together in the 1940s and '50s — but why it should have been so. Sealtest ice cream executives, convinced that children influenced their mothers' supermarket buying habits, went so far as to hire the legendary industrial designer Raymond Loewy, in 1951, to retool the makeup of its T.V. clown (a.k.a. Ed McMahon, future late-night talk-show sidekick) so that the same telegenic image would be clearly visible to avid little shoppers on the pints and quarts at the bottom of the freezer case.[4] Ronald McDonald, who was adopted by the hamburger chain as its official mascot and television pitchman in 1963, firmly identified the restaurants as happy places for children (and their parents) — but not for loitering teenagers or bums.[5]

Television was, in many ways, the ideal medium for the circus in the 1950s. The broad gestures, the wild physical movement, and the exaggerated makeup of the big-top setting ideally suited the little hard-to-see black-and-white screen. Whereas the traveling circus of an earlier day always spoke of the transitory pleasures it

brought as the tent went up and the trapeze artists dazzled for only a day or two, the magic of television was that it brought rare sights from far away right into one's own living room, week in and week out. Why should Junior run away to join a circus that was performing not three feet from his nose, as the family dined on tasty T.V. dinners? One of the earliest Disney animated features to be shown in its entirety on television was the circus movie *Dumbo* (1941), broadcast twice in 1955 as part of the wildly popular Wednesday-night *Disneyland* show.[6]

A little circus elephant who doubled as a clown by virtue of his enormous ears, Dumbo was a figure of pathos, ridiculed for his appearance and cruelly separated from his anguished mother. This cartoon animal was an everyman — guileless, sweet, and ultimately triumphant: the child as inspiration and hero.[7] The new genre of kids' T.V. adopted the circus as the ideal solution to creating inexpensive programming for a juvenile audience. Who needed a script? And circus shows didn't require expensive "stars," either: Ed McMahon, the resident clown of the long-running *Big Top* show (1950–57), originating in New Jersey, was an amiable nobody with a shiny red nose. The *Bozo the Clown* show, which began in 1957, was a kind of franchise, based on a line of children's records. Each participating station across the country dressed one of its own announcers as the red-headed clown and used him to introduce after-school cartoons.[8] As real circuses folded their tents and went out of business, victims of wartime stringencies and television, unemployed dog acts and acrobats relished guest spots on *The Buick Circus Hour* (1952–53) or *Circus Time* (1956–57).

The format of most early T.V. shows came from older sorts of entertainment: vaudeville and the circus, where acts were short and diverse. The canonical three-ring circus did not require close attention to any one detail, for example, nor did it depend on tight narrative continuity. With no loss of dramatic integrity, therefore, circus-theme T.V. programs allowed for trips to the refrigerator, phone calls, and finishing one's homework on the rug in front of the new nine-inch set — or squabbles between siblings over whether Clarabell Clown was a boy or a girl. The voiceless Clarabell, who honked a horn instead of speaking, was the nemesis of "Buffalo" Bob Smith, host of *Howdy Doody* (1947–60), one of the two most memorable kids' shows of television's Golden Age. Howdy himself was a marionette and leading resident of the fictional Doodyville, a circus town populated by a mixture of puppets and live people. The latter included a zebra-striped Clarabell (played by Bob Keeshan, who several years later originated the character of Captain Kangaroo on the show of that name) and an Indian princess, a reference to the Wild West show that had been folded into the American circus in the 1920s.[9] The former included Flub-a-Dub, a strange hybrid made up of eight exotic animals — a circus menagerie in a single creature.

Smith, the controlling genius who brought *Howdy Doody* to network television, was working in radio, too, and had no time for

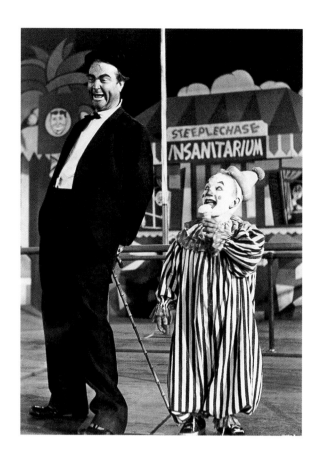

sophisticated scripts: the circus storyline, he remembered, practically wrote itself and permitted the flexibility needed for a low-budget live show performed before a "Peanut Gallery" full of school-age spectators.[10] Every afternoon, the villains tried to buy up (or steal) Howdy's circus. The good guys, an international cast of cowboys and carnival characters, valiantly foiled their plots, until the original premise gradually disappeared, leaving behind only a balding white-face circus clown with a horn. But Doodyville can stand for the transience, the endless change, and the daily quest for something new and different that would also characterize T.V.'s second great children's show of the 1950s, *The Mickey Mouse Club*.

The Mickey Mouse Club made its ABC television debut in 1955 with a format that glorified the episodic spectacle of the three-ring circus. For every day of the week, there was a different theme; and every show was composed of a potpourri of short "acts," ranging from cartoons to dramatic serials, from dance numbers to guest spots. Thursday was "Circus Day." In the opening segment for Thursdays, the Mouseketeers – the regular cast of child hosts wearing mouse-eared beanies – appeared in elaborate costumes, such as clown, bearded lady, or strong man. Various Mouseketeers also tried their hand at simple big-top stunts, but most of Thursday's program consisted of genuine circus folk, demonstrating acrobatic feats, clowning, or showing off their trained animals.[11] According to the words of the much-repeated "Circus Day" song, "everyone loves the circus" for its clowns, its animals, and its human anomalies: "a man who's nine feet tall! And a lady five feet wide."[12]

Tim Considine, a legitimate child star who appeared in several of *The Mickey Mouse Club*'s "soap opera" segments, had made his mark in Hollywood by playing the son of an alcoholic clown in

Red Skelton's 1952 movie *The Clown* (fig. 112).[13] For twenty years Skelton had his own television variety series, in which he also spotlighted a number of self-created characters derived from "clown alley" (the area behind the tents where the guys with the red noses adjusted their makeup) and the circus of his youth. Television proved to be a natural milieu for Skelton, a former vaudevillian best known for broad physical comedy. His Freddie the Freeloader, a sad tramp clown in the tradition of Emmett Kelly, became a staple of T.V. for grown-ups, beginning in 1951.[14] The pathos of the Skelton clown came in part from his own autobiography: the story aired by his publicists made much of the fact that he was the son of a clown with the old Hagenbeck-Wallace Circus, and was born in Indiana on the show's Midwest loop in the dead of summer, two months after his father's death. By the mid-1950s, when his Bel Air mansion had become one of the showpieces on the tour-bus circuit of Hollywood, Skelton was the American everyman, risen from humble beginnings to fame and fortune. But the manicured lawn of his proper red-brick home was strewn with circus relics. In the living room, a sad-clown doll on the coffee table struck an odd note amid the decorator-perfect tastefulness. And in a pink studio in the back garden. Skelton painted picture after picture of the father he had never known, in full sad-clown regalia.[15]

Red Skelton's clowns are still for sale today, years after his death, in the form of original oils, on-canvas reproductions, prints, and collectible plates – relics of a decade in which clowns, circuses, and amateur art amounted to national obsessions.[16] Among the painter-celebrities of the '50s, Frank Sinatra, too, specialized in clowns.[17] Lesser mortals settled for paint-by-numbers kits: in 1952, according to the chief designer of the fill-in-the-blanks pic-

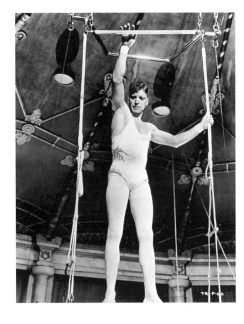

tures, clowns and trapeze artists were among the most popular subjects in the line.[18] Glass clowns made in Murano, a suburb of Venice, were the number-one souvenir items brought home by tourists on package tours of Europe.[19] The materials and the techniques were intriguingly foreign, but the subject matter was pure Howdy Doody, out of Red Skelton and the *The Mickey Mouse Club*. T.V. ads for Slinky toys, the amazing postwar springs that waddled down stairs, promised that they were "More Fun Than a Circus!"[20] The small-screen comedy team of Dean Martin and Jerry Lewis scored a big movie hit with *Three Ring Circus* in 1954.

Shot in Phoenix at the Clyde Beatty Circus, *Three Ring Circus* (fig. 113) reminded Jerry Lewis of the first film he had ever seen: Charlie Chaplin's *The Circus* (1928). Like that earlier silent movie, the plot of *Three Ring Circus* centered on a star turn by the comic. This pleased the competitive Lewis, whose partner and straight man, Dean Martin, was relegated to the role of heavy.[21] Lewis, meanwhile, got five scenes in full circus makeup as Jerricho the Wonder Clown, a part that catered to his own idiosyncratic stage persona, cobbled together from sentiment, pathos, a manic vulgarity, and slapstick in roughly equal proportions. *Three Ring Circus* also witnessed the onset of Lewis's full-fledged circus mania. The living room of his Bel Air mansion, which he purchased in the early '60s, was dominated by a giant painting of the master of the house dressed as a tramp-style clown, complete with stick and bandanna, and a family portrait featuring his wife, his children, and his pets as a troupe of sad-eyed harlequins in the style of early Picasso.[22] Meanwhile, at the opposite end of the taste spectrum, actor Burt Lancaster, who had broken into show business during the Great

continued on p. 130

112
Red Skelton and Billy Barty in *The Clown*, MGM (1952).

113
Jerry Lewis in *Three Ring Circus*, Paramount (1954).

114
Burt Lancaster on the high wire, in *Trapeze*, United Artists (1956).

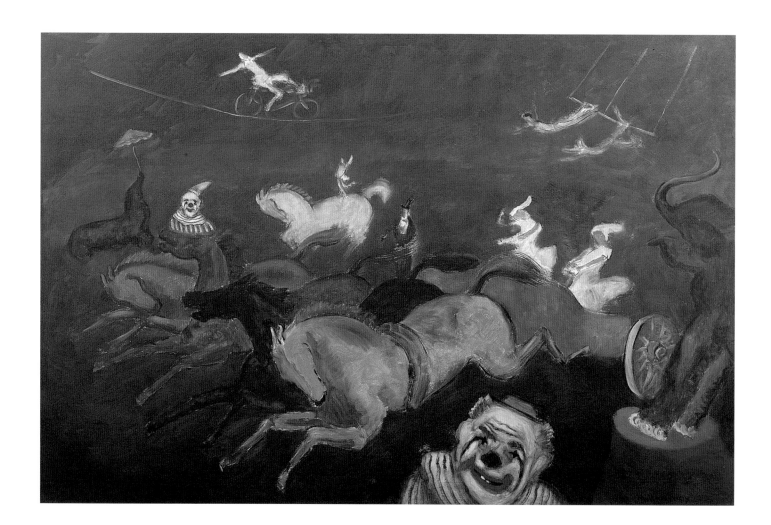

115
Milton Avery,
Chariot Race, 1933.
Oil on canvas,
48 x 72 in.

116
John Steuart Curry,
Circus Elephants,
1932.
Oil on canvas,
25 1/4 x 36 in.

117
John Steuart Curry,
Clyde Beatty, 1932.
Oil on canvas,
20 1/2 x 30 1/2 in.

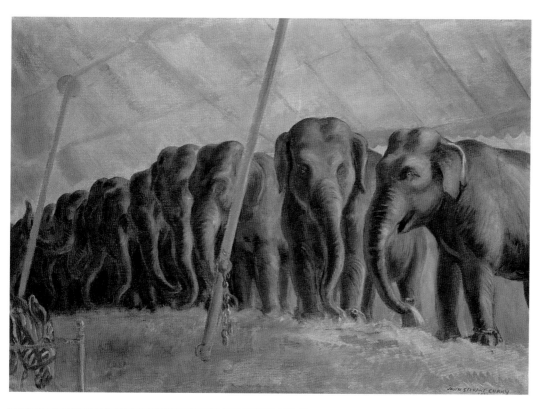

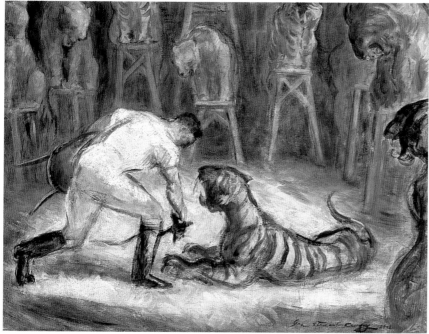

Depression as an acrobat with the Kay Brothers Circus – a strug-
gling, twenty-five-person, one-ring "mud show" – decorated the
lavish offices of his new Hollywood production company in 1956 with
a pricey series of Georges Rouault circus studies.[23]

Lancaster's own circus movie, *Trapeze* (fig. 114), was filmed in
Paris, at the venerable 5,000-seat Cirque d'Hiver, at the height of
Hollywood's Red Scare. The storyline seems to reflect Lancaster's
personal desire for freedom, represented by the ultimate aerial
stunt, the triple somersault off the flying trapeze. Lancaster played
Mike Kibble, a crippled circus star reaching for new glory by teach-
ing his perilous trick to the younger Tony Curtis, and catching him
as he rockets through the air. In the early 1930s, Lancaster himself
had witnessed a triple – the most celebrated of all circus feats –
accomplished by Alfredo Codona at Madison Square Garden. Eddie
Ward, Jr., who caught for the Codonas and the Concellos and later
worked with Lancaster in the Cole Brothers Circus, became the
star's stunt double.[24]

In 1962, according to Lancaster's most recent biographer, a
fourteen-year-old Mexican trampoline artist, Tito Gaona, saw *Trapeze*
in a seedy, all-night theater on Times Square and made the triple
his mission in life. Four years later, with the Ringling Brothers and
Barnum & Bailey Circus, Gaona became the first performer since
the Great Codona to do the triple on a regular basis.[25] By then, of
course, the trick had been the stuff of circus legend for decades. In
1932, thanks to the personal intervention of Codona, Regionalist
artist John Steuart Curry joined the Ringling Circus for its spring
tour through New England. He painted Baby Ruth, the fat lady
(fig. 66, page 66); the elephants (fig. 116); Clyde Beatty, the lion tamer
(fig. 117); the Wallendas on the high wire; Hugo Zacchini, the human
cannonball; the Reiffenach Sisters, bareback riders (fig. 87); and
Tamara, the trapeze beauty, bathed in her brilliant spotlight.[26]
So popular were these big-name acts that Curry may have seen the
canvases as a surefire way to sell pictures in a tight market. Yet
by his own account, he followed the circus because it was "one of
the most colorful phases of the American Scene."[27]

Whatever his motives, Curry created a period masterpiece when
he succeeded in immortalizing Alfredo Codona's twisting, death-
defying leap into the waiting hands of his brother, Lalo (fig. 121).[28]
The triple was unforgettable because it illustrated so plainly the
narrow distance between life and death, the space between Alfredo's
wrists and Lalo's waiting fingers. As Alfredo told a reporter in
1930, "The history of the triple somersault is a history of death....
As long as there have been circuses, there have been men and
women whose sole ambition was to accomplish three full turns
in the air.... The triple somersault has killed more persons than
all other dangerous circus acts combined."[29]

The bravado of Codona and his peers – their ability to turn
chaotic action into order, to snatch victory from the jaws of
annihilation – endeared them to circus-goers in the 1930s. The dar-
ing young men (and women) on the flying trapeze, the wild animal

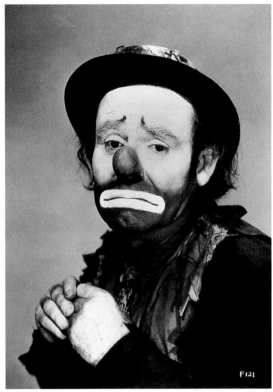

trainers, and even the stars of the sideshow ballyhoo depicted in Tod Browning's grotesque horror classic, *Freaks* (fig. 118), defied great odds to achieve success, on a nightly basis. In that sense, the circus had a moral to teach its Depression-era audience: even in the worst of circumstances, pluck, hard work, and sheer guts could see you through. Codona was a headliner in spangled tights, a hero, a star; he had conquered fear, gravity, and hard times.

The young Burt Lancaster did not make his fortune as a circus acrobat in the 1930s, but he did make a living at it. By the end of the decade, his momentum as a performer had carried him first into the theater and later into the movie business. Indeed, class lines between the circus and other forms of entertainment were often blurred during the Depression. In New York City, where Lancaster was hired at welfare wages, the Federal Theatre Project for unemployed actors ran several busy circus units. In fact, the first scheduled F.T.P. performance, in October 1935, was a circus; during the following year, its managers secured a 4,000-seat tent and began touring the boroughs and city parks during the summer months.[30] Emmett Kelly (fig. 119 and fig. 74, page 74) became a national celebrity in the winter of 1934–35 when, during an engagement of the Moslem Shrine Circus in Detroit, his Weary Willie character leaned on a shovel while the other clowns scurried about pretending to work. The sign he carried read "P.W.A." (Public Works Administration), and Kelly's so-called shovel or "boondoggle routine" soon became a symbol of Republican Party opposition to Franklin Roosevelt's make-work programs for the unemployed.[31] But the sad, unshaven Willie himself, with his hobo's bundle and ruined shoes, poignantly bespoke the plight of the jobless thousands who had taken to the highways and the freight trains in search of a better life.

More than the individual acts themselves, however, the very idea of the circus attached itself in the 1920s and '30s to a renewed

interest in Americana, or those traditions and rituals uniquely characteristic of what artists such as Curry called the American Scene. In the 1920s, as modernists — Demuth and Kuniyoshi, for example (figs. 122–24) — struggled with the problem of how Parisian aesthetics might be applied to the facts of American life, the circus emerged as a promising theme.[32] In the spring of 1929, the Whitney Studio Galleries in New York mounted an elaborate exhibition called *The Circus in Paint* (fig. 48, p. 48), complete with warm peanuts, balloons, sawdust, and a simulated circus tent (by painter Louis Bouché) that disguised the rather pedestrian interiors of the showroom.[33] Many of the participants seized upon the vibrant patterns and colors of the circus, and a kind of naïve, child's-eye view thereof, to simplify form in radical ways. But the majority of the exhibitors (including Curry, with his first circus images) were realists, intent on preserving some visual likeness of the traveling circus and capturing the emotional climate of a beloved American institution.[34] After the stock-market crash of 1929, the focus shifted toward remembering the good times, and preserving a way of life threatened by the vagaries of hard times.

Historians have chronicled the precipitous decline of the circus in the 1930s. The Depression wiped out venerable companies that had been in existence since the nineteenth century. Moving the show by rail grew too expensive for most marginal operations. "Circus King" John Ringling lost his Madison Avenue venue, most of his fortune, and control of the show that bore his name.[35] What stood to disappear were all the iconic moments in American life that were firmly attached to the circus. In small towns in Indiana, as novelist Booth Tarkington looked back on his boyhood, that moment had been the glorious circus parade, full of camels and elephants and beautiful ladies in tights, splendors seen only once

continued on p. 136

120
John Steuart Curry,
*The Reiffenach
Sisters*, 1932.
Oil on board,
22 x 24 in.

121
John Steuart Curry,
Flying Codonas,
1932.
Oil on canvas,
36 x 30 in.

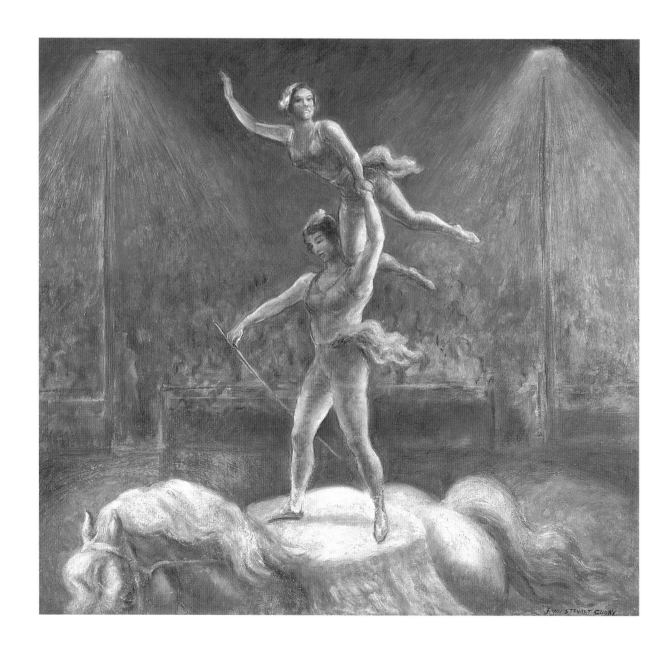

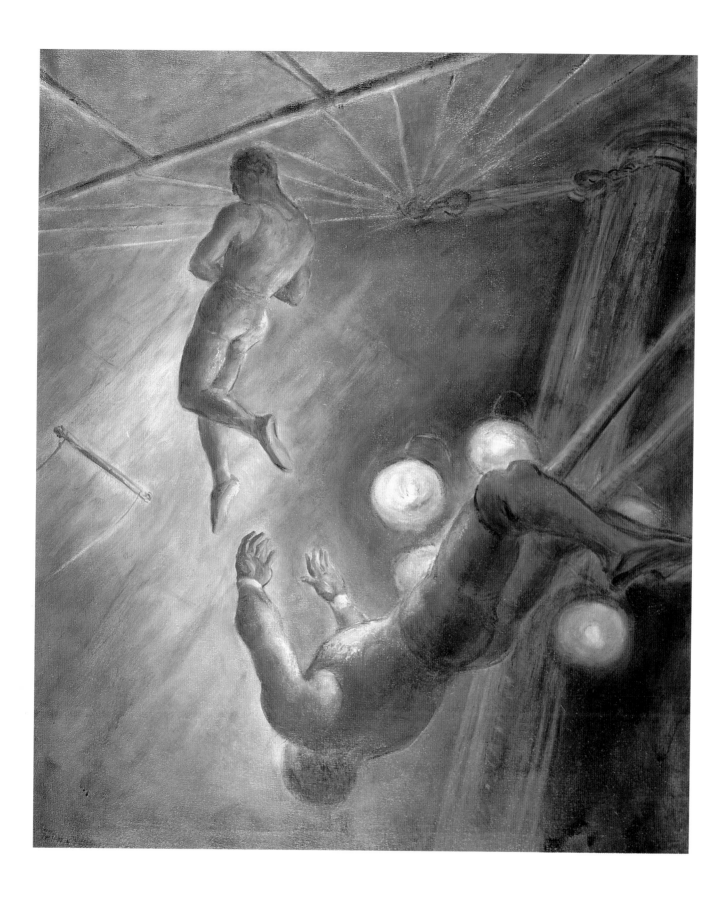

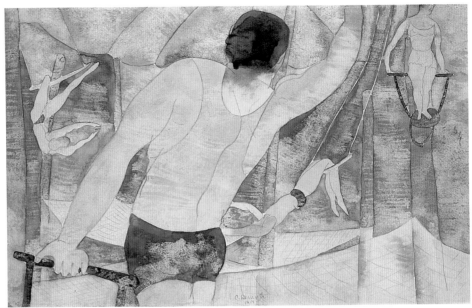

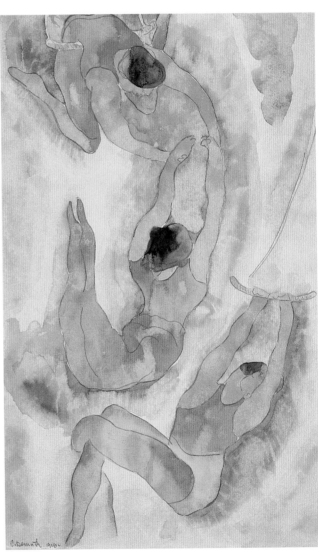

122
Charles Demuth,
Circus, 1917.
Watercolor and
graphite on paper,
8 1/16 x 13 in.

123
Charles Demuth,
Three Acrobats,
1916.
Watercolor and
graphite on paper,
13 x 7 3/8 in.
Amon Carter
Museum, Fort Worth,
Texas (1983.127)

124
Yasuo Kuniyoshi,
Circus Ball Rider,
1930.
Lithograph on
wove paper,
15 x 11 in.

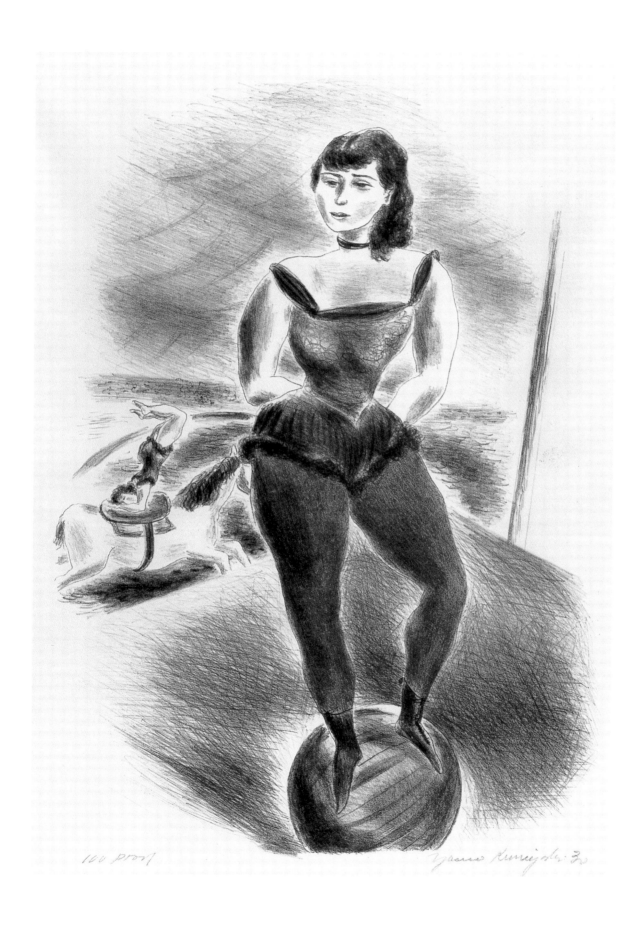

100 proof Yasuo Kuniyoshi 3

a year along the dusty thoroughfares of rural Indiana. For the sheer joy of it all, swarms of little "boys whooped in the middle of the street."[36]

In Asheville, North Carolina, around 1900, that moment came when the giant tent went up in the semidarkness of early morning, as sleepy elephants nudged the poles into position. "Great flares of gaseous circus light," wrote novelist Thomas Wolfe, "would blaze down on the seared and battered faces of the circus toughs," while he and his kid brother looked on in wonder.[37] No, poet Joyce Kilmer decided. The best thing of all was the acts, passing one after another through the magical center ring, as though in a dream: "the amazing contortionist, the graceful juggler, ... roller-skating bears, trained seals" — each one captivating, peerless, and profoundly equal, in a living pageant of American sawdust democracy.[38] Ogden Nash begged to differ: *everything* was wonderful — parades, spangles, clowns, the whole dazzling spectacle. He wanted to "shake hands with Mr. Ringling," Nash quipped, "and tell him his circus is a beautiful thingling."[39] In Manhattan, according to journalists assigned to the beat, "elephants rather than robins mark[ed] the arrival of spring."[40] Sculptor Alexander Calder first unveiled a version of his miniature, three-dimensional, mechanical *Circus* (fig. 36, page 41) in Paris in the spring of 1927, as the Ringling show prepared to wow New York again.[41] Although Calder knew the highly formal French circus well, this was a lively, all-American circus instead, a memory of home, full of spectacle and ceaseless motion, and based, perhaps, on a famous American toy manufactured in Philadelphia beginning in 1903 — the "Humpty Dumpty Circus," which came with its own little tent.[42]

What Americans remembered and cherished about the circus, as those memories were threatened by the economic and social upheavals of the 1930s, gave inspiration to artists working to preserve what was unique and wonderful about their country. The Federal Writers' Project, for example, produced guidebooks to the states predicated on the notion that what ought to be recorded were the striking historical moments, the most vivid pictures in the life cycles of the most ordinary places.[43] Similarly, the painters — the men and women who worked for the Federal Art Project, and the ones who didn't — bent their common effort toward finding those particular times and places in the great ongoing American panorama. Call it the American Scene. Call it Regionalism. American artists flocked to the circus.

Clarence Carter, Aaron Bohrod, Marvin Cone, and Henry Keller were among the established midwestern painters who looked to the big top for splendid animals, almost-nude figures in motion, happy faces, or scenes of sad and frightened people in greasepaint struggling to make a living with their painted-on smiles.[44] Regional exhibitions of the pictures produced by artists on the welfare rolls included circus tableaux in disproportionate numbers and in a wide variety of styles.[45] Anton Refregier painted one of the earliest

government murals of the period for New York's Greenpoint Hospital in New York City (fig. 125), a cavalcade of circus fragments, under the auspices of the Federal Art Project in 1935 (figs. 126 and 127). The surest measure of the affection with which Americans viewed the circus in the 1930s was the sheer number of clowns and elephants featured in paintings that were now directed at the general public, or the "man in the street," rather than wealthy gallery-going connoisseurs. The circus was a hallmark of populism in hard times.

Throughout the 1940s, despite the shortages of railroad cars and canvas and personnel due to the war, the symbolic importance of the circus — the joy, the innocence, the old-fashioned star-spangled Americanism of the institution — never quite lost its luster. The month of April (fig. 128) in the free calendars issued by the Pepsi-Cola Co. was almost always illustrated by a circus scene, chosen by popular vote in an annual art competition that replicated the format of the old New Deal programs. But the circus was beginning to show its age. And the cheerful pictures of the Big Show painted by what one critic called the "linsey-woolsey" artists seemed woefully outdated as early as 1940, when Ringling Brothers and Barnum & Bailey suddenly streamlined itself. "Abstract art is alive and kicking up a hell of a lot of attention on the ceiling of the circus," Carlton Brown concluded. The bright primary colors (even the sawdust was tinted) and the polished chrome apparatus for the aerial acts were "the best surrealism ever made. (Alexander Calder's 'mobiles' were never like *that*)."[46]

In fact, the cosmetic makeover of the circus cleverly disguised serious structural problems. As jobs became more plentiful and unions more powerful, it became harder and harder to meet the demands of the roustabouts who tended to the physical arrangements of a good-size traveling city of tents. In 1938, the Ringling show had been closed down by labor troubles after only eleven weeks of a thirty-week tour; the circus limped back to winter quarters in Florida amid press reports that raised the specter of "possible doom."[47] In the wake of the strike, John Ringling North, nephew of the family and the new acting head of the company, spearheaded a national "Save the Circus" campaign and guaranteed more publicity by pledging to change the show "from the ground."[48] Or, as the *New York Times* insisted, by "streamlining" the circus.[49]

In practice, this meant changing the old costumes, scrapping the old tent, air-conditioning the big top, and using trucks and tractors in place of animal power to wrestle equipment off the train and into position. But the glamorous aspects of the streamlining got the most attention. In 1940, North hired Max Weldy of the Folies-Bergère to redo the costuming, with special attention to brilliant color and the visual effect of the opening "pageant," or indoor parade of animals and performers. After that season, North added Norman Bel Geddes to the payroll, on the strength of his success as a showman at the 1939 New York World's Fair, for which he had

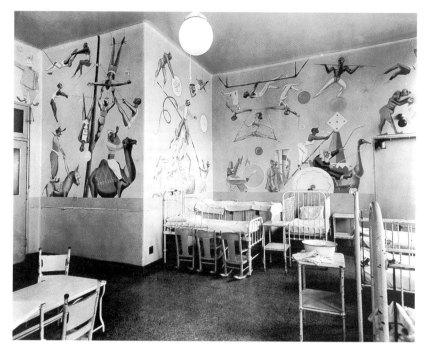

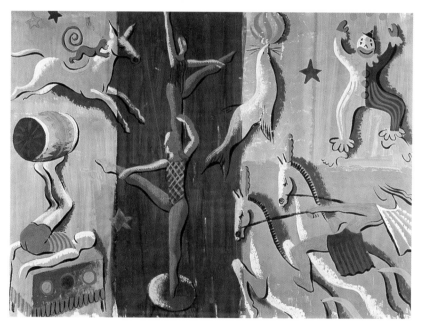

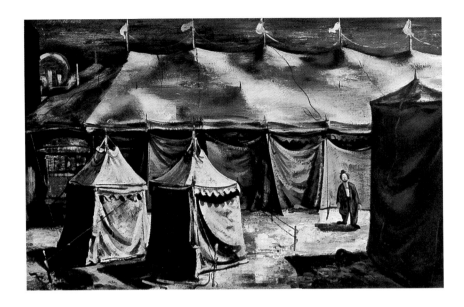

conjured up the streamlined élan of the General Motors Pavilion's *Futurama*, the fair's most popular attraction.[50] In an effort to mute alarmed criticism from nostalgists, Bel Geddes published an open letter to circus fans in which he pointed out that the big top was "about the last American institution that has held out against the mechanical age." Modern kids had already seen exotic animals in zoos. "The boy of today is more impressed by a bomber or strato-liner than he is by a hayrack or a corn wagon." So out with the old and in with the new – a circus with modern "marvels of stage lighting and all the technique of spectacle."[51]

There was some cautious support for modernization within the ranks of circus professionals. In 1940, *Billboard*, the industry's journal of record, endorsed better circus lighting, new equipment, and longer stands in each location, while cautioning against "placing chromium-plated bands around its stakes or installing a revolving cocktail bar to circle the center pole in the menagerie."[52] But that was pretty much what Bel Geddes wanted to do. In March 1941, he unveiled plans for an entirely new poleless tent, dramatically hung from exterior masts, to permit uninterrupted sightlines from any point under the big top.[53] With a dark blue top and red side walls, the new Ringling tent took to the road later that year, sheltering an all-new cast of European refugee-stars – just in time for America to enter World War II.[54]

The Spec (themed opening spectacular) devised by Bel Geddes charmed even the skeptics, however, with its stately rhythms and sumptuous trappings. "The Circus had changed to look as fabu-lously beautiful as [onlookers] imagined it had looked when they were children," *Time* magazine rhapsodized.[55] It was also circus as Fine Art, however: music by Stravinsky, choreography by Balanchine, and six thousand yards of tulle for a nightly "Packyderm Corps de

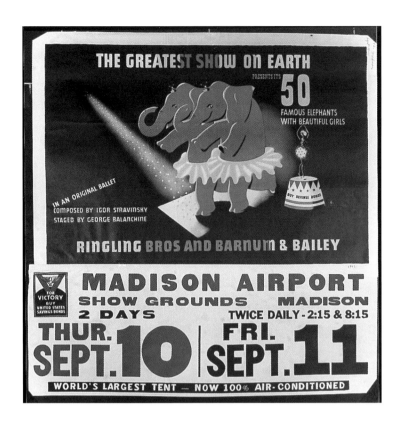

Ringling Bros. Barnum, Bailey Circus
Last Stand Under Canvas
Pittsburg, Pa. July 16 1956

Ballet" performance (fig. 129).[56] Bel Geddes's contract for the 1942 season included new floats, a Spec featuring scenes from American holidays, and a "nostalgia number" based not on the glory days of P. T. Barnum but on the cirque sketches of Toulouse-Lautrec.[57] Nonetheless, in January 1943 his association with the Ringlings ended and so did the streamlined circus, to the relief of Bel Geddes's critics. *Business Week* welcomed a return to three rings, a nice white tent, and a lot less artsy glamour.[58] The purge was in keeping with the austere tenor of wartime America: 1943's Specs had military themes; the government shortened the itinerary of the Ringling circus to conserve rolling stock; and the crowds of jittery civilians that turned out found the tired old clown routines curiously comforting in comparison to the recent fad for highbrow Toulouse-Lautrec-ism.

The worst tragedy in circus history struck amid the change and indecision of the 1940s. On July 6, 1944, during the matinee of the Ringling Brothers circus in Hartford, Connecticut, while seven thousand people craned their necks toward the center ring, the tent was suddenly engulfed in flames. The bandleader struck up John Philip Sousa's rousing march "The Stars and Stripes Forever," the tune that signifies disaster to circus employees. The wild animals were quickly led to safety. But the crowd panicked, and within six minutes, 168 men, women, and children were dead, and hundreds more were hurt. Local authorities put five top Ringling officials on trial. The company finally paid off the last of the six hundred claims for damages in 1954.[59] The cause of the fire was listed as a shortage of fire-proofing chemicals for use on the seventy-five thousand yards of canvas in the big top. The necessary retardants had been confiscated by the armed forces for the duration of the war.[60]

Along with tire rationing and blackouts, the fire might have spelled the end of the circus, had it not been for a U.S. government decision that clowns and elephants were crucial for the "sustainment of morale on the home front." So, in the aftermath of the Hartford disaster, clown Emmett Kelly urged a fast return to business as usual. "We must forget the fire," he said. "We must entertain. In wartime, it's more important than ever."[61] Kelly's Weary Willie planted a victory garden in the center ring and the show went on. V-E Day was announced on May 8, 1945, while "The Greatest Show on Earth" was playing its usual spring engagement at Madison Square Garden. But then came peacetime, television, things to do at home in suburbia, and new forms of outdoor entertainment. When Disneyland opened in July 1955, one of the first things Walt Disney learned was that nobody wanted to sit still for a tent circus — even a circus produced by the company that made *Dumbo* — when one could paddle a canoe with Davy Crockett or take a perilous journey down the Amazon on a real boat with real water. Admitting one of his rare failures, Disney reluctantly hauled down his tent only weeks after it had gone up.[62] And less than a year before, John Ringling North, in a Pittsburgh press conference, announced that "the tented circus as it exists today is, in my opinion, a thing of the past" (fig. 130). After the evening show on July 16, 1956, the Ringling Brothers and Barnum & Bailey Circus stowed its tents and plodded sadly back to its winter quarters. "A magical era has passed," *Life* wrote in its eulogy for the big top.[63]

July 1956 wasn't the end of the circus, of course, but it felt like it. Tent circuses were prohibitively expensive: all that stuff to offload, all those meals to cook, all those Teamsters to pay. Thereafter the circus played indoor venues (fig. 131): arenas, armories, amphitheaters, Madison Square Garden — and television.

In the 1950s, more and more T.V. variety shows were booking clowns and jugglers. "The circus is less circusy after tv," said *Variety*, echoing the common complaint that in-home entertainment had all but replaced the genuine article.[64] Howdy Doody appeared on the sideshow platform when the Ringling circus played New York in 1950.[65] During the '50s, no fewer than four prime-time network programs (not counting kiddie shows) billed themselves as on-air circuses.[66] Eventually, with Jell-O as his sponsor, John Ringling North brought "The Greatest Show on Earth" to television in 1955. T.V. comic Milton Berle was the ringmaster; Marilyn Monroe rode a pink elephant in the Spec. And the circus special became an annual network event.[67]

Ironically, when the biggest American circus of them all gave up one of the primary marks of its identity – its ability to construct a virtual city of canvas overnight at each stop in its itinerant wanderings – that infinite capacity for architectural regeneration became a subject for study, celebration, and a prolonged national bout of nostalgia. A major article in *Fortune* magazine in the summer of 1947 dwelt on the Big Show's ability to maintain an "illusion of stability" in the midst of constant movement: at every stop, the tents went up, the equivalent of a small city was built in an afternoon – and then it came down again, even more quickly, and vanished overnight. Like a Roman military camp, the circus lot had a standard layout, called the straightaway or "Jack Robinson."[68] The main tent (486 stakes, 12 tons of fabric) was positioned in the middle of an eighteen-acre rectangular lot, with the public entrance on the short side, to the left, and the circus-only quarters – cookhouse, dressing tents, and smaller "tops" for wardrobe, animals, blacksmith, and the rest – clustered in protective isolation at the other end, or backyard. The sight of "billowing tents and flags whipping the halyards on a horizon that wasn't there a few hours ago" was as American as hot dogs, according to a 1948 feature article ("The Wonder City That Moves By Night") in the *National Geographic*. There was a lesson to be learned from the circus lot: "Here today and gone tomorrow, it is a state of restless American achievement, a pioneer peddler with magic in its pack."[69]

Cecil B. De Mille's movie *The Greatest Show on Earth* (1952) captures precisely this sense of the circus as the last vestige of the pioneer spirit: a place that springs to life in coherent form, as towns always do in the Western film, representing a flimsy outpost of civilization in the midst of chaos – except, of course, that the circus was the leaven of mystery, mirth, and madness intended to lighten the burdens of everyday life. De Mille joined the Barnum & Bailey show in Chicago in 1949, and stayed on to travel with the circus through a spell of bad weather, during which he learned to admire the determination and organizational genius that raised the tents regardless of obstacles. The trucks and the poles and the roustabouts became the real story of his blockbuster movie, despite a series of clichéd subplots involving rival aerialists and a criminal clown (played by Jimmy Stewart) hiding out behind the scenes.

In the introductory narration, recited over shots of tents and fluttering pennants, a plummy, melodramatic voice pays tribute to the circus as "a massive machine … a mechanized army on wheels," capable of replicating itself again and again, despite terrible adversity. Then the camera pulls back to reveal the entrance to winter quarters in Sarasota, Florida, and Charleton Heston, the iron-willed boss who gets the tents up and builds the circus city day after weary day (fig. 132). This is also the format of De Mille's *Ten Commandments* (1956), in which the same voice points out the moral of the story, and Heston, playing Moses, builds a city for the pharaoh of Egypt. The tent circus, in its final days under canvas, had acquired a sort of proto-biblical significance.

Whatever else it may have been, De Mille's Academy Award-winning *Greatest Show on Earth* is a tribute to American know-how and grit, and, incidentally, the best documentary view of the circus backyard ever filmed. To achieve its aura of visual credibility, De Mille's cameras followed the circus northward from Sarasota to its performance venues in Philadelphia and Washington.[70] Although the real stars of the big top were only glimpsed in passing in the final cut, they enjoyed the special treatment laid on by Paramount. Emmett Kelly (who was relieved to find he had only one spoken line in the script) remembered the delicious incongruity of stepping out of a studio limousine on "Clown Alley" in full "bum" makeup.[71] Critics and moviegoers alike made *The Greatest Show on Earth* the smash hit of 1952 less on account of the sappy story than because of the poetic beauty of three rings of acrobats soaring beneath a canvas sky in lyrical harmony.

In the 1930s and '40s, with only a few exceptions, the circus was B-movie, black-and-white fare. Circuses were only too happy to rent out props and performers. Clyde Beatty (fig. 133) became a minor-league star of the period, but more common were formula pictures, in which such familiar figures as Charlie Chan, Laurel and Hardy, or the Marx Brothers just happened to turn up under the big top (fig. 134).[72] In the 1950s and early '60s, on the other hand, the circus became a prime excuse for wide-screen Technicolor spectaculars, calculated to lure suburbanites back to the movies. De Mille's ambitious effort spawned many imitators: *The Big Circus* (1959), produced by Irwin Allen, added T.V. teen David Nelson to the cast in an effort to attract regular fans of *The Ozzie and Harriet Show* and *Trapeze* featured the much-photographed Italian sexpot Gina Lollabrigida in her American film debut. Fellini's brooding *La Strada* (1954), which showed the fringes of Italian circus life through the struggles of a waif played by Fellini's wife, Giuletta Massina, and a strongman played by Anthony Quinn, was neither gaily colored nor impressively panoramic in scale; its success nonetheless confirmed that the circus was a matter of concern across the board, for both Hollywood and the highbrows.

What the spate of circus stories indicates, perhaps, is a widepread regret that streamlining had gone too far in the postwar world – that tail fins and home freezers and Dior dresses and

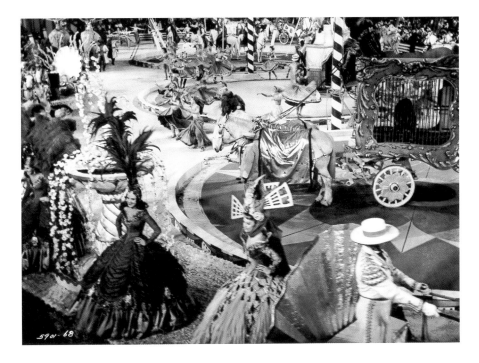

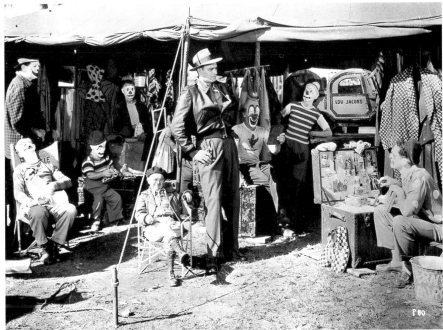

131
The "spec" as
re-created in
The Big Circus,
Allied Artists (1959).

132
The boss visits
Clown Alley in
*The Greatest Show
on Earth*,
Paramount (1952).

circus cakes by Betty Crocker had come at the price of important sectors of American culture. The fictional world of the circus (like the typical platoon in a war movie) constituted a kind of ideal society, diverse but tolerant, tight-knit, ready to pull together in times of crisis, or the ideals of neighborhood and front-porch friendliness abandoned in the flight to the suburbs. The circus was cotton candy and peanuts, little girls whining for celluloid kewpie dolls tied to a majorette's baton, and little boys begging their fathers for a toy whip just like Clyde Beatty's. Television could hardly do justice to sticky fingers, souvenirs, and the unforgettable aroma of peanuts roasting in the shell.

Design historian Bevis Hillier has observed that the circus was the storehouse in which the last of the great folk traditions of the prewar era were preserved. According to his count, at least thirty major books on the circus were published between 1943 and 1959 in England alone; for the United States, the list is even longer.[73] Fred Bradna's *The Big Top*, for example, offers an insider's look back on a forty-year career under canvas.[74] But there are also the circus tents emblazoned on wallpaper for children's bedrooms, the Bernard Buffet clowns printed on silk scarves (forerunners of that perennial flea-market favorite, the Sad Clown on black velvet), Fernand Léger's *Le Cirque* in postcard reproduction, and dishware adorned with bareback riders and trapeze artists.[75] The real circus seldom played small or even middling towns anymore. Most of the tents were gone. And so was the big parade down Main Street from the railroad tracks. Circus clowns were making animals out of balloons at children's birthday parties, when they worked at all. It was all a myth now, a memory, a motif on a playful summer outfit for m'lady, a babysitter-in-a-box for the kids who watched after-school television.

Today the circus has all but dissolved into a cluster of Las Vegas lounge acts: Sigfried and Roy with their white tigers; the postmodern artistry of Cirque de Soleil, carrying on the Bel Geddes tradition in a tent pitched in the parking lot of the Mirage Hotel; or the sophisticated, low-key performance art that passes for clowning in the stage-show version of the Big Apple Circus.[76] The Ringling Brothers and Barnum & Bailey Circus, when it does come to town, emphasizes the role of the circus menagerie in preserving and breeding rare animal species, the musical talents of its singing ringmaster, and the opportunity for the whole family to come early and learn the acrobats' tricks before the show starts.[77] Activists, meanwhile, meet the circus with picket lines and passionate assertions that any use of trained animals in a traveling show constitutes blatant abuse. "We're a business, but we're also protecting a way of life," asserted a spokeswoman for the Ringling circus, during a much-publicized Seattle protest in February 2000. As a kind of insurance, however, Ringling has developed a new one-ring "upscale" troupe (modeled on Cirque de Soleil and the Big Apple Circus): Kaleidoscope, as it is called, plays in a tent without any of the usual animal acts.[78] The name of the show acknowledges the fact that the contemporary circus has shattered into so many glittering fragments of enchantment, without a coherent physical or conceptual core. "Circus" has become a phrasebook of isolated quotations: candy stripes, spangles, an elephant (preferably mechanical) standing on his hind legs, a clown.

The most trenchant commentary on the meaning of the circus in our time comes from cartoonist Matt Groening, creator of the animated television series *The Simpsons*. Bart Simpson, the bad-boy hero, has chosen Krusty the Clown as his idol: Bart's room is awash in Krusty paraphernalia, and most episodes cut to the Simpson kids lined up on the couch in front of the set to watch Krusty's afternoon show. The highlight is a cat-versus-mouse kiddie cartoon that always manages to end in a bloodbath, to the vast amusement of the audience. Krusty, in other words, is no benign Bozo, no bumbling Clarabell, no vacuous Ronald McDonald. Groening draws upon the tradition of jesters and clowns as trans-

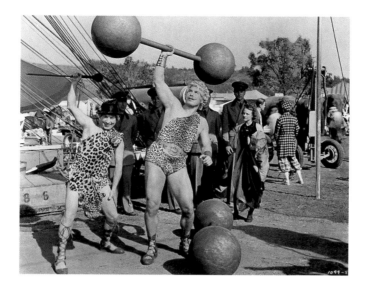

gressive figures who upset the rules of everyday life, much as red-nosed Shriners on tiny, noisy motorcycles disrupt the Memorial Day Parade. There is something vaguely "off" about Krusty, which appeals mightily to Groening's worldly-wise Simpson kids.

In *Simpsons* episodes aired during the 1990 and 1991 seasons, viewers learned more about the "man" behind the makeup (which Krusty never takes off). He is a sad clown because his father has disowned him for failing to become a rabbi; can he redeem himself by doing good for others in his role as a T.V. clown? Accused of robbery, Krusty tearfully admits that he can't read, thereby winning the sympathy of the jury. Bart, meanwhile, demonstrates that the robber on the surveillance tape has normal-size feet, but poor Krusty's are just as big as his funny clown shoes.[79] Although the aim is a sort of generalized satire, the Krusty shows pinpoint some of the most problematic aspects of the circus in today's world, including the disguise of the self in costumery, social attitudes toward those with physical anomalies,[80] and the feelings of acute discomfort that pass for genuine emotion when pathos is at issue (or what might be called the "Jerry Lewis Telethon effect"). Despite its recent reformations, the circus still reeks of freakery and sleazy sideshows, trickery, dishonest practices, and falsity of every kind. Krusty stands for the grifter who shortchanges the rube buying a ticket to see wonders that are merely grotesque.[81] Krusty exposes the make-believe tears of Weary Willie and his ilk.[82] What lurks behind the comic makeup could scare you half to death.

One of Stephen King's patented best-sellers relies on Americans' growing suspicion that clowns are creatures of terror, bent on dragging us to perdition and laughing all the way. *It*, set in New England over a thirty-year period ending in the mid-1980s, is the story of a sinister figure who periodically rises from the storm sewers of Derry, Maine, to dismember children. Some of his would-be victims, grown-ups now, come back to Derry to avenge

continued on p. 146

133
Clyde Beatty
stares down a lion in
***The Big Cage*,**
Universal (1933).

134
Harpo Marx
spoofs the Strong
Man in *At the Circus*,
MGM (1939).

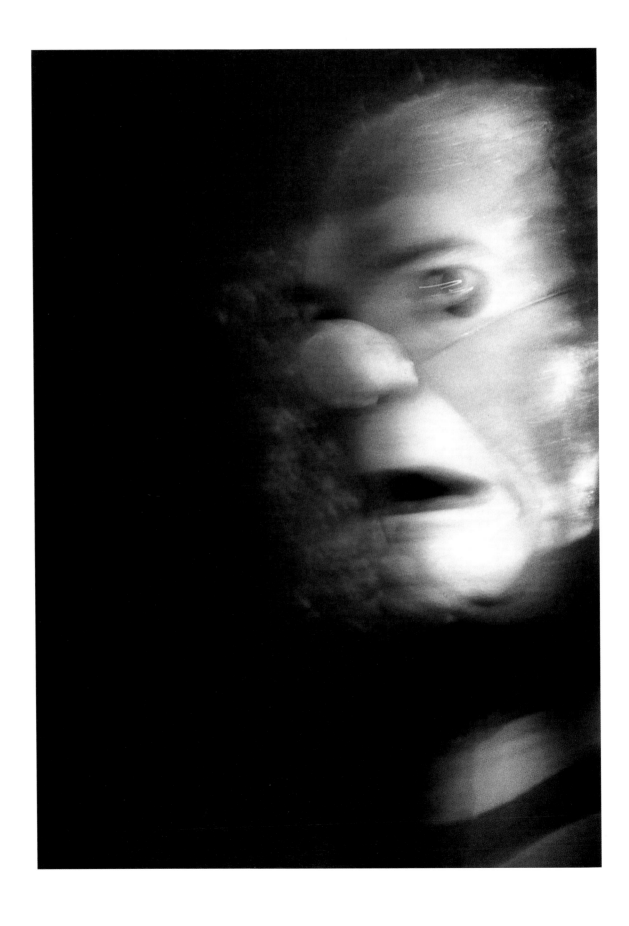

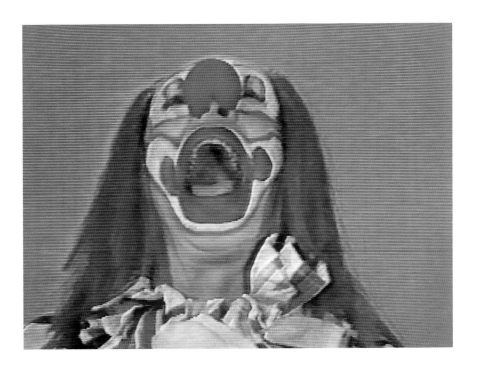

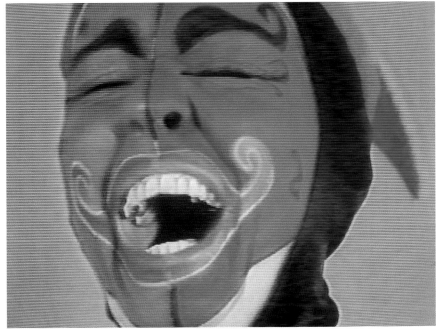

135
Kimberly Gremillion,
Clown #1, 1996.
Gelatin-silver print,
12 x 18 in.

136
Bruce Nauman,
Two stills from *Clown
Torture (Dark and
Stormy Night with
Laughter)*, 1987.
Two color video moni-
tors, two vcrs, two
videotapes

themselves on the malign spirit who appeared to them as Pennywise the Dancing Clown, in a shiny silver suit with big orange pompom buttons. "It was a clown," King writes, "like in the circus or on TV. In fact he looked like a cross between Bozo and Clarabell." And he had huge, lethal teeth, "like the lion in the circus." "It's time for the circus!" Pennywise screams with glee, as he snatches his latest victim.[83] Like Groening, King draws on a reservoir of popular culture to create works that mesmerize by virtue of their sheer familiarity: suddenly, because we remember Bozo so well, we *know* what is happening in Derry and can appreciate the spine-chilling horror of characters whose ordinary lives skew sideways by inches, to disclose the abyss. Pennywise, when his happy whiteface smile begins to slip, is revealed as the Antichrist on a rampage though Maine, the archetypal child molester.

There's a name for the condition King discusses: "Coulrophobia," or just plain "clownaphobia," a neurotic fear of clowns sparked by a growing suspicion that people in weird outfits may actually be weirdos.[84] Artist Bruce Nauman, in his video work *Clown Torture* (fig. 136), uses the clown as a punching bag for the sins of a century. "It's existential vaudeville," says one cultural historian, "equal parts Bozo and Beckett, slapstick and schadenfreude.... All the world hates a clown."[85] John Wayne Gacy, the serial killer who murdered thirty-three boys and then buried them under the crawlspace of his Chicago home in the 1970s, passed himself off as a model citizen and part-time "registered clown." "I work with kids," Gacy told the investigating officers. "I go to hospitals to entertain them. You guys are barking up the wrong tree." In full makeup, he also supervised parades for the city. Gacy enjoyed that job best. "Nobody ever questions what clowns do. Hell, clowns can go up to broads on the sidelines and squeeze their tits, and all the women do is giggle. You know, clowns can get away with murder."[86] The front room of the murder house was decorated with maudlin paintings of weeping clowns; to pass the time on Death Row, Gacy painted clowns as gifts for his jailhouse pen pals.[87]

Stephen King and John Wayne Gacy may have been the muses who inspired the classic, terrible, low-budget teen/horror flick called *Killer Klowns from Outer Space* (1988). Or perhaps it was the generic clown who hands out balloons at the opening of the latest used car lot: the commercial alliteration of the title (Madison Avenue loves words like "klean," "krispy," and "krusty") points in that direction. The sketchy storyline of *Killer Klowns* involves a group of teenage friends; they stumble upon a striped tent that has rocketed to earth near a lover's lane, a tent filled with pink cotton-candy pods from which an army of evil-faced clowns suck bloody fluids through curvy "krazy" straws. When discovered at their gruesome snack, the clowns fight back with guns that shoot deadly pellets of popcorn and then spread out through town to wreak havoc on unwary citizens conditioned to see clowns as harmless pests. A big clown with a pizza delivery? No problem, until the unwary customer is fitted out for a pod. A street-corner clown,

making animals out of balloons? Cool, until the cute little toy dog turns into a vicious man-tracking hound. Pursued by a band of brave teens in an ice-cream truck with a plastic clown head on top, the villains finally retreat to their tent and take off for outer space. When the tent explodes in midair, cream pies rain down upon the startled onlookers, and the movie is over, with no further explanation of why the aliens chose to present themselves as clowns. Is it simply because, underneath the greasepaint and the polka dots, clowns really are evil?

Or because the circus no longer serves as a potent self-congratulatory metaphor for the restless energy of the American pioneer and the conquest of the natural world? Because we have begun to question the morality of that ur-story of nineteenth-century history? Because we are more apt to root for the lion nowadays than for Clyde Beatty, with his whip and his chair? Because feats of daring on the high wire have been reduced to ho-hum status by endless repetition? Because we've seen it all before on T.V. or in the movies? Because the laughter and tears of the clown seem both indistinguishable and profoundly bogus? Or because, like the circus cake, it's just kid stuff?

Notes

1
Betty Crocker's Picture Cook Book (Minneapolis: General Mills, 1950), 166. See also Karal Ann Marling, *As Seen on TV: The Visual Culture of Everyday Life in the 1950s* (Cambridge: Harvard University Press, 1994), 226–30.

2
The circus giveaway in my collection, ©1952, celebrated the twenty-fifth anniversary of G.E.'s refrigerators.

3
"The Circus Barker" depicts children putting on a circus sideshow; Starkey Flythe, Jr., *Norman Rockwell and the "Saturday Evening Post,"* vol. 1 (New York: MJF Books, 1994), 5–6.

4
"Biggest Show on Television Promotes Ice Cream," *Ice Cream Review*, October 1951, 108, 110.

5
John A. Jakle and Keith A. Sculle, *Fast Food: Roadside Restaurants in the Automobile Age* (Baltimore: Johns Hopkins University Press, 1999), 153.

6
Bill Cotter, *The Wonderful World of Disney Television: A Complete History* (New York: Hyperion), 106–07. *Dumbo* was based on the Cole Brothers circus.

7
The film suffered at the box office because its initial release coincided with the beginning of World War II; "Mammal-of-the-Year," *Time*, December 29, 1941, 27–28.

8
Alex McNeil, *Total Television*, 4th ed. (New York: Penguin, 1996), 96, 114. Long-time NBC weatherman Willard Scott got his start as Bozo in Washington, D.C.

9
John Culhane, *The American Circus: An Illustrated History* (New York: Henry Holt, 1990), 109.

10
Buffalo Bob Smith and Donna McCrohan, *Howdy and Me: Buffalo Bob's Own Story* (New York: Plume Books, 1990), 42.

11
Lorraine Santoli, *The Official Mickey Mouse Club Book* (New York: Hyperion, 1995), 132.

12
For segments from the show, see *The Mickey Mouse Club*, vols. 1–6, Walt Disney home video series (undated).

13
For detailed information on *The Clown*, see the IMDb website at http://us.imdb.com.

14
Tom Ogden, *Two Hundred Years of the American Circus: From Aba-Daba to the Zoppe-Zavatta Troupe* (New York: Facts on File, 1993), 349–50.

15
Karal Ann Marling, *Graceland: Going Home with Elvis* (Cambridge: Harvard University Press, 1996), 163–64.

16
See "Pagliacci – Clowns a Specialty," 327A John Ringling Boulevard, Sarasota, Florida. There are other specialist dealers who trade in autographed copies of Skelton's autobiography and clown reproductions in other mediums. See 1-800-899-4RED.

17
Marling, *As Seen on TV*, 70.

18
Dan Robbins, *Whatever Happened to Paint-by-Numbers?* (Delavan, Wis.: Possum Hill Press, 1997), 115, 118.

19
Madeline Marsh, *Miller's Collecting the 50s* (London: Miller's 1997), 67.

20
Richard Horn, *Fifties Style* (New York: Beech Tree Books, 1985), 27; Robin Langley Sommer, *"I Had One of Those:" Toys of Our Generation* (New York: Crescent Books, 1992), 9, 10–11.

21
Shawn Levy, *King of Comedy: The Life and Art of Jerry Lewis* (New York: St. Martin's, 1996), 178–88.

22
Ibid., 309–10. Lewis's major (unreleased) film project of the 1960s and '70s cast him as a German circus clown who leads children into the gas chamber at Auschwitz.

23
Kate Buford, *Burt Lancaster: An American Life* (New York: Alfred A. Knopf, 2000), 35, 170. See also *Mud Show: American Tent Circus Life* (Albuquerque: University of New Mexico Press, 1988) and Fred Powledge, *Mud Show: A Circus Season* (New York: Harcourt Brace Jovanavich, 1975).

24
Buford, *Burt Lancaster*, 152.

25
Ibid., 155.

26
Laurence E. Schmeckebier, *John Steuart Curry's Pageant of America* (New York: American Artists Group, 1943), 207, 211.

27
Ibid., 156.

28
Louis Zara, "The Flying Codonas," *Esquire*, July 1937, 131; "Kansan at the Circus," *Time*, April 10, 1933, 41–42, 1933, 41–42.

29
Quoted in Patricia Junker, *John Steuart Curry: Inventing the Middle West* (New York: Hudson Hills Press. 1998), 157. See also Alfredo Codona, "Split Seconds," *Saturday Evening Post*, December 6, 1930, 12–13, 75–76.

30
William F. McDonald, *Federal Relief Administration and the Arts* (Columbus: Ohio State University Press, 1969), 561.

31
Emmett Kelly with F. Beverly Kelly, *Clown* (New York: Prentice-Hall, 1954), 122–25.

32
See Andrea O. Dean, "He Was an Acrobat on the Leading Edge of Jazz Age Art," *Smithsonian* 18, no. 7 (1987), 58–67.

33
Edward Alden Jewell, "Sawdust and Peanuts," *New York Times*, April 7, 1929.

34
In 1933, Curry invited Codona, Beatty, Zacchini, and his other famous subjects to a circus-themed exhibition of his work at the Ferargil Galleries; see "Circus Troupe to View Art of Sawdust Ring," *New York Herald Tribune*, March 29, 1933.

35
Culhane, *The American Circus*, 204, 238; George Leonard Chindahl, *A History of the Circus in America* (Caldwell, Idaho: Caxton Printers, 1959), 164–69. See also Tom Parkinson and Charles Philip Fox, *The Circus Moves by Rail* (Newton, N.J.: Carstens Publications, 1993), 28–29.

36
Booth Tarkington, *The Gentleman from Indiana* (New York: AMS Press, 1899), 107–08. See also Lewis Atherton, *Main Street on the Middle Border* (Chicago: Quadrangle Books, 1966), 131–35.

37
Thomas Wolfe, *Only the Dead Know Brooklyn* (New York: New American Library, 1977), 32–34.

38
Joyce Kilmer, *The Circus and Other Essays* (New York: Lawrence J. Gommer, 1916), 6.

39
Odgen Nash, "The Big Tent Under the Roof," in *Verses From 1929 On* (Boston: Little Brown, 1959), 60–61.

40
"Rites of Spring," *Time*, April 21, 1947, 69. This connection between the circus and the seasons was already a tired journalistic convention in the 1920s.

41
L. Joy Sperling, "Calder in Paris: *The Circus* and Surrealism," *Archives of American Art Journal* 23, no. 2 (1988), 16–29.

42
L. Joy Sperling, "The Popular Sources of *Calder's Circus: The Humpty Dumpty Circus*, Ringling Brothers and Barnum and Bailey, and the Cirque Medrano," *Journal of American Culture* 17, no. 4 (1994), 1–14.

43
See Bernard A. Weisberger, ed., *The WPA Guide to America* (New York: Pantheon Books, 1985), x–xvi.

44
See, for example, Joseph S. Czestochowski, *Marvin D. Cone: An American Tradition* (New York: Dutton, 1985), 29, 38–39, 51.

45
One good example is *Art for the Public*, a show of works by local artists of the Federal Art Project, held in 1938 at the Art Institute of Chicago. Washington, D.C., hosted similar exhibitions, beginning in 1934, to show the public what it was getting for its tax dollars.

46
Carlton Brown, "Notes on a Peanut Bag," *New Republic*, May 13, 1940, 642.

47
William Hausberg, "Rebirth of an Old Sawdust Empire," *Nation's Business*, August 1940, 30.

48
Ernest J. Albrecht, *A Ringling by Any Other Name: The Story of John Ringling North and His Circus* (Metuchen, N.J.: Scarecrow Press, 1989), 101.

49
Norman Bel Geddes, "The Circus Goes Mechanical," *New York Times*, December 2, 1940.

50
Jennifer Davis Roberts, *Norman Bel Geddes* (Austin: Michener Galleries, University of Texas, 1979), 44–46.

51
Bel Geddes, "The Circus Goes Mechanical."

52
Billy Pape, "Renovating the Circus," *Billboard*, March 2, 1940, 32, 59.

53
"Four Steel Towers Support New Poleless Circus Tent," *Popular Science*, March 1941, 97.

54
"Circus Time," *Newsweek*, April 10, 1940, 18.

55
"Menagerie in Blue," *Time*, April 21, 1941, 61.

56
Jane Preddy, "Costumes and Clowns: Bizarre Projects of Norman Bel Geddes," *Journal of Popular Culture* 20: 2 (1986), 35–36. See also Davis Lewis Hammarstrom, *Big Top Boss: John Ringling North and the Circus* (Urbana and Chicago: University of Illinois Press, 1992), 89–91.

57
For a time, in the 1920s, Bel Geddes had produced and designed the Macy's Thanksgiving Day Parade, with balloon figures he later suggested leasing from Macy's for use in the circus in the 1940s; see Karal Ann Marling *Merry Christmas: Celebrating America's Greatest Holiday* (Cambridge: Harvard University Press, 2000), chapter 3.

58
"Circus Defrilled," *Business Week*, April 10, 1943, 28.

59
R. J. Brown, "The Day the Clowns Cried," *Hartford Courant*, April 22, 1989. See also Stewart O'Nan, *The Circus Fire* (New York: Doubleday, 2000).

60
"Signs of Spring," *Time*, April 16, 1945, 84; "Circus Terms Lightened," *Business Week*, April 14, 1945, 46; "It's Circus Time," *Business Week*, April 7, 1945, 24.

61
Culhane, *The American Circus*, 241, 250.

62
Randy Bright, *Disneyland: Inside Story* (New York: Harry N. Abrams, 1987), 124–25.

63
"Big Top Bows Out Forever," *LIFE*, July 30, 1956, 13.

64
Hammarstrom, *Big Top Boss*, 200.

65
Albrecht, *A Ringling by Any Other Name*, 188.

66
McNeil, *Total Television*, 96, 165.

67
Hammarstrom, *Big Top Boss*, 206–07.

68
"The Circus," *Fortune*, July 1947, 109–13, with paintings and drawings by Karl Zerbe.

69
Francis Beverly Kelly, "The Wonder City That Moves by Night," *National Geographic*, March 1948, 289.

70
Albrecht, *A Ringling by Any Other Name*, 194–95.

71
Kelly, *Clown*, 249–54.

72
The Marx Brothers' *At the Circus* (1939) features Groucho's greatest comic song, "Lydia the Tattooed Lady."

73
Bevis Hillier, *The Decorative Art of the Forties and Fifties: Austerity/Binge* (New York: Clarkson N. Potter, 1975), 68–79.

74
Fred Bradna with Hartzel Spence, *The Big Top: My Forty Years with The Greatest Show on Earth* (New York: Simon and Schuster, 1952).

75
See Jennifer Heath, *Black Velvet: The Art We Love to Hate* (San Francisco: Pomegranate, 1994), 80. Paul S. Donhauser, *History of American Ceramics: The Studio Potter* (Dubuque, Ind.: Kendall/Hunt, 1978), 88, illustrates American ceramic sculpture depicting circus animals.

76
"Burning Bright," *People Weekly*, April 17, 200, 136–38; Ernest J. Albrecht, *The New American Circus* (Gainesville: University Press of Florida, 1995), 148; program for "Oop! The Big Apple Stage Show" (1999), unpaginated. For the latter, see also http://www.bigapplecircus.org/ oopsgrameset.html.

77
Program for Ringling Brothers and Barnum & Bailey Circus, "The Living Carousel" (2000), unpaginated.

78
"Critics Put Circuses in Hot Spotlight," *USA Today*, February 11, 2000.

79
"Krusty Gets Busted" (1990) and "Like Father, Like Clown" (1991), aired on the Fox network.

80
On contemporary attitudes toward "extraordinary" bodies, see Rosemarie Garland Thomson, ed., *Freakery* (New York: New York University Press, 1996) and Robert Bogdan, *Freak Show: Presenting Human Oddities for Amusement and Profit* (Chicago: University of Chicago Press, 1988). The Jim Rose Freak Show – with a cast that eats glass, regurgitates peculiar substances, and practices various self-mutilations – makes a performance piece out of the old sideshow; see Jim Rose with Melissa Rossi, *Freak Like Me* (New York: Dell, 1995), with an introduction by Katherine Dunn (author of *Geek Love*, a novel with a huge underground following).

81
See "Grifting Isn't So Good," *Saturday Evening Post*, May 17, 1924, 16.

82
Emmett Kelly, Jr., *Travels Through American History with the World's Most Famous Hobo Clown* (San Dimas, Calif.: EKJ Books, 1992).

83
Stephen King, *It* (New York: Signet, 1987), 12, 33, 591.

84
See Garg Greenberg, *The Pop-Up Book of Phobias* (New York: Morrow, 1999).

85
Mark Dery, *The Pyrotechnic Insanitarium: American Culture on the Brink* (New York: Grove Press, 1999), 65–66.

86
Terry Sullivan with Peter T. Maiken, *Killer Clown: The John Wayne Gacy Murders* (New York: Pinnacle, 1983), 77.

87
See Jason Moss with Jeffrey Kottler, *The Last Victim* (New York: Warner Books, 1999).

CHICK
AUSTIN:
THE
RINGMASTER
AT THE MUSEUM

EUGENE R. GADDIS

ON MORE THAN ONE OCCASION, A. EVERETT AUSTIN, JR., KNOWN TO NEARLY EVERYONE AS "CHICK," APPEARED IN PUBLIC DRESSED IN THE COSTUME OF A RINGMASTER. NOT SIMPLY A REFLECTION OF HIS FLAIR FOR THE DRAMATIC, THE ROLE WAS A FITTING METAPHOR FOR HIS MULTIPLE ACTIVITIES AS DIRECTOR OF THE WADSWORTH ATHENEUM IN HARTFORD FROM 1927 TO 1944 AND OF THE JOHN AND MABLE RINGLING MUSEUM OF ART IN SARASOTA FROM 1946 UNTIL HIS DEATH IN 1957. CONNOISSEUR, TEACHER, PAINTER, ACTOR, MAGICIAN, AND DESIGNER OF SETS AND COSTUMES (FIG. 137), CHICK AUSTIN WAS ONE OF AMERICA'S MOST INNOVATIVE MUSEUM DIRECTORS.

In Hartford Austin pioneered the rediscovery of Baroque art through his acquisitions and exhibitions, beginning with *Italian Paintings of the Sei- and Settecento* in 1930; and he helped introduce modern art to the United States with the nation's first comprehensive exhibitions of the Surrealists in 1931 and Pablo Picasso in 1934. He essentially designed the interior of the museum's Avery Memorial wing of 1934 – the first example of the radically new International Style of architecture in an American museum. He led the way in bringing all the arts into the modern museum – music, drama, dance, film, and photography – and with his deeply theatrical nature, he engaged in such far-reaching artistic enterprises as sponsoring, at the urging of his friend Lincoln Kirstein, the immigration of choreographer George Balanchine to America in 1933 and producing the premiere of the celebrated opera by Gertrude Stein and Virgil Thomson, *Four Saints in Three Acts* (1928) in 1934.

Like many of the artists he championed – whether old masters or modernists – Chick loved the circus. He saw in it a theatrical setting where the adventures and misadventures of life were heightened to the utmost, where music and gaudy spectacle, acts inspiring laughter or pathos, and amazing feats created a fantasy world of unending entertainment. The theme of the circus could be found in his exhibitions, acquisitions, and even in the public parties he organized at the Wadsworth Atheneum. In Sarasota he presented exhibitions specifically linked to the enterprise that had enabled Ringling to amass his art collection. Austin also opened, on the grounds of the Ringling, the Museum of the American Circus, the first serious institution of its kind in the United States.

Austin's fascination with the circus began in Paris in the spring of 1910, when he was taken to see "Bostock's Jungle," one of Europe's best-known circus acts, at the Jardin Zoologique. On the back of a postcard of a lion tamer in the show, the nine-year-old Austin recorded, as if it were an historic occasion: "Everett Austin has seen this in Paris, 28 April 1910."[1] A few months earlier, while a student in Dresden, he had begun his theatrical career, having constructed a miniature set for Wagner's *Flying Dutchman* and performed his own version of the opera for his classmates. In Paris that same year, he made his first appearance as a magician, "Professor Marvel," entertaining his French school friends with feats of prestidigitation. He continued polishing his magic skills throughout his teenage years, performing publicly in Windham, New Hampshire, where his mother owned a hundred-acre estate, and in South Harpswell, Maine, where his parents had built a summer cottage.

His interest in spectacle was considerably broadened as a Harvard undergraduate by his introduction to the Ballets Russes of Serge Diaghilev in Paris in 1923. Seeing the unprecedented collaboration of artists, composers, choreographers, and dancers was, Austin later wrote, "the most intense emotional experience of my life."[2] He returned to Europe every summer thereafter, until Diaghilev's death in 1929, to attend performances of the Ballets Russes. This fusion of talents inspired Austin to become as much an impresario of the arts as a director of museums.

Throughout his Hartford career, as he introduced the public to the greatest artists of the seventeenth and eighteenth centuries, Austin showed a particular fondness as well for the commedia dell'arte, that irresistibly colorful form of Italian popular theater (with its connections to the street acrobats and clowns who evolved into circus performers), which had inspired painters and poets for at least four centuries. Austin made the commedia dell'arte a thematic element of the Wadsworth Atheneum's first costume ball, the Venetian Fête, which he organized April 1928, six months after arriving in Hartford. He urged party-goers to dress as members of the Doge's court, Murano glass figurines, or characters from paintings by Pietro Longhi, plays by Carlo Goldoni, or the Italian comedy. He himself appeared as the melancholy clown Gilles, as depicted in the eighteenth century by Jean-Antoine Watteau, in a blouse, trousers, and circular hat (all of white satin), but with the addition of a floor-length dark cape (fig. 138).

Among the seventeenth-and eighteenth-century paintings in this spirit that Austin subsequently bought for the Atheneum were such works as *Carnival in the Piazza Colonna, Rome*, of about 1645–50, by Jan Miel (fig. 139), and five large painted panels by Johann Joseph Scheubel II, collectively called *Carnival in Venice*, from about 1745 (fig. 140). The panels were cartoons for a tapestry series commissioned for the Archepiscopal Palace in Würzburg, Germany, and in 1940 Austin installed them in the Art Deco lobby of the theater he had designed for the museum's Avery Memorial wing. Here, actors from the Italian comedy could be contemplated eating, drinking, and flirting against the backdrop of the Grand Canal and other Venetian scenes. In 1928, Austin made his greatest purchase of a nineteenth-century work on a circus-related theme: Honoré Daumier's *The Saltimbanques Changing Place*, a profoundly affecting drawing in charcoal and watercolor from about 1865 (fig. 141), showing a family of Paris street performers moving on with their few worldly possessions.

The circus theme appeared in pictures by contemporary artists whose paintings Austin showed in Hartford. Not surprisingly, in the vast Picasso retrospective that opened the Avery Memorial wing in 1934, visitors could see such works as *The Harlequin's Family*, an oil of 1905, and a drawing called *Les Saltimbanques*, of 1926. But it was the paintings of younger artists based in Paris, the Neo-Romantics – Pavel Tchelitchew, the brothers Léonid and Eugene Berman, Kristians Tonny, and Christian "Bébé" Bérard – that Austin found especially congenial. These works suggested to Austin and members of his modernist circle – architectural historian Henry-Russell Hitchcock, collector and Museum of Modern Art curator James Thrall Soby, and New York dealer Julien Levy – that there might be a return to figurative painting after nearly three decades of abstract and Cubist painting. Austin gave the Neo-Romantics their first museum group exhibition in 1931, which included *The*

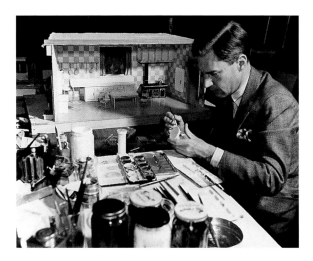

137
Chick Austin
designing the set
for *Tovarich*
produced by the
Little Theater of
Hartford, 1940.

138
Chick Austin
chatting with Mrs.
Charles Goodwin
(left) and Mrs.
Richard Bissell
(right) at the
Venetian Fête,
April 1928.

139
Jan Miel,
*Carnival in the
Piazza Colonna
Rome*, ca. 1645–50.
Oil on canvas,
35 x 69 ¼ in.
Wadsworth
Atheneum Museum
of Art, Hartford;
the Ella Gallup
Sumner and Mary
Catlin Sumner
Collection Fund

140
Johann Joseph
Scheubel II,
Carnival in Venice
(central panel of
five, *Table in the
Kiosk*), ca. 1745
Oil on canvas,
123 ¾ x 347 ½ in.
Wadsworth
Atheneum Museum
of Art, Hartford;
the Ella Gallup
Sumner and Mary
Catlin Sumner
Collection Fund

141
Honoré Daumier,
*The Saltimbanques
Changing Place*,
ca. 1865.
Charcoal and
watercolor on
paper,
14 ½ x 11 in.
Wadsworth
Atheneum Museum
of Art, Hartford; the
Ella Gallup Sumner
and Mary Catlin
Sumner Collection
Fund

Burial of a Clown and Fallen Clown by Tchelitchew, who had a life-long obsession with the circus. In 1938 Austin showed that artist's monumentally controversial painting *Phenomena* (1935–38), an expression of the grotesque elements (including freaks of various descriptions) that Tchelitchew believed were pervading modern culture. In 1943, toward the end of his tenure in Hartford, Austin purchased one of Tchelitchew's most memorable images, *Pip and Flip* (fig. 148), an unsettling portrait of two well-known freak-show per-formers at home in New York, originally intended as an oil sketch for *Phenomena*. During Austin's career at the Atheneum, he also exhibited works by several twentieth-century American artists inspired by subjects from the circus world: Alexander Calder, Charles Demuth, Yasuo Kuniyoshi, John Marin, and Reginald Marsh.

Perhaps Austin's most dramatic presentation of the circus theme came in February 1936 as part of the Hartford Festival. Following in the footsteps of impresarios Diaghilev and Max Reinhardt (founder of the Salzburg Festival in 1920), Austin produced a weeklong series of programs and performances that included the American premiere of Erik Satie's symphonic drama *Socrate*, with a mobile set by Calder; a specially commissioned ballet choreographed by George Balanchine, *Serenata: "Magic,"* with sets and costumes by Tchelitchew; a concert version of Stravinksy's ballet cantata *Les Noces*; a film festival arranged by Iris Barry (founder of the film library at the Museum of Modern Art); and a concert of eighteenth- and twentieth-century music.

The festival culminated with the Paper Ball, or "Le Cirque des Chiffoniers." Austin invited Tchelitchew to create a fantastical

décor for the ball by covering the balconies of the Avery Memorial wing's central court with painted newspapers and paper garlands (fig. 142) and then asked him, Eugene Berman, Alice Halicka, and Calder to design costumes for several of the twelve groups of rev-elers, who paraded through the museum. Austin led the proces-sion, waving a whip and dressed, in one of Tchelitchew's creations, as "The Ringmaster" in a top hat and a red coat (fig. 143). Although there was a group called "On Va au Cirque" (We're Going to the Circus), in which Hartfordites appeared as a circus audience attired in costumes suggesting the Gay Nineties, the most original presen-tation was Calder's "Nightmare Side Show" (fig. 144). This consisted of a menagerie of circus animals — lions, horses, and elephants — impersonated by guests wearing brown-paper costumes made for them by Calder that night after dinner at James Thrall Soby's house in nearby Farmington. (Among the members of this group was Henry-Russell Hitchcock, wearing a Calder pachyderm costume over an outfit representing "Architecture.") Soby recalled that the party did not break up until well into the morning hours of the next day and "ended quite literally with a splash. Sandy Calder in one of his chronic fits of playfulness pushed Chick Austin into one of the shallow pools in the Avery court, and the marble floor ran scarlet from the red paper costume Chick had been wearing."[3]

Four years later, Austin again took on the persona of ringmas-ter in one of the annual Christmas magic shows he had been pre-senting at the museum since 1932 for the benefit of the children's art classes. (He called himself "The Great Osram," after the German company that made the light bulbs used in the International Style

rooms of the Palladian-style house he had built in Hartford. His December 1940 magic show, called "Magical Merry-Go-Round," was inspired by three turn-of-the-century carousel horses he had used for the museum the previous summer and borrowed for the performance. He began the show with a leap from a carousel as "The Tricky Hussar" (fig. 145) and ended it as the ringmaster in a scene called "The Incredible Circus" (fig. 149). As Austin cracked his whip, an assortment of dancers dressed as lions, tigers, and other wild animals broke out of their cages, ponies galloped around the ring, and trapeze artists and tightrope walkers demonstrated their skills — all to the music of Saint-Saëns's *Carnival of the Animals*. The Ringmaster was only able to restore order to the scene with the help of three circus freaks: "The Blue Man," "The Tattooed Man," and "Emma, the Fat Girl." These were based on figures in Tchelitchew's *Phenomena*, which had shocked Hartford viewers two years earlier — a typically teasing Austin gesture.

In addition to appearing as "The Great Osram," Austin took on leading roles in a variety of plays in the Atheneum's theater, ranging from Noël Coward comedies to Shakespeare's *Hamlet*. He continued acting after becoming director of the Ringling Museum in 1946, joining the Players of Sarasota. That same year, on the New Hampshire property he had inherited from his mother, he converted a barn into a summer theater, where he produced plays and frequently performed in them.

At the Ringling Museum, Austin seized the chance to focus on the circus component of the museum's collection and its origins. As early as his interview for the directorship in the spring of 1946 (at which his old Harvard mentor, Edward Forbes, was present),

he proposed creating a circus museum. He reported excitedly to his wife Helen back in Hartford: "You should see the warehouses of 1870 Baroque – Im [sic] going to exhibit it – with circus wagons etc … a circus museum which shocked Edward Im [sic] afraid but entranced the board … it will be fun."[4] To the Sarasota press at his first news conference that May, Austin said that he "wanted to play up the theme, 'Art in the Circus,'" a theme that "should be constantly developed."[5]

The circus museum remained a favorite project, even as Austin faced the most pressing tasks of conserving the badly deteriorating paintings in the collection, refurbishing the galleries and Ringling's mansion, Ca'd'Zan, and starting an educational program. He gathered up circus material and, based on a model he made himself, renovated a small warehouse on the grounds of the museum by adding a wooden entrance resembling that of a circus tent or an eighteenth-century pavilion (fig. 150). The interior was also redesigned to give visitors the illusion that they were under the "big top" (fig. 151). A central pole and curved steel girders supported a striped awning ceiling beneath the roof; the floor was covered in black-and-white parquet; and the walls were resplendent with red-and-gold painted paneling from the Astor mansion in New York (which John Ringling had purchased but never used). On March 27, 1948, the Museum of the American Circus opened to the public, touted as the first serious museum in the country devoted to the history of the circus. Austin was resolved that it would be "an authentic art museum."[6] He told the *Florida Times-Union* that "the new museum will evoke the romantic spirit of the American circus," and he linked it to the Ringling collection,

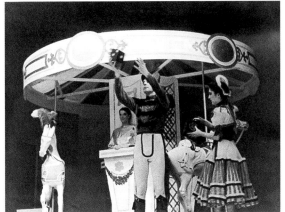

calling the modern circus "a Baroque spectacle, not a Roman tri-umph."[7] A later annual report, clearly written by Austin, declared that

the Circus Museum shall illustrate more and more completely the stages whereby the modern circus evolved from the Baroque Spectacle and the Italian Comedy of the 17th century, and the exotic influences on these traditions prevalent in the 18th. With the help of documents drawn from those centuries as well as from the 19th, the exhibits will increasingly emphasize the peculiar beauty of the art of the circus with its emphasis on the fantastic, the bizarre, the grotesque and the exotic.[8]

At the beginning, the Circus Museum contained a small number of objects – vintage posters and handbills, photographs, masks, costumes, and five gilded and painted horse-drawn circus wagons lent from the Ringling Brothers & Barnum and Bailey Combined Shows. Austin steadily added to the collections during his decade at the Ringling Museum with such items as eighteenth-century peep shows, a calliope, a mechanical doll in the form of a music box, prints, woodcuts, photographs, books, a miniature eighteenth-century French circus, a model of Astley's Amphitheater in London, and a vast working model of the Ringling circus. He also incorpo-rated a large collection of magic paraphernalia into the Circus Museum, in accord with his belief that magic shows were closely allied with the circus.

In January 1949 Austin presented, as his second major winter exhibition at the Ringling Museum, *Art, Carnival and the Circus.*

continued on p. 158

142
Avery Court as decorated by Pavel Tchelitchew for the Paper Ball, February 15, 1936.

143
Pavel Tchelitchew, *Ringmaster*, 1936. Watercolor on cardboard, 16 7/8 x 7 7/8 in. Wadsworth Atheneum Museum of Art, Hartford; the Ella Gallup Sumner and Mary Catlin Sumner Collection Fund

144
"Nightmare Side Show" at the Paper Ball, brown-paper costumes designed by Alexander Calder. Burton E. Moore still from *Le Cirque des Chiffoniers*.

145
Chick Austin as "The Tricky Hussar" in the Magical Merry-Go-Round, with "Steffi, a Dancer at the Opera" (Elena Longo), Avery Theater, Wadsworth Atheneum Museum of Art.

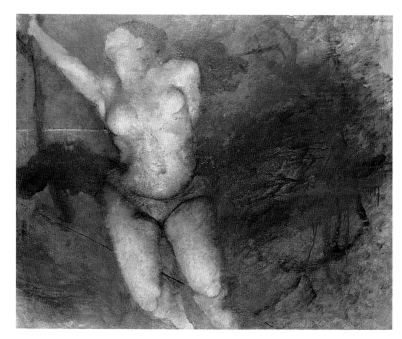

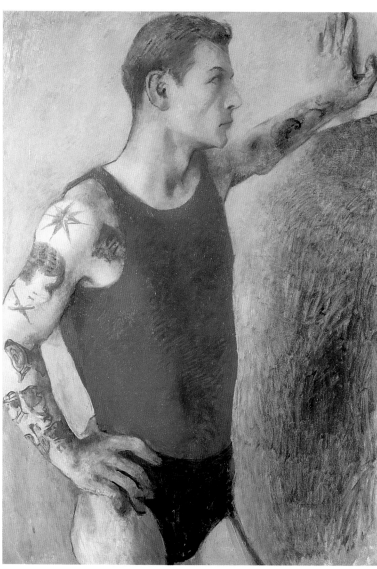

146
Pavel Tchelitchew,
Female Acrobat,
1931.
Oil on canvas,
31 ¾ x 39 ½ in

147
Pavel Tchelitchew,
*Acrobat in
Red Vest*, 1931.
Oil on board,
41 ½ x 29 ¾ in.

148
Pavel Tchelitchew,
Pip and Flip, 1935.
Oil on canvas,
18 x 15 in.

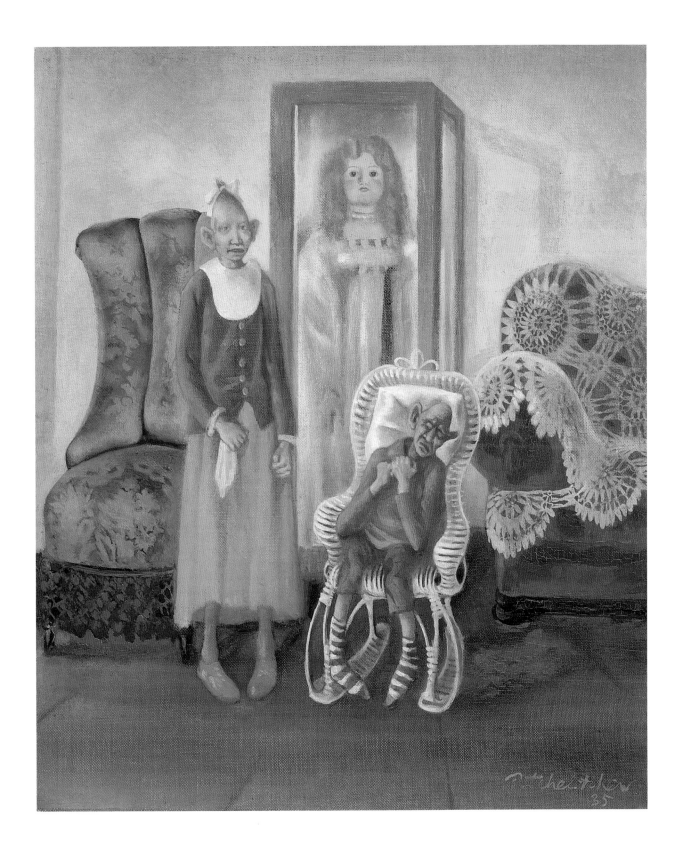

This included works from the seventeenth century to the twentieth, ranging from Luca Carlevaris's *Acrobats* to Giambattista Tiepolo's *Group of Punchinellos with Dancing Dogs*, Daumier's *The Saltimbanques Changing Places*, Henri de Toulouse-Lautrec's *Le Cortege du Rajah*, Juan Gris's *Pierrot – Sketch for a Costume*, Marc Chagall's *The Trapeze*, Walt Kuhn's *The Juggler*, and Reginald Marsh's *Merry-Go-Round*. To the Florida press, he explained his long-range view of art history, linking the past to the present, as he had throughout his career: "This museum was made possible by the circus. But that was the American circus. We want to remind the public that as a form of entertainment, it is based on a long tradition, and that it has always appealed to artists as material for their compositions."[9]

Austin made many purchases for the Ringling Museum related to the Italian comedy, which now assumed greater significance for him as a subtext in the Ringling's collection. In 1950 he acquired fifteen decorative paintings, collectively called *The Disguises of Harlequin*, by the eighteenth-century Florentine painter Giovanni Ferretti (fig. 152). Austin was delighted that they came from the estate of Max Reinhardt, who had installed them in his castle, Schloss Leopoldskron. They formed the centerpiece of Austin's next major exhibition, *Reflections on the Italian Comedy*, in January 1951, which included seventeenth- and eighteenth-century paintings, drawings, prints, and decorative objects. He later displayed the *Harlequin* series in the lobby of the Asolo Theater, the tiny, exquisite eighteenth-century playhouse from the castle at Asolo, Italy, which he purchased in 1950 and set up inside the Ringling Museum until a separate building could be constructed. Among the more delightful oils he acquired for the museum was Pierre Goudréaux's *Lovers' Pilgrimage*, a head-and-shoulders view of a young woman looking rapturously at her lover, dressed as Harlequin. This was featured in Austin's most personal exhibition at the Ringling, *The Artful Rococo*, in 1953. Austin

never tired of collecting objects from this period to decorate his homes in Hartford, Sarasota, Hollywood, and the south of France.

From the outset of his time in Sarasota, Austin befriended many of those connected with the Ringling Brothers and Barnum & Bailey Circus, including John Ringling's sister, Ida North, and her two sons, Henry Ringling North and John Ringling North. Austin was often among those elite guests who could be found dining in John Ringling North's private railroad car with the likes of Bette Davis and playwright Thornton Wilder, or at Ida North's dinner for Cecil B. De Mille, when the director arrived in Sarasota in 1950 to prepare for his film *The Greatest Show on Earth* (1952). And he counted among his friends the performers at the circus's winter quarters, from the famous acrobat Barbette to the immortal clown Emmett Kelly (fig. 74, page 74). Returning to Florida after his Christmas holiday at home in Hartford with his wife and children, Austin sounded exuberant to be back amid the hustle and bustle of the big top: "The circus folk are getting out their biceps and aerial trapezes again and its [*sic*] just like old times," he wrote to actress Ruth Ford one winter morning.[10] He died at the relatively young age of fifty-six while still director of the Ringling, less than a year after the original Ringling Brothers and Barnum & Bailey Circus ceased operations.

Austin was at heart an artist and performer in his own right, and like the artists he promoted, he felt a kinship to the show people in the circus. For artists, too, often live on the outskirts of conventional society, which in turn looks to them for drama, for amusement – sometimes even for vicarious thrills – and, perhaps most of all, for a wider vision of the human condition.

149
Chick Austin as
"The Ringmaster"
in the Magical
Merry-Go-Round,
with "The Tattooed
Man" (Thomas
Hughes) and
"The Blue Man"
(James Hellyar),
Avery Theater,
Wadsworth
Atheneum,
December 1940.

150
Exterior, Ringling
Museum of the
Circus, Sarasota,
Florida, 1948.

151
Interior, Ringling
Museum of the
Circus, Sarasota,
Florida, 1948.
Postcard,
5 1/2 x 3 1/2 in.

152
Giovanni Domenico
Ferretti, *Harlequin
As Painter* (from
the Disguises of
Harlequin Series),
ca. 1742.
Oil on canvas,
38 1/2 x 30 1/2 in.
The John and
Mable Ringling
Museum of Art,
the State Art
Museum of Florida;
museum purchase,
1950

Notes

1
A. Everett Austin, Jr., postcard, April 28, 1910, Austin Papers, Wadsworth Atheneum Archives.

2
Austin quoted in the *Hartford Courant*, November 21, 1934.

3
James Thrall Soby, "My Life in the Art World," unpublished memoir, chapter 4, p. 13, copy in the Wadsworth Atheneum Archives.

4
A. Everett Austin, Jr., to Helen Austin, March 17, 1946, Austin Papers, Wadsworth Atheneum Archives.

5
Sarasota Herald-Tribune, May 5, 1946.

6
Ibid., January 20, 1947.

7
Florida Times-Union (Jacksonville), January 22, 1947.

8
"Museum of the American Circus," *Ringling Museums Annual 1951*.

9
Unidentified newspaper clipping [January 1949] in A. Everett Austin, Jr., Scrapbook, Ringling Museum, November 1948–January 1950, Austin Papers, Wadsworth Atheneum Archives.

10
A. Everett Austin, Jr., to Ruth Ford, January 21, 1948, Austin Papers, Wadsworth Atheneum Archives.

POINT/
COUNTER POINT

THE CIRCUS IN ART, THE CIRCUS IN LIFE

LEE SIEGEL

MARK TWAIN'S WORD-PICTURE OF THE CIRCUS IN HIS NOVEL *THE ADVENTURES OF HUCKLEBERRY FINN*, PUBLISHED IN 1885, EVOKES THE EXCITEMENT FELT BY THE CROWD SITTING UNDER THE BIG TOP IN THE MID-NINETEENTH CENTURY:

WELL, ALL THROUGH THE CIRCUS THEY DONE THE MOST ASTONISHING THINGS; AND ALL THE TIME THAT CLOWN CARRIED ON SO IT MOST KILLED THE PEOPLE. THE RING-MASTER COULDN'T EVER SAY A WORD TO HIM BUT HE WAS BACK AT HIM QUICK AS A WINK WITH THE FUNNIEST THINGS A BODY EVER SAID; AND HOW HE EVER COULD THINK OF SO MANY OF THEM, AND SO SUDDEN AND SO PAT, WAS WHAT I COULDN'T NOWAY UNDERSTAND. WHY, I COULDN'T A THOUGHT OF THEM IN A YEAR.

And by-and-by a drunk man tried to get in to the ring – said he wanted to ride; said he could ride as well as anybody that every was. They argued and tried to keep him out, but he wouldn't listen, and the whole show came to a standstill. Then the people begun to holler at him and make fun of him, and that made him mad, and he begun to rip and tear; so that stirred up the people, and a lot of men begun to pile down off of the benches and swarm towards the ring, saying, "Knock him down! Throw him out!" and one or two women begun to scream. So, then, the ring-master he made a little speech, and said he hoped there wouldn't be no disturbance, and if the man would promise he wouldn't make no more trouble, he would let him ride, if he thought he could stay on the horse. So everybody laughed and said all right, and the man got on. The minute he was on, the horse begun to rip and tear and jump and cavort around, with two circus men hanging on to his bridle trying to hold him, and the drunk man hanging onto his neck, and his heels flying in the air every jump, and the whole crowd of people standing up shouting and laughing till the tears rolled down. And at last, sure enough, all the circus men could do, the horse broke loose, and away he went like the very nation, round and round the ring, with that sot laying down on him and hanging to his neck, with first one leg hanging most to the ground on one side, and then t'other on t'other side, and the people just crazy. It warn't funny to me, though; I was all of a tremble to see his danger. But pretty soon he struggled up astraddle and grabbed the bridle, areeling this way and that; and the next minute he sprung up and dropped the bridle and stood! And the horse agoing like a house afire, too. He just stood up there, a sailing around as easy and comfortable as if he warn't ever drunk in his life – and then he begun to pull off his clothes and sling them. He shed them so thick they kind of clogged up the air, and altogether he shed seventeen suits. And then, there he was, slim and handsome, and dressed the gaudiest and prettiest you ever saw, and he lit into that horse with his whip and made him fairly hum – and finally skipped off, and made his bow and danced off to the dressing room, and everybody just a-howling with pleasure and astonishment.

Then the ring-master he see how he had been fooled, and he was the sickest ring-master you ever see, I reckon. Why it was one of his own men! He had got up that joke all out of his own head, and never let on to nobody. Well, I felt sheepish enough, to be took in so, but I wouldn't a been in that ring-master's place, not for a thousand dollars. I don't know; there may be bullier circuses than what that one was, but I never struck them yet. Anyways it was plenty good enough for me; *and wherever I run across it, it can have all of my custom, every time.*[1]

This passage is the representative moment of the circus in American literature, occurring in the most original and most influential work of American literature. But to truly fathom it, you first have to understand the circus in modernist European writing; and you have to consider the nature of the circus itself.

We know what happens when we go to the circus, or we remember what happened when, as children, we used to go to the circus. We are swept out of the monotonous mundane, beyond the relentless routines, past the aggravating actuality of our days and nights. Every civilization has constructed and made available a moment of carnival; every society has established a convention of unconventionality. We have the circus.

A circumstance of culture and entertainment: death is the great counterpoint to life. The animal in us harbors this knowledge, which comes to consciousness in moments of danger, or anxiety, or deep reflection. This is why glimmerings of this counterpoint, ordered and restrained by the imagination, delight us so much. Anything that exposes our buried apprehension of annihilation in forms that give us pleasure relaxes the vigilant tension of the animal in us. But for this pleasure to go deep, it has to embody the fears from which it sprang, even as it has to turn them inside out or on their head. Art is one such reordering. The circus is another.

The circus is the great counterpoint to death, and to all the degrees of death in life. We toil to make a home in one place, and the circus travels through the world in perpetual motion. We strive to stay attached to our lives, and to keep hold of the material possessions that support our lives, and the circus sends men and women flying through the air. We try to suppress our animal natures; the circus puts humans and animals on an equal footing, or sometimes even reverses the hierarchy. We laugh until we cry; the clown cries until we laugh. We feign normalcy to conceal our strangeness; the circus freaks flaunt their strangeness until, observing them, we begin to doubt our normalcy. The circus comes to an end, moves on, and begins again; when our lives come to an end, there is no place to go to.

All this radical change and upheaval strengthens our necessary human delusion that we will be able to witness our death without experiencing it. In this sense, the circus is not only the counterpoint to annihilation but the opposite of art.

For art reconciles us to extinction. The circus travels through the world in perpetual motion. We stay in one place when we read a poem or gaze at a painting or listen to music, and yet these experiences transport us through time and space. The circus sends men and women flying through the air. A work of art, through metaphor, through breathtaking imagery, through new harmonies and weirdly recognizable dissonances, sends reality flying through the air by anchoring our attention to our imagination. The circus puts humans and animals on an equal footing. Art discloses our animal nature to our intellect, which suppresses our "animalness" under the yoke of contemplation. The clown cries until we laugh. Art runs us through the gamut of powerful emotions without making us lose our composure. The circus freaks flaunt their strangeness until we begin to

doubt our normalcy. Art presents the strange as something familiar and the familiar strange, making the easy coexistence of normalcy and its inversion seem the most natural thing in the world. And art, which fuses the particular with the universal, promises us that after we die, the human essence that animated us will live on. *Ars longa, circens breva.*

So the appearance of the circus in a work of art has functioned simultaneously as a contrast with life, and a contrast with art. The circus in art has been a hybrid conceit, like the bearded lady or the hermaphrodite. The heyday of such a representation of the circus was the early-to-mid-twentieth century, when, in the absence of God and religion, European modernist literature applied itself to a transfiguration of the quotidian. During this period, the circus crops up almost exclusively in poetry rather than prose, for poetry itself is a hybrid genre in the way it bends prose into philosophy and language into song. And the world of clowns and acrobats and muscle-men appears in three modes: the circus as an intermediate stage between life and art; the circus as a nihilistic vantage point from which to excoriate life's imperfections; and the circus as transcendent perfection, beside which life's possibilities glow and expand.

William Butler Yeats's poem "The Circus Animals' Desertion" portrays the circus as a door from the everyday to the extraordinary, and it presents something like a theory of the relationship between the circus and art.

I sought a theme and sought for it in vain,
I sought it daily for six weeks or so.
Maybe at last, being but a broken man,
I must be satisfied with my heart, although
Winter and summer till old age began
My circus animals were all on show,
Those stilted boys, that burnished chariot,
Lion and woman and the Lord knows what.

———

Those masterful images because complete
Grew in pure mind, but out of what began?
A mound of refuse or the sweepings of a street,
Old kettles, old bottles, and a broken can,
Old iron, old bones, old rags, that raving slut
Who keeps the till. Now that my ladder's gone,
I must lie down where all the ladders start,
In the foul rag-and-bone shop of the heart.[2]

The "stilted boys, that burnished chariot / Lion and woman and Lord knows what" — these are images from some of Yeats's early poems, which he here characterizes as "circus animals." It is a curious association, if we stick for a moment to a conception of the circus as a form of artfulness that cultivates distraction, rather than as a form of art that nourishes attention. Why would the poet want to denigrate his art by identifying it with mere boisterous spectacle? The answer appears in the final stanza. Yeats's circus animals, which had stood for his poetic images, are here transformed into the brute facts of grimy actuality: "a mound of refuse," etc. Thus, for Yeats the circus represents the middle ground between art and the raw existential materials of art: destitution, madness, and the violence implicit in the act of a crazy or enraged woman, perhaps a prostitute, greedily and desperately guarding money in a till. The circus is brute reality, in greasepaint and patches. Indeed, roughness and violence attended the circus's origins, for in ancient Rome the "circus" was the name of the place where many spectacles were held, but first among them in prestige was gladiatorial combat. Appropriately, Yeats uses the circus to echo a powerful tendency in modern art and thought, which is that the truth in life lies in the most degraded or extreme experiences of life.

This credo, invented and practiced by the nineteenth-century French decadent poets — Charles Baudelaire, Arthur Rimbaud, and others — who called it "nostalgie de la boue" (yearning for the mud), wends its way though the twentieth century in the fiction of Louis Ferdinand Céline, André Gide, and Jean Genet; the plays of Antonin Artaud; and the philosophy of Jean-Paul Sartre. The philosopher Jean Wahl called it "transcendence downward." Unlike Yeats, who invoked the raw dimension of experience in hopes of transforming it even as he borrowed its energies, the mariners of transcendence downward conceived of the circus as truth's final stop. Baudelaire, in his prose poem "The Old Acrobat," uses an aged circus-figure as both a kind of memento mori and an image of the fate of the artist in modern society. In the midst of a street circus in high revelry, Baudelaire, the observer strolling through the city, spots.

a pitiful acrobat, stooped obsolete, decrepit, a human ruin, backed against one of the posts of his shack; a shack more wretched than that of the most mindless savage, and whose adversity was still illumined all too well by two burned-down candles, dripping and smoking.

Everywhere joy, profit, debauchery: everywhere the certainty of tomorrow's bread: everywhere the frenzied explosion of vitality. Here absolute wretchedness, wretchedness rigged out, most horrible, rigged out in comic rags, where necessity, much more than art, had introduced the contrast. He was mute and motionless. He had given up, he had abdicated. His destiny was done.... And turning around, obsessed by that vision, I tried to analyze my sudden sorrow, and I told myself: I have just seen the image of the old writer who has survived the generation whose brilliant entertainer he was; of the old poet without friends, without family, without children, debased by his wretchedness and the public's ingratitude, and whose booth the forgetful world no longer wants to enter![3]

And here is a poem by French Symbolist poet Jules Laforgue – "Pierrots (Some of Us Have Principles) – whose work is the exquisitely dessicated fruit of the decadents' aesthetic:

She was saying, with the wisdom of the ages,
"I love you just for yourself!" Bravo! A charming device –
Yes, like art! Keep calm, illusory wages
From capitalist Paradise!

She said, "I'm waiting, here I am, don't know…"
Her eyes copied from large and candid moons.
Bravo! Perhaps it wasn't just for prunes
That we went to school here below?

But she was found one evening, impeccably out of luck,
Deceased! Bravo! A change of key!
We know that you'll revive in three
Days, if not in person at least

In the perfume, the leaves, the brooks of the spring!
And fools will be entangled, as you flirt,
In the Veil of the Gioconda, in the Skirt!
I might even be there on your string.[4]

The sardonic speaker is Pierrot, whom Laforgue uses to undermine conventional ideas of romance. Pierrot dismisses the sentiment of loving someone just for himself, along with the bourgeois notion of art, as a "charming device." He associates it with the kind of fake propriety that hides the way modern society turns human connection into a form of commerce – "illusory wages from capitalist Paradise." Every high feeling is counterfeit. The woman's eyes "copy" the mood that they reflect; and the romantic image of "moons" is undermined with the unlovely reality of "prunes." The poem's only truth is the fact of death, which Pierrot sarcastically juxtaposes with the naïvely romantic images of perfume, leaves, and springtime, and with the naïve Christian hope of resurrection ("you'll revive in three days"). Pierrot, the clown-figure par excellence – and once a romantic, poetic convention himself – now plays the role of gritty truth-teller. In Laforgue's poem, the circus is not Yeats's stage on the way to art, but an ultimate brute fact beyond the making of art. As with Baudelaire, Laforgue's circus occupies an Archimedean point, from which the poet may pass corrosive judgment on the world from the vantage point of the grave.

At the other extreme from these decadents' conception and use of the circus is another Archimedean point. This perspective envisions the circus as an ideal of human life and human possibility, against which the imperfect world is to be measured and inspired. It finds its consummate expression in a turn-of-the-century German poet Rainer Maria Rilke, who in the Fifth Elegy of his *Duino Elegies* (1923) took as his inspiration Pablo Picasso's 1905

painting *The Family of Saltimbanques*. (In Apollinaire's poem "Saltimbanques," Picasso's Saltimbanques play the very same role.) In the last stanza of Rilke's poem, the circus acrobats become nothing less than the embodiments of a hope – an impossible one – that true love might pry the secret of happiness from the all-knowing dead:

Angel: If there were a place that we didn't know of, and there,
on some unsayable carpet, lovers displayed
what they never could bring to mastery here – the bold
exploits of their high-flying hearts,
their towers of pleasure, their ladders
that have long since been standing where there was no ground, leaning
just on each other, trembling, – and could master all this,
before the surrounding spectators, the innumerable soundless dead:
* Would these, then, throw down their final, forever saved-up,*
forever hidden, unknown to us, eternally valid
coins of happiness before the at last
genuinely smiling pair on the gratified carpet?[5]

Thus the poet surveys and sifts the elements of reality through the fine mesh of first and last things.

For all the differences between Yeats, Laforgue, and Rilke, in each one's work the circus is an ultimate illumination of life's obscurities, and an ultimate reduction of life's baggy extenuations. As such, the circus embodies the problematic aspect of human existence. It is foul actuality, illusory hope, harsh rebuke. Only in the works of Franz Kafka, popularly regarded as the darkest and most pessimistic writer of the twentieth century, does the circus acquire the nature of a child's happy escape from ordinary life.

Franz Kafka wrote his first novel – unfinished and untitled, but now known as *Amerika* (published 1927) – about the United States, even though he had never been there (and would never go there). His hero is Karl Rossmann, whom his parents send across the ocean after Karl gets a maidservant pregnant. *Amerika* is first of all, a picaresque novel, like every great American novel from Herman Melville's *The Confidence Man* (1857) and *Huckleberry Finn* to Saul Bellow's *The Adventures of Augie March* to Pynchon's *V*. And it ends when Karl joins the Nature Theater of Oklahoma: a circus, of sorts.

The Nature Theater of Oklahoma has been described by critics as a kind of a W.P.A. project, but this distorts its meaning. It is not any kind of reality at all, but the passionate figment of a hope. It is a place whose motto is, "Everyone is welcome." Though situated in Oklahoma, the Nature Theater's boundaries seem to be without end. Kafka seems to identify it with America itself. Certainly, the promise it holds out of finding work for anyone who asks for it mirrors the promise that America has always extended to the rest of the world.

Kafka never specifies exactly what the Nature Theater is, but he does portray a place full of entertaining spectacle. He implies that it peregrinates, like a circus, and tells us that it includes people on stilts, in angel or devil costumes, playing trumpets. (One of these

figures, a girl whom Karl knew earlier in his journey through American life and now encounters for a second time, bears a surreal resemblance to the Statue of Liberty – again, as if the Nature Theater embodied the American idea of freedom and opportunity.) The Theater's outsize dimensions are circuslike, and its distractions are loud and rambunctious, also as in a circus.

Yet this mysterious extravaganza also contains another dimension: it offers employment as an actor. For Kafka, the finale of Karl's voyage through the New World – the author told his friend Max Brod that he intended to end the novel with Karl's enrollment in the Nature Theater – occurs in an enterprise that, for him, epitomizes the spirit of America, which is the plasticity of identity and the playing of roles. If Kafka's Nature Theater represents American freedom and opportunity, American freedom and opportunity in this novel also signify boundless possibilities for the human will, and for the human personality. In Kafka's vision of America, the circus is no longer the alternative world to art and life that it was for the other European modernist writers. Here, the circus is American life itself, where art and everyday existence blur and fuse together. It is as if Kafka's imagination were the vessel for the emigration of the European idea of the circus to the shores of the New World and for its transformation. Which brings us to Mark Twain, and to Huck Finn's visit to the circus.

In the small, rural town where he has been, Huck goes to see the circus at a dramatic moment. A certain Colonel Sherburn has just killed another man in cold blood. The victim was the town drunk, for years given to riding wildly up and down the main street, screaming abusive accusations and threatening to kill all and sundry. On this day, the drunk, whose name is Boggs, directs his insults and threats at the dignified and elegantly clad Sherburn, who warns Boggs that if he does not stop menacing him, Sherburn will cut him down at one o'clock. Eventually, some townspeople, who know how sad and harmless Boggs is – he's never hurt a fly – prevail on him to leave Sherburn alone, although Twain never tells us whether he passed his deadline. Boggs's pacification, however, means nothing to Sherburn, who murders him as Boggs stands helpless in the middle of the street, pleading for his life, his sixteen-year-old daughter running to try to rescue him.

Astonished and outraged, the townspeople also rush to see the dead Boggs, shoving each other out of the way in order to get a titillating glimpse of the corpse. Some of them even play-act the violent scene that they've just witnessed. After a while, one of them stirs everybody up, and they march off to seize Sherburn and lynch him. But in still another reversal, Sherburn confronts the angry mob with his pistol, speaks with eloquence and power about the cowardice of crowds and of the average citizen; the chastised townspeople slink away. Huck, who has watched things unfold, then turns away and goes off to see the circus.

And here is where, *avant la lettre*, Twain meets Kafka. For what does Huck see at the circus but a version of the events he has just witnessed on the street outside the circus? Like Boggs, a drunken man comes riding in, upsetting the routine and making everyone laugh except for Huck, who is frightened, just as Boggs made the townspeople shrug but caused Sherburn to react gravely. Yet the incident at the circus also reverses what happened in the street. Rather than fall to his death, the clown stands up on the horse, and guides the animal around the arena in virtuoso fashion with great style and elegance. In fact, Twain's description of the clown's clothes echoes his description of Sherburn's sartorial style: Sherburn is "a heap the best-dressed man in that town"; the clown "shed seventeen suits. And, then, there he was, slim and handsome, dressed the prettiest you ever saw." The reader is left with as many questions about reality as the clown has suits. Did Sherburn kill the defenseless Boggs because he lacked the imagination to realize that Boggs was merely faking, or did he kill him because his imagination of what Boggs could do ran away with him? Where does the shock lie – in Boggs's unexpected fate, or in Sherburn's unexpected reaction? And Boggs himself is as much an actor as the clown in the circus. In *Huckleberry Finn*, as in Kafka, the circus collapses art into life. Twain uses the circus to clarify reality because in wild, free, radically individualistic America, the circus is often redundant with reality.

Such redundancy perhaps is why you find the most significant appearance of the circus in American literature in Twain's novel rather than in the work of an American poet, for the novel is in more intimate relation to actual life than poetry is. And the circuslike nature of American life is perhaps why, in the twentieth century, you will rarely find any significant use of the circus in American literary art. The picaresque novel, where the hero's identity is always on the move, does the work of the circus, which young boys proverbially run away to join as an image of American mobility and possibility.

There is another reason for the strange absence of the circus in modern American literature. It is the high-technology form of the circus called movies; it is why Hart Crane's description of movies uncannily evokes the circus – "panoramic sleights / with multitudes bent toward some flashing scene" – and it is a whole different story altogether. Yet the circus only disappeared after it taught Huck Finn, and thus all ensuing American fictional heroes, a fundamental lesson about the American condition.

Notes

1
Mark Twain, *The Adventures of Huckleberry Finn* (New York: Charles L. Webster and Company), pp. 198–200.

2
William Butler Yeats, "The Circus Animals' Desertion," in *The Collected Poems of W.B. Yeats* (New York: Collier Books, 1989, 1983), pp. 346–48. Edited by Richard J. Fineran.

3
Charles Baudelaire, "The Old Acrobat," in *Baudelaire, Rimbaud, Verlaine: Selected Verse and Prose Poems* (Secaucus, N.J.: The Citadel Press, 1974, 1947), pp. 108–09. Edited by Joseph M. Bernstein.

4
Jules Laforgue, "Pierrots (Some of Us Have Principles)," in *Anchor Anthology of French Poetry* (New York: Anchor Books, 1958, 1986), p. 212. Translation by Patricia Terry.

5
Rainer Maria Rilke, "Duino Elegies," in *Ahead of All Parting: The Selected Poetry and Prose of Rainer Maria Rilke* (New York: Modern Library, 1995), pp. 363. Translation by Stephen Mitchell.

Not all works in the exhibition
can be seen at all venues.

Polly Apfelbaum (b. 1955)

Drown the Clown, 1990
Fabric, live flowers, and hangers
Three clown suits in various sizes
Courtesy the artist and D'Amelio
Terras Gallery, New York
(PA-83-SC)
(fig. 76, page 76)

Diane Arbus (1923–1971)

*Girl in Her Circus Costume,
Maryland 46/75*, 1970
Gelatin-silver print
14 ¼ x 14 ¼ in.
Courtesy Robert Miller Gallery,
New York
(A003.027.0)
(fig. 104, page 114)

*Albino Sword Swallower at
a Carnival, Maryland 10/75*, 1970
Gelatin-silver print
14 ¼ x 14 ¼ in.
Courtesy Robert Miller Gallery,
New York
(A0003.028.0)
(fig. 105, page 115)

Milton Avery (1885–1965)

Trapeze Artist, 1930
Oil on canvas
36 x 24 in.
Milton Avery Trust
(fig. 55, page 56)

Chariot Race, 1933
Oil on canvas
48 x 72 in.
Milton Avery Trust
(fig. 115, page 128)

Three Ring Circus, ca. 1939
Oil on canvas
32 x 48 in.
AXA Financial, Inc. through
its subsidiary The Equitable Life
Assurance Society of the U.S.
(fig. 56, page 57)

Gifford Beal (1879–1956)

Circus Rehearsal, n.d.
Oil on Masonite
18 x 24 in.
Courtesy Kraushaar Galleries,
New York
(fig. 18, page 26)

Circus Ring and Elephants, n.d.
Oil on canvas
24 x 30 in.
Courtesy Kraushaar Galleries,
New York
(fig. 19, page 26)

George Bellows (1882–1925)

The Circus, 1912
Oil on canvas
33 ⅞ x 44 in.
Addison Gallery of American Art,
Philips Academy, Andover,
Massachusetts; gift of Elizabeth Paine
Metcalf (1947.8)
(fig. 10, page 19)

CHECKLIST
OF THE EXHIBITION

Thomas Hart Benton (1889–1975)

Circus Performers, ca. 1911
Watercolor on laid paper
16 3/8 x 9 7/16 in.
Philadelphia Museum of Art;
The Samuel S. White, III, and Vera
White Collection (1967-030-001)
(fig. 20, page 27)

Rhona Bitner (b. 1960)

Circus Series, 1991–99
Color photographs
25 photographs, 8 x 10 in. each
Courtesy the artist
(fig. 109, page 119)

Alexander Calder (1898–1976)

Circus Scene, 1926
Gouache on canvas
69 3/4 x 83 1/2 in.
Berkeley Art Museum, University of
California; gift of Richard B. Bailey
and Nanette C. Sexton in memory of
Margaret Calder Hayes (1991.4)
(fig. 32, page 38)

Tightrope Walker, 1931–32
Ink on paper
19 1/16 x 25 1/16 in.
University of Michigan Museum
of Art (1948/1.262)
(fig. 34, page 39)

Circus Interior, 1932
Pen and ink on paper
19 x 14 in.
The Museum of Modern Art,
New York; gift of Mr. and Mrs. Peter
A. Rübel (54.65)
(fig. 33, page 39)

Circus Acrobats, 1932
Pen and ink on wove paper
14 1/16 x 19 1/16 in.
Philadelphia Museum of Art;
purchased, Lola Downin Peck Fund,
from the Carl and Laura Zigrosser
Collection, 1969 (1969-026-003)
(fig. 35, page 40)

Lion Tamer, 1932
Pen and ink on wove paper
19 1/16 x 13 15/16 in.
Philadelphia Museum of Art;
purchased, Thomas Skelton
Harrison Fund, 1941
(1941-053-133)
(fig. 37, page 41)

The Catch II, 1932
Pen and ink on paper
19 1/8 x 14 1/8 in.
The Museum of Modern Art,
New York; gift of Mr. and Mrs. Peter
A. Rübel (56.65)
(fig. 38, page 41)

Joe Coleman (b. 1955)

Phineas T. Barnum, 1999
Acrylic on Masonite
26 x 32 in.
Private collection
(fig. 75, page 75)

Russell Cowles (1887–1979)

Snake Charmer, n.d.
Oil on canvas
27 7/8 x 30 1/2 in.
Des Moines Art Center Permanent
Collections; bequest of the artist
(1980.28)
(fig. 62, page 63)

John Steuart Curry (1897–1946)

The Reiffenach Sisters, 1932
Oil on board
22 x 24 in.
Samuel P. Harn Museum of Art,
University of Florida; gift of Eloise R.
Chandler in memory of William H.
Chandler (1993.20.1)
(fig. 120, page 132)

Baby Ruth, 1932
Oil on canvas
26 x 30 in.
Brigham Young University
Museum of Art; gift of Mr. and Mrs.
William H. Child (820016900)
(fig. 66, page 66)

Circus Elephants, 1932
Oil on canvas
25 1/4 x 36 in.
National Gallery of Art, Washington,
D.C.; gift of Admiral Neill Phillips in
memory of Grace Hendrick Phillips
(1976.50.1)
(fig. 116, page 129)

Clyde Beatty, 1932
Oil on canvas
20 1/2 x 30 1/2 in.
Courtesy Vivian Kiechel Fine Art,
Lincoln, Nebraska (99-03-994)
(fig. 117, page 129)

Flying Codonas, 1932
Oil on canvas
36 x 30 in.
Courtesy Curtis Galleries,
Minneapolis
(fig. 121, page 133)

Bruce Davidson (b. 1933)

Clown with Flowers (from the Dwarf
Series), 1958
Gelatin-silver print
11 x 14 in.
Private collection, New York
(fig. 106, page 116)

*Clown Outside of Tent with
Coca-Cola Vendor* (from the Dwarf
Series), 1958
Gelatin-silver print
11 x 14 in.
Private collection, New York
(fig. 107, page 117)

Clown Outside of Tent with Elephants
(from the Dwarf Series), 1958
Gelatin-silver print
20 x 24 in.
Private collection, New York
(not illustrated)

Dwarf in Doorway of Van
(from the Dwarf Series), 1958
Gelatin-silver print
11 x 14 in.
Private collection, New York
(not illustrated)

Dwarf Performing Inside Tent
(from the Dwarf Series), 1958
Gelatin-silver print
11 x 14 in.
Private collection, New York
(not illustrated)

Dwarf Running Through Crowd
(from the Dwarf Series), 1958
Gelatin-silver print
11 x 14 in.
Private collection, New York
(not illustrated)

Dwarf with Transistor Radio in Van
(from the Dwarf Series), 1958
Gelatin-silver print
11 x 14 in.
Private collection, New York
(not illustrated)

Dwarf in Diner (from the Dwarf
Series), 1958
Gelatin-silver print
11 x 14 in.
Private collection, New York
(not illustrated)

Charles Demuth (1883–1941)

White Horse, 1912
Graphite and watercolor on paper
9 3/8 x 5 9/16 in.
Carnegie Museum of Art, Pittsburgh;
bequest of Mr. and Mrs. James H.
Beal, 1993 (93.189.12)
(fig. 23, page 30)

The Circus, 1917
Watercolor and graphite on paper
8 x 10 5/8 in.
Columbus Museum of Art, Ohio;
gift of Ferdinand Howald (1931.127)
(fig. 24, page 31)

Circus, 1917
Watercolor and graphite on paper
8 1/16 x 13 in.
Hirshhorn Museum and Sculpture
Garden, Smithsonian Institution;
gift of the Hoseph H. Hirshhorn
Foundation, 1966 (1966.1325)
(fig. 122, page 134)

**Charles Eames (1907–1978) and
Ray Eames (1912–1988)**

Clown Face, 1971
Videotape
Courtesy The Eames Office and
Pyramid Media
www.eamesoffice.com,
www.pyramidmedia.com
(fig. 79, page 78)

Walker Evans (1903–1975)

*Relief Carving, Ringling Bandwagon,
Circus Winter Quarters, Sarasota,*
1941
Gelatin-silver print
8 3/8 x 6 1/2 in.
The J. Paul Getty Museum,
Los Angeles (84.XM.956.875)
(fig. 80, page 88)

Torn Ringling Brothers Poster, 1941
Gelatin-silver print
6 1/2 x 8 1/16 in.
The J. Paul Getty Museum,
Los Angeles (84.XM.956.914)
(fig. 96, page 106)

*Circus Trainer Leading Elephant,
Winter Quarters, Sarasota*, 1941
Gelatin-silver print
6 9/16 x 7 1/2 in.
The J. Paul Getty Museum,
Los Angeles (84.XM.956.941)
(fig. 97, page 107)

Kimberly Gremillion (b. 1955)

Horse #13, 1997
Gelatin-silver print
12 x 18 in.
Courtesy Ricco/Maresca Gallery,
New York (KG248)
(fig. 87, page 95)

Clown #1, 1996
Gelatin-silver print
12 x 18 in.
Courtesy Ricco/Maresca Gallery,
New York (KG20)
(fig. 135, page 144)

Shadow #3, 1997
Gelatin-silver print
12 x 18 in.
Courtesy Ricco/Maresca Gallery,
New York (KG29)
(fig. 81, page 88)

Shadow #25, 1997
Gelatin-silver print
12 x 18 in.
Courtesy Ricco/Maresca Gallery,
New York (KG270)
(fig. 86, page 94)

Chaim Gross (1904–1991)

Strong Woman (Acrobat), 1935
Wood (lignum vitae)
48 1/4 x 11 5/8 x 8 in.
Hirshhorn Museum and Sculpture
Garden, Smithsonian Institution;
gift of the Joseph H. Hirshhorn
Foundation, 1972 (1972.145)
(fig. 57, page 59)

Lillian Leitzel, 1938
Macassar ebony
52 x 14 7/8 x 12 in.
The Metropolitan Museum of Art;
Rogers Fund 1942 (42.172)
(fig. 47, page 47)

Samuel Halpert (1884–1930)

The Juggler, 1924
Oil on canvas
59 x 39 in.
Courtesy Berry-Hill Galleries,
New York (C/9870)
(fig. 11, page 20)

Trapeze Artist, 1924
Oil on canvas
59 x 39 in.
The Detroit Institute of Arts;
gift of Dr. and Mrs. Ralph
Coskey (F75.13)
(fig. 12, page 21)

Walt Kuhn (1877–1949)

Acrobat in Green, 1927
Oil on canvas
40 7/16 x 30 1/4 in.
Addison Gallery of American Art,
Philips Academy, Andover,
Massachusetts; bequest of
Miss Lizzie P. Bliss (1931.88)
(fig. 28, page 34)

White Clown, 1929
Oil on canvas
40 1/4 x 30 1/4 in.
National Gallery of Art, Washington,
D.C.; gift of the W. Averell Harriman
Foundation in memory of Marie N.
Harriman (1972.9.16)
(fig. 31, page 37)

The Blue Clown, 1931
Oil on canvas
30 x 25 in.
Whitney Museum of American Art;
purchase (32.25)
(fig. 30, page 36)

Lancer, 1939
Oil on canvas
45 1/2 x 26 1/4 in.
The Currier Gallery of Art,
Manchester, New Hampshire;
Currier Funds (1958.7)
(fig. 29, page 35)

Yasuo Kuniyoshi (1889–1953)

Circus Ball Rider, 1930
Lithograph on wove paper
15 x 11 in.
Hood Museum of Art, Dartmouth
College, Hanover, New Hampshire;
gift of Mr. and Mrs. Preston Harrison
(PR.940.30)
(fig. 124, page 135)

George Luks (1867–1922)

The Circus Tent, ca. 1928–30
Oil on canvas
18 x 22 in.
Heckscher Museum of Art,
Huntington, New York; museum
purchase, Heckscher Trust
Fund (1975.5)
(fig. 9, page 18)

Clown, 1929
Oil on canvas
24 1/8 x 20 in.
Museum of Fine Arts, Boston;
bequest of John T. Spaulding, 1948
(48.574)
(fig. 14, page 23)

John Marin (1870–1953)

Circus Forms, 1934
Oil on canvas
29 x 36 1/4 in.
The Detroit Institute of Arts; gift of
Robert H. Tannahill (69.307)
(fig. 26, page 32)

The Juggler, 1936
Watercolor and ink on paper
21 3/4 x 30 1/2 in.
Yale University Art Gallery,
New Haven; The Philip L. Goodwin,
B.A. 1907 Collection
(Gift of James L. Goodwin, 1905,
Henry Sage Goodwin, 1927, and
Richmond L. Brown, 1907) (1958.26)
(fig. 25, page 32)

Mary Ellen Mark (b. 1940)

*Shavanaas Begum with Her
Three-Year-Old Daughter, Parveen.
Great Gemini Circus, Perintalmanna,
India*, 1989
Gelatin-silver print
16 x 20 in.
Courtesy the artist
(fig. 59, page 59)

*Contortionist with Sweety the Puppy,
Raj Kamal Circus, Upleta, India*, 1989
Gelatin-silver print
16 x 20 in.
Courtesy the artist
(fig. 108, page 118)

*A Passage to Vietnam: National
Circus of Vietnam. Lenin Park, Hanoi,
North Vietnam*, 1994
Gelatin-silver print from an
edition of 25
16 x 20 in.
Courtesy the artist
(fig. 88, page 98)

Reginald Marsh (1898–1954)

*Wonderland Circus, Sideshow,
Coney Island*, 1930
Tempera on paper stretched
on Masonite
48 3/4 x 48 in.
The John and Mable Ringling Museum
of Art, the State Art Museum of
Florida; museum purchase (SN 951)
(fig. 49, page 50)

The Barker, 1931
Etching on paper
9 3/4 x 7 7/8 in.
The William Benton Museum of Art,
University of Connecticut, Storrs;
gift of Helen Benton Boley
(78.5.19.196E-S115)
(fig. 51, page 52)

Pip and Flip, 1932
Tempera on paper mounted
on canvas
48 x 48 in.
Terra Foundation for the Arts, Chicago;
Daniel J. Terra Collection (1999.96)
(fig. 50, page 51)

The Flying Concellos, 1936
Etching on paper
7 7/8 x 9 7/8 in.
The William Benton Museum of Art,
University of Connecticut, Storrs;
gift of Helen Benton Boley
(78.5.19.148C-S163)
(fig. 52, page 53)

Edwin Martin (b. 1943)

*Center Pole Holes, Lake Isabella,
California*, 1984
Gelatin-silver print
8 x 10 in.
The John and Mable Ringling Museum
of Art, the State Art Museum of
Florida; museum purchase (SN
8983.2)
(fig. 110, page 120)

*Setting the Flag, Rainelle,
West Virginia*, 1986
Gelatin-silver print
8 x 10 in.
The John and Mable Ringling Museum
of Art, the State Art Museum of
Florida; museum purchase
(SN8983.28)
(fig. 111, page 121)

Lisette Model (1901–1983)

Circus, New York, 1945
Gelatin-silver print
24 x 18 in.
National Gallery of Canada, Ottawa;
gift of the Estate of Lisette Model,
1990, by direction (35253)
(fig. 98, page 108)

Circus, New York, 1945
Gelatin-silver print
24 x 20 in.
National Gallery of Canada, Ottawa;
gift of the Estate of Lisette Model,
1990, by direction (35254)
(fig. 99, page 109)

Circus, New York, 1945
Gelatin-silver print
24 x 20 in.
National Gallery of Canada, Ottawa;
gift of the Estate of Lisette Model,
1990, by direction (35255)
(fig. 100, page 110)

Circus, New York, 1945
Gelatin-silver print
24 x 20 in.
National Gallery of Canada, Ottawa;
gift of the Estate of Lisette Model,
1990, by direction (35256)
(fig. 101, page 111)

Bruce Nauman (b. 1941)

*Clown Torture (Dark and Stormy
Night with Laughter)*, 1987
Two color video monitors,
two vcrs, two videotapes
Dimensions variable
Collection Barbara Balkin Cottle
and Robert Cottle, courtesy
Donald Young Gallery, Chicago
(fig. 136, page 145)

John O'Reilly (b. 1930)

A Field of View, 1969
Paper montage and casein
44 1/4 x 40 1/2 in.
De Cordova Museum and Sculpture
Park, Lincoln, Massachusetts;
museum purchase (1997.70)
(fig. 78, page 77)

Paul Outerbridge Jr. (1869–1958)

Elephant, 1934
Pen and ink on paper
18 x 24 in.
Yale University Art Gallery;
gift, Estate of Katherine S. Dreier,
gift of the artist, 1942 (1942.156)
(fig. 43, page 44)

Tightrope Walker, 1934
Pen and ink on paper
18 x 24 in.
Yale University Art Gallery;
gift, Estate of Katherine S. Dreier
to the Societé Anonyme Collection
(1942.155)
(fig. 44, page 45)

Trapeze, 1934
Pen and ink on paper
18 x 24 in.
Yale University Art Gallery;
gift, Estate of Katherine S. Dreier
(1942.157)
(fig. 45, page 46)

Clown, 1934
Pen and ink on paper
18 x 24 in.
Yale University Art Gallery;
gift of Collection Societé
Anonyme (1942.158)
(fig. 46, page 46)

Guy Pène du Bois (1884–1958)

Trapeze Performers, 1931
Oil on canvas
25 x 20 in.
The Butler Institute of American Art,
Youngstown, Ohio; museum
purchase 1964 (964-0-113)
(fig. 53, page 54)

Robert Riggs (1896–1950)

Center Ring, 1933
Lithograph on paper
14 ½ x 19 ½ in.
Philadelphia Museum of Art;
purchased, Thomas Skelton Harrison
Fund, 1941
(1941-053-055)
(fig. 67, page 67)

Elephant Act, 1935
Lithograph on paper
14 ¼ x 19 ½ in.
Philadelphia Museum of Art;
purchased, Thomas Skelton Harrison
Fund, 1941
(1941-053-301)
(fig. 69, page 69)

Tumblers, 1936
Lithograph on wove paper
14 ¼ x 18 ¹⁵⁄₁₆ in.
Pennsylvania Academy of the Fine
Arts, Philadelphia; gift of Drs. Marcia
and Stephen Silberstein (1977.6)
(fig. 68, page 68)

Harry C. Rubincam (1871–1940)

In the Circus, 1905
Photogravure
8 ¼ x 11 ¾ in.
Gernsheim Collection, Harry Ransom
Humanities Research Center,
University of Texas at Austin
(964: 0356: 0173)
(fig. 89, page 99)

Anne Ryan (1889–1954)

Circus I (Equestrienne) 1/15, 1945
Color woodcut on rice paper
12 x 18 in.
Courtesy Kraushaar Galleries,
New York
(fig. 70, page 70)

Circus V (Monkey and Lamp) 26/30,
1945
Color woodcut on paper
17 ½ x 11 ½ in.
Courtesy Kraushaar Galleries,
New York
(fig. 71, page 71)

Paul Sample (1896–1974)

Country Circus, 1929
Oil on canvas
36 x 48 in.
Swarthmore College, Pennsylvania
(385)
(fig. 63, page 64)

Clown Reading, 1933
Oil on canvas
25 x 30 in.
Audrey Chamberlain Foote,
Washington, D.C.
(fig. 64, page 64)

George Segal (1924–2000)

Trapeze, 1971
Plaster, wood, metal, rope
H. 71 in.
Wadsworth Atheneum Museun of Art,
Hartford; gift of Henry and Walter
Keney with additional funds contributed
by Joseph L. Shulman and an
Anonymous donor (1972.12)
(fig. 77, page 77)

Everett Shinn (1876–1953)

The Tightrope Walker, 1924
Oil on canvas
23 ½ x 18 in.
The Dayton Art Institute; museum
purchase with funds provided by
the James F. Dicke Family and
the E. Jeanette Myers Fund (1998.7)
(fig. 15, page 24)

The Clown, 1930
Oil on canvas
36 x 42 in.
Private collection
(fig. 17, page 25)

John Sloan (1871–1951)

Clown Making Up, 1910
Oil on canvas
32 ⅛ x 26 in.
The Phillips Collection, Washington,
D.C. (1757)
(fig. 13, page 22)

Luke Swank (1890–1944)

Circus: Otto Griebling, Head Clown,
ca. 1934
Gelatin-silver print
5 ⁵⁄₁₆ x 4 ⁷⁄₁₆ in.
Carnegie Museum of Art, Pittsburgh;
gift of the Carnegie Library of
Pittsburgh, 1983 (83.40.10)
(fig. 82, page 89)

Circus: Tents, 1934
Gelatin-silver print
6 ¹⁄₁₆ x 4 ⁵⁄₁₆ in.
Carnegie Museum of Art, Pittsburgh;
gift of the Carnegie Library of
Pittsburgh,1983 (83.76.16)
(fig. 83, page 90)

Circus: Workmen with Tent, ca. 1934
Gelatin-silver print
6 ¹⁄₁₆ x 4 ¹¹⁄₁₆ in.
Carnegie Museum of Art, Pittsburgh;
gift of the Carnegie Library of
Pittsburgh, 1983 (83.40.36)
(fig. 84, page 91)

Pavel Tchelitchew (1898–1957)

Female Acrobat, 1931
Oil on canvas
31 ¾ x 39 ½ in
Courtesy Curtis Galleries,
Minneapolis
(fig. 146, page 156)

Acrobat in Red Vest, 1931
Oil on board
41 ½ x 29 ¾ in.
Courtesy Curtis Galleries,
Minneapolis
(fig. 147, page 156)

Pip and Flip, 1935
Oil on canvas
18 x 15 in.
Wadsworth Atheneum Museum of Art,
Hartford; The Ella Gallup Sumner and
Mary Catlin Sumner Collection Fund
(1943.38)
(fig. 148, page 157)

Helen Torr (1886–1967)

Circus, 1930s
Watercolor on paper
8 ¼ x 10 ¼ in.
William H. Lane Collection, courtesy
Museum of Fine Arts, Boston
(fig. 27, page 33)

Carlos Vilardebos (b. 1926)

Cirque Calder, 1961
Video of Alexander Calder performing
the circus
The Roland Collection
(not illustrated)

Weegee (1899–1968)

*Circus, New York (Sleeping Man
and Giraffe)*, 1945
Gelatin-silver print
13 ½ x 10 ¼ in.
International Center of Photography,
New York
(fig. 102, page 111)

*Danger: Do Not Walk on Ceiling
(Hanging Clown Effigy)*, ca. 1945
Gelatin-silver print
13 ⅛ x 10 ⅝ in.
International Center of Photography,
New York
(fig. 65, page 65)

*Emmett Kelly at Madison
Square Garden*, ca. 1945
Gelatin-silver print
10 ⅝ x 13 ⅜ in.
International Center of Photography,
New York
(fig. 74, page 74)

Edward Weston (1886–1958)

Circus Tent, 1923
Platinum-palladium print
9 ⅜ x 7 ⅛ in.
Oakland Museum of California;
gift of Mr. and Mrs. Edward Weston
(A67.47.1)
(fig. 90, page 99)

Adams, Bluford. "'A Stupendous Mirror of Departed Empires': The Barnum Hippodromes and Circuses, 1874–1891," *American Literary History* 8, no. 1 (Spring 1996).

———. *E. Pluribus Barnum: The Great Showman and the Making of U.S. Popular Culture.* Minneapolis: University of Minnesota Press, 1997.

Adams, Philip Rhys. *Walt Kuhn, Painter: His Life and Work.* Columbus: Ohio State University Press, 1978.

Ahlander, Leslie Judd. *The Circus in Art.* Sarasota, Fla.: John and Mable Ringling Museum of Art, 1977. Exh. cat.

Albrecht, Donald, Beatriz Colomina, Joseph Giovanni, Alan Lightman, Hélène Lipstadt, and Philip and Phyllis Morrison. *The Work of Charles and Ray Eames: A Legacy of Invention.* New York: Harry N. Abrams, in association with the Library of Congress and the Vitra Design Museum, 1997.

Albrecht, Ernest J. *A Ringling by Any Other Name: The Story of John Ringling North and His Circus.* Metuchen, N.J.: Scarecrow Press, 1989.

———. *The New American Circus.* Gainesville: University Press of Florida, 1995.

Alexander Calder: Circus Drawings, Wire Sculptures, and Toys. Houston: Museum of Fine Arts, 1964. Exh. cat.

Arbus, Diane. *Diane Arbus: An Aperture Monograph.* New York: Aperture, 1972.

Arbus, Doon, and Marvin Israel. *Diane Arbus, Magazine Work.* New York: Aperture, 1984.

Art, Carnival and the Circus. Sarasota, Fla.: John and Mable Ringling Museum of Art, 1949. Exh. cat.

Barnes, Djuna. *Nightwood.* New York: New Directions, 1937.

———. *Interviews.* College Park, Md.: Sun and Moon Press, 1985.

———. *New York.* Los Angeles: Sun and Moon Press, 1989.

Barnum, P.T. *The Story of My Life.* Cincinnati, Ohio: Forshee and McMakin, 1886.

Barth, Miles, ed. *Weegee's World.* Boston: Bulfinch, 1997.

Bassham, Ben. *The Lithographs of Robert Riggs with a Catalogue Raisonné.* Philadelphia: Art Alliance; and London: Associated University Presses, ca. 1986.

Benezra, Neal, Kathy Halbreich, Paul Schimmel, and Robert Storr. *Bruce Nauman.* Minneapolis and New York: Walker Art Center and Distributed Art Publishers, 1994.

Berman, Avis. *Rebels on Eighth Street: Juliana Force and the Whitney Museum of American Art.* New York: Atheneum, 1990.

SELECTED BIBLIOGRAPHY

Bogdan, Robert. *Freak Show: Presenting Human Oddities for Amusement and Profit.* Chicago: University of Chicago Press, 1988.

——. "Freak Shows and Talk Shows," *Parkett* 46 (1996).

Boissac, Paul. *Circus and Culture, A Semiotic Approach.* Bloomington: University of Indiana Press, 1976.

Bosworth, Patricia. *Diane Arbus: A Biography.* New York: Avon, 1984.

Braun, Emily, and Tom Branchick. *Thomas Hart Benton: The America Today Murals.* New York: Equitable Life Assurance Association of the United States, 1985.

Brown, Maria Ward. *The Life of Dan Rice.* Long Branch, N.J.: published by the author, 1901.

Bruggen, Coosje van. *Bruce Nauman.* New York: Rizzoli, 1988.

Buford, Kate. *Burt Lancaster: An American Life.* New York: Alfred A. Knopf, 2000.

Calder, Alexander. "Voici une petite histoire de mon cirque." In *Permanence du Cirque.* Paris: Revue Neuf, 1952.

Carmeli, Yoram S. "The Invention of Circus and Bourgeois Hegemony: A Glance at British Circus Books." *Journal of Popular Culture* 29 (Summer 1995).

——. "The Sight of Cruelty: the Case of Circus Animal Acts," *Visual Anthropology* 10, no. 1 (1997).

Cate, Phillip Dennis. "The Cult of the Circus." In Barbara Shapiro, *The Pleasures of Paris, Daumier to Picasso.* Boston: Museum of Fine Arts and David R. Godine, 1991.

Chindahl, George Leonard. *A History of the Circus in America.* Caldwell, Idaho: Caxton Printers, 1959.

Clarke, John S. *Circus Parade.* London: B.T. Batsford Ltd., 1936.

Colomina, Beatriz, "Reflections on the Eames House." In Donald Albrecht et al, *The Work of Charles and Ray Eames: A Legacy of Invention.* New York: Harry N. Abrams, in association with the Library of Congress and the Vitra Design Museum, 1997.

Conger, Amy. *Edward Weston: Photographs from the Collection of the Center for Creative Photography.* Tucson: Center for Creative Photography, University of Arizona, 1992.

Cooper, Diana Starr. *Night After Night.* Washington, D.C., and Covelo, Calif.: Island Press, 1994.

Corn, Wanda M. *The Great American Thing: Modern Art and National Identity, 1915–1935.* Berkeley and London: University of California Press, 1999.

Cox, Antony Hippisley. *A Seat at the Circus.* Hamden, Conn.: Archon Books, 1980.

Cside, Joseph, and June Bundy Csida. *American Entertainment.* New York: Billboard, 1978.

Culhane, John. *The American Circus: An Illustrated History.* New York: Henry Holt, 1990.

Cummings, E.E. *Him.* New York: Liveright Publishing Corporation, 1927.

——. "The Adult, the Artist and the Circus." *Vanity Fair,* October 1925.

Dahlinger, Fred, and Stuart Thayer. *Badger State Showmen: A History of Wisconsin's Circus Heritage.* Baraboo, Wis.: Circus World Museum; Madison: Grote Publishing, 1998.

DeFazio, Edith. *Everett Shinn: 1876–1953.* New York: Clarkson N. Potter, 1974.

DePietro, Anne Cohen. *Under the Big Top: The Circus in Art.* Huntington, N.Y.: Hecksher Museum of Art, 1991. Exh. bro.

Dery, Mark. *The Pyrotechnic Insanitarium: American Culture on the Brink.* New York: Grove Press, 1999.

Durant, John and Alice. *A Pictorial History of the American Circus.* New York: A.S. Barnes and Co., 1957.

Eckley, Wilton. *The American Circus.* Boston: Twayne Publishers, 1984.

Edgerton, Harold. *Stopping Time: the Photographs of Harold Edgerton.* New York: Harry N. Abrams, 1987.

Evans, Walker. *Photographs for the Farm Security Administration, 1935–1938.* New York: Da Capo, 1973.

Feiler, Bruce. *Under the Big Top.* New York: Scribner's, 1995.

Fine, Ruth. *John Marin.* Washington D.C.: National Gallery of Art; and New York: Abbeville Press, 1990.

Fox, Charles Philip, ed. *American Circus Posters in Full Color.* New York: Dover, 1978.

Fréjaville, Gustave. "Les Poupées Acrobats du Cirque Calder." *Comoedia,* April 24, 1929.

Frost, Rosamund. "Kuhn Under the Big Top." *Art News* 40 (December 15, 1941): 13.

——. "Walt Kuhn Clowns in a Great Tradition." *Art News* 42 (May 1, 1943): 11.

Fulton, Marianne. *Mary Ellen Mark: 25 Years.* Boston: Bulfinch, 1991.

Gaddis, Eugene R. *Magician of the Modern: Chick Austin and the Transformation of the Arts in America.* New York: Alfred Knopf, 2000.

Gray, Cleve. "Calder's Circus." *Art in America* 52 (October 1964): 23–48.

Gregor, Jan T., and Tim Cridland. *Circus of the Scars: The True Inside Odyssey of a Modern Circus Sideshow.* Seattle: Brennan Dalsgard, 1998.

Gremillion, Kimberley. "Interview." *Aperture* 154 (Winter 1999).

Hale, Eunice Mylon. "Charles Demuth: His Study of the Figure." Ph.D. dissertation, New York University, 1974.

Hammarstrom, David Lewis. *Big Top Boss: John Ringling North and the Circus.* Urbana and Chicago: University of Illinois Press, 1992.

Harris, Neil. *Humbug: The Art of P. T. Barnum.* Boston: Little Brown, 1973.

Hartley, Marsden. "The Greatest Show on Earth: An Appreciation of the Circus from One of Its Grown-up Admirers." *Vanity Fair,* August 1924.

——. *Somehow a Past: The Autobiography of Marsden Hartley.* Edited by Susan Elizabeth Ryan. Cambridge and London: MIT Press, 1998.

Hayes, Margaret Calder. *Three Alexander Calders: A Family Memoir.* Introduction by Tom Armstrong. Cupertino, Calif.: De Anza College Press, 1998.

Henri, Robert. *The Art Spirit.* Compiled by Margery Ryerson. New York: Harper & Row, 1984.

Hillier, Bevis. *The Decorative Art of the Forties and Fifties: Austerity/Binge.* New York: Clarkson N. Potter, 1975.

Hobbs, Robert. *Milton Avery.* New York: Hudson Hills Press, Inc., 1990.

Jarmusch, Jim, John Yan, and Harold Schechter. *Original Sin: The Visionary Art of Joe Coleman.* New York: HECK editions/Gates of Heck, 1997.

Jeffrey, Ian. *Bill Brandt: Photographs 1928–1983.* London: Thames and Hudson, 1993.

Jensen, Dean. *Center Ring: The Artist: Two Centuries of Circus Art.* Milwaukee: Milwaukee Art Museum, 1981. Exh. cat.

Jones, Louisa E. *Sad Clowns and Pale Pierrots: Literature and the Popular Comic Arts in 19th-Century France.* Lexington, Ky.: French Forum, 1984.

Junker, Patricia. *John Steuart Curry: Inventing the Middle West.* New York: Hudson Hills Press, in association with the Elvehjem Museum of Art, University of Wisconsin at Madison, 1998.

Kammen, Michael. *The Lively Arts: Gilbert Seldes and the Transformation of Cultural Criticism in the United States.* New York: Oxford University Press, 1996.

Kelly, Emmett, with F. Beverly Kelly. *Clown.* New York: Prentice-Hall, 1954.

Kennedy, Richard S. *Dreams in a Mirror: A Biography of E.E. Cummings.* New York: Liveright, 1980.

King, Stephen. *It.* New York: Signet, 1987.

Kunhardt, Philip B., Jr., Philip B. Kunhardt III, and Peter W. Kunhardt. *P. T. Barnum: America's Greatest Showman.* New York: Knopf, 1995.

Lax, Robert. *Circus of the Sun.* New York: Journeyman Books, 1959; reprinted Zurich, Pendo, 1981.

Lears, Jackson. *Fables of Abundance: A Cultural History of Advertising in America.* New York: Harper Collins, Basic Books, 1994.

Leuchtenburg, William E. *Franklin D. Roosevelt and the New Deal, 1932–1940.* New York: Harper and Row, 1963.

Levy, Shawn. *King of Comedy: The Life and Art of Jerry Lewis.* New York: St. Martin's, 1996.

Lipman, Jean, and Nancy Foote. *Calder's Circus.* New York: E.P. Dutton, in association with Whitney Museum of American Art, 1972.

Lord, Fred. *Little Big Top.* Adelaide: Rigby, Ltd., 1965.

Lowe, Sarah M. *Tina Modotti Photographs.* New York: Harry N. Abrams, Inc., 1995

Loxton, Howard. *The Golden Age of the Circus.* London: Regency House, 1997.

MacGregor-Morris, Pamela. *Sawdust and Spotlight.* London: H.F. & G. Witherby, Ltd., 1960.

McKennon, Joe. *Logistics of the American Circus Written by a Man Who Was There.* Sarasota Fla.: Carnival Publishers, 1977.

McMullan, Richard Dale, and Kneeland McNulty. *Circus in Art.* Boston: Boston Public Library, 1985.

McNamara, Brooks. *Step Right Up.* Garden City, N.Y.: Doubleday & Co., 1976.

Mardon, Michael. *A Circus Year.* London: Putnam, 1961.

Margulis, Marianne F. *Camera Work, a Pictorial Guide.* New York: Dover, 1978.

Mark, Mary Ellen. *Indian Circus.* San Francisco: Chronicle Books, 1993.

Marling, Karal Ann. *As Seen on TV: The Visual Culture of Everyday Life in the 1950s.* Cambridge: Harvard University Press, 1994.

———. *Graceland: Going Home with Elvis.* Cambridge: Harvard University Press, 1996.

Marter, Joan. *Alexander Calder.* Cambridge: Cambridge University Press, 1991.

Martin, Edward. *Mud Show: American Tent Circus Life.* Albuquerque: University of New Mexico Press, 1988.

May, Earl Chapin. *The Circus from Rome to Ringling.* New York: Dover, 1963, reprint of 1932 edition.

Miller, Henry. *The Smile at the Foot of the Ladder.* New York: New Directions Press, 1974.

Mishler, Doug A. "'It Was Everything Else We Knew Wasn't': The Circus and American Culture." In *The Cultures of Celebrations,* edited by Ray B. Browne and Michael T. Marsden. Bowling Green, Ohio: Bowling Green State University Popular Press, 1994.

Naef, Weston. *André Kertész in Focus.* Malibu, Calif.: The J. Paul Getty Museum, 1994.

Newhall, Beaumont. *Supreme Instants: the Photography of Edward Weston.* Boston: New York Graphic Society, 1996.

Newhall, Nancy, ed. *The Daybooks of Edward Weston.* New York: Aperture, 1981.

Newhart, John, Marilyn Neuhardt, and Ray Eames. *Eames Design: The Work of the Office of Charles and Ray Eames.* New York: Harry N. Abrams, 1989.

Norden, Martin F., and Madeleine A. Cahill. "Violence, Women, and Disability in Tod Browning's *Freaks* and *The Devil Doll.*" *Journal of Popular Film and Television* 26, no. 2 (Summer 1998).

North, Henry Ringling, and Alden Hatch. *The Circus Kings: Our Ringling Family Story.* Garden City, N.Y.: Doubleday, 1960.

O'Brien, Esse Forrester. *Circus Cinders to Sawdust.* San Antonio, Tex.: The Naylor Company, 1959.

Ogden, Tom. *Two Hundred Years of the American Circus: From Aba-Daba to the Zoppe-Zavatta Troupe.* New York: Facts on File, 1993.

Pagel, David. "Fortune's Orbit: Polly Apfelbaum's Evocative Arrangements." *Arts Magazine* (January 1991): 39–43.

Parkinson, Tom, and Charles Philip Fox. *The Circus Moves by Rail.* Newton, N.J.: Carstens Publications, 1993.

Platt, Ron. *Cannibal Eyes.* Cambridge, Mass.: MIT List Visual Arts Center, 1992.

Politzer, Heinz. *Franz Kafka, Parable and Paradox.* Ithaca, N.Y.: Cornell University Press, 1962, reprinted in 1965 as *Franz Kafka der Kunstler.*

Powledge, Fred. *Mud Show: A Circus Season.* New York: Harcourt Brace Jovanovich, 1975.

Plunket, Robert. "Walker Evans, The Mangrove Coast and Me." In *Walker Evans: Florida.* Los Angeles: J. Paul Getty Museum, 2000.

Prather, Marla, Alexander S. C. Rower, and Arnauld Pierre. *Alexander Calder: 1898–1976.* Washington, D.C.: National Gallery of Art, 1998. Exh. cat.

Reff, Theodore. "Harlequins, Saltimbanques, Clowns, and Fools in Picasso's Art." *Artforum* 10 (October 1971): 30–43.

Richardson, John. *A Life of Picasso.* Vol. 1, *1881–1906.* New York: Random House, 1991.

Ritter, Naomi. *Art As Spectacle: Images of the Entertainer Since Romanticism.* Columbia: University of Missouri Press, 1989.

Russo, Mary. *The Female Grotesque: Risk, Excess and Modernity.* New York: Routledge, 1994.

Ross, Novelene. "Toward an American Identity: The Formulation of the Wichita Art Museum Collection of American Art in an Era of Aesthetic Nationalism." In Novelene Ross and David Cateforis, *Toward an American Identity: Selections from the Wichita Art Museum Collection of American Art.* Wichita: Wichita Art Museum, 1997. Exh. cat.

Sander, August. *Men Without Masks.* New York: New York Graphic Society, 1972.

Santoli, Lorraine. *The Official Mickey Mouse Club Book.* New York: Hyperion, 1995.

Schmeckebier, Laurence E. *John Steuart Curry's Pageant of America.* New York: American Artists Group, 1943.

Seldes, Gilbert. *The Seven Lively Arts.* New York: Sagamore Press, 1957.

Skal, David J., and Elias Savada. *Dark Carnival: the Secret World of Tod Browning, Hollywood's Master of the Macabre.* New York: Anchor Books, 1995.

Smelstor, Marjorie. "'Damn Everything but the Circus': Popular Art in the Twenties and *him.*" *Modern Drama* 17, no. 1 (March 1974).

Smith, Buffalo Bob, and Donna McCrohan. *Howdy and Me: Buffalo Bob's Own Story.* New York: Plume, 1990.

Snyder, Jill, and Ingrid Schaffner. *Bruce Nauman, 1985–1996: Drawings, Prints, and Related Works.* Ridgefield, Conn.: Aldrich Museum of Contemporary Art, 1996. Exh. cat.

Snyder, Robert W. *The Voice of the City: Vaudeville and Popular Culture in New York.* New York: Oxford University Press, 1989.

Strauss, Darin. *Chang and Eng.* New York: E.P. Dutton, 2000.

Sullivan, Terry, with Peter T. Maiken. *Killer Clown: The John Wayne Gacy Murders.* New York: Pinnacle, 1983.

Swortzell, Lowell. *Here Come the Clowns.* New York: Viking Press, 1978.

Taylor, Robert Lewis. *Center Ring: The People of the Circus.* Garden City, N.Y.: Doubleday, 1956.

Thomas, Ann. *Lisette Model.* Ottawa: National Gallery of Canada, 1990.

Thomson, Richard. *Seurat.* New York: Phaidon Universe, 1990.

Todd, Jan. "Bring on the Amazons: An Evolutionary History." In Laurie Fierstin Frueh and Judith Stein, *Picturing the Modern Amazon.* New York: Rizzoli and The New Museum, 1999.

Turner, Elizabeth Hutton. *Americans in Paris (1921–1931): Man Ray, Gerald Murphy, Stuart Davis, Alexander Calder.* Washington, D.C.: Counterpoint, in association with the Phillips Collection, 1996.

Twain, Mark. *The Adventures of Huckleberry Finn.* New York: Ballantine Books, 1996.

Varnedoe, Kirk, and Adam Gopnick. *High and Low: Modern Art and Popular Culture.* New York: Museum of Modern Art, 1991.

Wagner, Geoffrey. "Art and the Circus." *Apollo* n.s. 82 (August 1965): 134–36.

Weegee (Fellig, Arthur). *Naked City.* New York: Da Capo, 1973, reprint of 1945 original.

Weegee's New York: 335 Photographs 1935–1960. Munich: Schirmer Art Books, 1982.

Wilkins, Charles. *The Circus at the Edge of the Earth: Travels with the Great Wallenda Circus.* Toronto: McClelland & Stewart, 1998.

Wilmeth, Don. Introduction. In Edwin Martin, *Mud Show: American Tent Circus Life.* Albuquerque: University of New Mexico Press, 1988.

Winkiel, Laura. "Circuses and Spectacles: Public Culture in *Nightwood.*" *Journal of Modern Literature* (Summer 1997).

Yount, Sylvia. "Consuming Drama: Everett Shinn and the Spectacular City." *American Art* (Fall 1992): 82–109.

Zucker, Wolfgang, M. "The Image of the Clown." *Journal of Aesthetics* 12 (March 1954): 310–17.

Zurier, Rebecca, Virginia Mecklenburg, and Robert W. Snyder. *Metropolitan Lives: The Ashcan Artists and Their New York.* New York: National Museum of American Art, in association with W.W. Norton, 1995.

CREDITS

PHOTO

INDEX